Forgetting
the Art World

Forgetting
the Art World

Pamela M. Lee

The MIT Press Cambridge, Massachusetts London, England

MIT Press books may be purchased at special quantity discounts for business or sales promotional use. For information, please email special_sales@mitpress.mit.edu or write to Special Sales Department, The MIT Press, 55 Hayward Street, Cambridge, MA 02142.

This book was set in Utopia by The MIT Press. Printed and bound in Canada.

Library of Congress Cataloging-in-Publication Data

Lee, Pamela M.
Forgetting the art world / Pamela M. Lee.
p cm
Includes bibliographical references and index.
ISBN 978-0-262-01773-2 (hardcover : alk. paper) 1. Art and globalization. 2. Art, Modern—21st century. I. Title.
N72.G55L44 2012
701.03—dc23
 2011052296

10 9 8 7 6 5 4 3 2 1

To the brothers: David and Geoff

Contents

Acknowledgments

In 1991, a latecomer to the New York art world could write the following response to an emerging tendency in contemporary art:

> To be a tourist in the late twentieth century is to invest in a broad range of assumptions about the travel experience. Notions of escape, adventure and a return to an Edenic past are pervasive to the language of tourism, and the objects gathered during travel protract the sense of being in exotic and remote places. Yet the very factors that have made modern travel possible—industrialization, commercial enterprise, and increased leisure time—reveal that the tourist experience is historically conditioned and not merely the act of traveling. Rather, the desire to travel can be located in a complex register of cultural, political and sociological influences, many of which have been completely repressed by the tourist.[1]

That upstart author was me. I was a curatorial fellow at the Whitney Museum Independent Study Program (ISP), and, along with Karin Higa and Jonathan Caseley, organized a modest show at the Whitney's downtown branch called "Site/Seeing: Travel and Tourism in Contemporary Art." Under the direction of Ron Clark, and as advised by Hal Foster, the Senior Instructor at the ISP during those years, each of us had a particular stake in the project. Karin was steeped in the literature on tourism and souvenir art formulated by Nelson Grayburn. Jonathan was working through questions of hybridity and difference in the work of Homi Bhabha. I had taken a graduate seminar in anthropology with Vincent Crapanzano at CUNY and was reading the critiques of ethnography advanced by James Clifford and Arjun Appadurai. Together we seized upon a genre of imagery and a set of practices that we were more and more seeing in the galleries and alternative spaces. In the work of Renée Green and Jimmy Durham, Fred Wilson, James Luna, Tseng Kwong Chi, and Elaine Reicheck, to name some of the artists in the show, questions of alterity were expressed as touristic or traveling encounters—a confrontation between the Euro-American subject and his or her (highly qualified) "non-Western" Other.

We couldn't have know it then, but what we were surveying would bear a faint family resemblance to some of the interests of what is now called "globalism," precipitating the concerns for movement and migration relative to the tourist industry and the associated spectacles of modern travel. Of course a vast gulf separates our small,

student-initiated offering and the sprawling international exhibitions of "global" art in the present day. At that time, the concerns, conditions, and touchstones were radically different. In seminar we wrestled with controversial exhibitions such as "Magiciens de la terre," and debates around difference, identity politics, and postcolonial theory were our point of entry into the culture wars.

Still, there is something a little uncanny about returning to a related series of questions twenty years later, if through a different lens: by considering the processes of globalization rather than of globalism, of which our group show at the Whitney showcased but one very narrow strand. If my curatorial and critical instincts back then were inchoate, clunky, or naïve, I can now say, with the confidence that over two decades' hindsight brings, that perhaps we were on to something. To suggest as much is not to argue for anything as grand (or downright embarrassing) as the priority of our work so much as it is to underscore that the problem of globalization and contemporary art is already historical, with an eclectic reception that ranges from the groundbreaking work of international curators to the rhetorical fumblings of young art historians in training. The topic of globalization and contemporary art is a moving target where new names and practices are concerned, but the reception is dense and varied enough to warrant far more sustained analysis, including many more book-length studies.

If reception is communal and collective, so too is making a book. Much of what follows stems from my own encounters with artists, art historians, critics, curators, editors, scholars, and dealers over many years. They have supported me in ways that are not always about art history and the art world. To begin: for over a decade I've worked with Roger Conover at the MIT Press, and I could not ask for a more receptive and perceptive editor. The MIT Press, and Roger's support, have been essential to my work as an art historian. Anar Badalov also provided timely assistance and encouragement. And I thank Matthew Abbate for his meticulous editing, and Emily Gutheinz for her striking design. It is a privilege to be publishing this book with MIT.

I owe much to family, friends, and colleagues, including Alex Alberro; Monica Amor and Carlos Basualdo; Daniel Birnbaum; Yve-Alain Bois; Craig Buckley; Eduardo Cadava; Ron Clark; T. J. Demos; Sebastian Egenhofer; Joe Evans and Beau Rothrock; Hal Foster; Stephen Hartzog and Olivia Neel; Karin Higa and Russell Ferguson; Maria Gough (and the irrepressible Alexander Gough-Schnapp); Tim Griffin; Brian Holmes;

Steven Incontro; Shannon Jackson; Caroline Jones; Branden Joseph; Joseph Koerner; Juliet Koss; Michelle Kuo; Maria Loh; James Meyer; Freda Murck; Steven Nelson; Molly Nesbit; Judith Rodenbeck; Scott Rothkopf; Craig Smith; Margaret Sundell; Anne Walsh and Chris Kubick; Sarah Whiting and Ron Witte; and Yao Wu. In July 2007, under the auspices of the Stone Summer Theory, James Elkins and Zhivka Valiavicharska convened a terrifically provocative seminar on "Globalism in Art" at the School of the Art Institute of Chicago. Many thanks to the Stones for sponsoring this weeklong event, as well as to Jim and Zhivka for their heroic efforts on behalf of its organization. Simon Baier, Charlotte Bydler, Darby English, Pedro Erber, Michael Holly, Isla Leaver-Yapp, Keith Moxey, and Andrzej Szczerski were all inspiring interlocutors at the seminar table as well as off site in various restaurants, bars, cafes, and museums in Chicago.

At Stanford University, I taught three iterations of a graduate seminar on globalization and contemporary art, which helped bring my interests into sharper focus. I've learned much from discussion in class, but two PhD students deserve special acknowledgment: Karen Rapp and James Thomas. Both have variously worked on, and in, the global art world, and both served as fantastic research assistants during the long-haul process of putting this book together. I am grateful to both for their expertise, professionalism, diligence, and methodical work. Extra thanks go to Jim for his tireless efforts securing images as the project drew to its conclusion.

Generous support from the Stanford Provost and Dean's Office facilitated a number of graduate "travel seminars" in Tokyo, Istanbul, Shanghai, London, Venice, and Kassel; additional funds sponsored research in Caracas, Delhi, and the United Arab Emirates, among other places. I thank the Provost, John Etchemendy, as well as Arnold Rampersad and Sharon Long, who were Associate Dean and Dean of the School of the Humanities and Sciences when the research for this book got under way. I'm eager to acknowledge my faculty colleagues in the Department of Art and Art History as well, with gratitude to Michael Marrinan for his friendship and support. The Stanford Institute for Creative Arts (SICA) also provided additional monies for related research, and I thank my departmental colleague Bryan Wolf and the staff at SICA for making such work feasible.

It's an honor to thank the artists whose practices are the reason for this book, as well as the many galleries furnishing images of their work. Takashi Murakami and the many

workers at the former Kaikai Kiki Factory, especially Nobuko Sakamoto, generously granted access to his studio and shepherded a group of Stanford graduate students through it. And my thanks to Brad Plumb at KaiKai Kiki in New York for assisting with permissions. I've long admired the work of Steve McQueen, so it was a pleasure to communicate with him at length about his brilliant *Gravesend/Unexploded*. I first met Monica Narula, Jebeesh Bagchi, and Shuddhabrata Sengupta of the Raqs Media Collective in San Francisco and continued our conversation in Delhi as well as cyberspace: their critical intelligence and commitment has never failed to inspire. Over a decade ago I wrote an admiring letter to Thomas Hirschhorn, and since then he has become a friend and ally, particularly during a winter spent teaching in Paris in 2004. I wish I could repay his generosity, openness, sense of commitment, and support.

Finally, this book is dedicated to two travelers (or maybe we're just plain old tourists) who have always steered me in the right direction. Geoff: you come with. Once I took a long road trip with David Joselit through the so-called flyover states, touring the fabled sites of the heartland. Experiencing the world on the ground with David has been an inspiration in writing this book.

Introduction:

Forgetting the Art World

My name is someone and no one. I have borne witness to the world:
I have confessed the strangeness of the world. —Jorge Luis Borges

I am forgetting the art world. It's going now—and fast. With a strange sense of purpose (or is it resignation?) I have shelved the magazines and the announcement cards. Given up on the galleries and their established and emerging artists. No longer can I retain the names, details, gossip around this new phenomenon or that; this new current in theory or in art criticism; the fever dream around auctions, art fairs, biennials, MFA programs; the movement of curators, collectives, collectors, and dealers, the cultural emissaries *du jour*. I am forgetting the art world because the art world, at least as it has been theorized for nearly fifty years now, is subject to conditions that may soon cease to sustain it.

This is not to say that the art world is disappearing, diminishing in size, or slowing down in its capacity to generate capital and hype. The opposite is the case. The art world, as it is generically understood, is both escalating and accelerating, appearing to turn so fast—always on the brink of its next obsolescence—that its maps can no longer be read as fixed or stable, its borders blurred at best. For this reason, forgetting the art world is not the same as ignoring or standing outside it, as if one could lay claim to a space beyond its imperial reach by wandering just far enough afield.[1] I mean nothing so naïve as this outside or distance, the fabled Archimedean point from which to survey the workings of the art world as they take place down below.

Instead, to forget the art world is to acknowledge that what made its activities, operations, and communities so distinct or memorable in the past—a kind of figure to a social ground upon which it was historically fixed and dialectically established— has now given way to a pervasive routinization of its norms and procedures. When contemporary experience is ever rationalized through the logic of design; when the word "creativity" is taken as a cognate to the "market";[2] and when social relations are relentlessly mediated by a formidable visual culture—a culture of the image writ large through the peregrinations of global media—the art world as we once knew it begins to lose its singularity and focus, to say little of its exclusivity. From Benjamin to Adorno, Debord to Jameson, we've been told of both the promise and the threat of this culture for a very long time indeed.[3] This culture is such that whatever grasp we thought we had on the relative autonomy of works of art becomes increasingly tenuous, a condition exploited for reasons both progressive and reactionary. To update this by now familiar set of critical tropes, contemporary art has been increasingly recruited in the service of politics, economics, and civil society, a condition that George

Yúdice theorizes when he writes of culture as being an expedient "resource" to the incessantly managerial ethos of the global age.[4] What this condition suggests for these present reflections, among many important things, is a certain eclipse of a historical notion of the art world.

No doubt one forgets the art world because the competing logics of "globalization"—a word as banal as it is ugly—do not permit us to remember.[5] The longstanding controversies around that term have everything to do with the current state of the art world and its forgetting.[6] A typical shorthand on the topic describes a historical compression in time-space relations—the social acceleration of time and a virtual eclipse of distance—continuous with the liberalization of markets and the rise of the network society. Historians debate the periodization of the term; anthropologists its impact on indigenous cultures; activists haunt cities flush with capital or crowded with the poor, from Davos to Brussels, Porto Alegre to Bamako. Still, little consensus exists regarding globalization's consequences for the work of art; and still, the relay between contemporary art and globalization, by far the most important curatorial rubric of the last two decades, remains stalled in something like a critical holding pattern. Provisionally, one might take a cue from the phrasing of Immanuel Wallerstein, who in a formative analysis of world systems theory described the period between 1945 and 1990 as "The Age of Transition," a title that usefully captures a sense of the phenomenon's duration, restlessness, and motility. That globalization is an "act," a "process," or is "happening"—the ready-to-hand definition furnished by the *OED*—does indeed suggest a fitful relation to category that curators, critics, and art historians alike have earmarked as a historical "crisis." Whether or not this process is itself singular or directed to a unique objective is the source of what thinkers from Arjun Appadurai to Ulrich Beck identify as globalization's principal questions: whether its motivations are univocal or, conversely, what is the reach of its differentiation on both economic and cultural grounds.[7] This book takes as its project to interrupt, or at least to slow down, our view of such processes through charting what I call the *work* of art's world.

Globalization, to follow this brief, issues a challenge to representation equal if opposite to the colonizing impulse ascribed to it. It is a kind of *informe*: a new "allover" which seemingly trumps our collective efforts to give shape to its multivalent interests, let alone contain its deterritorializing mandate. Indeed the word "globalization" and its linked phenomena ("globality," "glocality," and even "globalism," the "ism"

here connoting either an ethos or a period style) bear the distinction of being both ubiquitous *and* amorphous: ubiquitous because inescapable to any world citizen and yet amorphous because subject to infinite shape-shifting in both mainstream and alternative media. No doubt the student of globalization knows full well that the term does mean many things, at once bound up in the rhetoric of galloping free markets and the lingering specter of Marx; the homogenizing of culture on the one hand and radical hybridity on the other.[8] Is it the Battle in Seattle or the so-called war on terror? Jihad or McWorld? The multitude or the Nike army? The controversy around the term is arguably what endows it with both its acute frisson and the capacity to be generalized *ad infinitum*. As with the art world's treatment of postmodernism two decades earlier, the semantic stalemate around globalization is typically resolved by conceding to the plurality of its representations.

And that's part of the problem as well. In the weakest iterations of the topic within the art world, it all seems like so much old-school pluralism, the bad dream of the postmodern that Hal Foster presciently warned against in observing that "the pluralist position plays right into the ideology of the 'free market.'"[9] Globalization, to follow this model, translates into the far-flung from all over, sponsoring an anything-goes approach to recent art in which terms such as "conflict," "tension," and "contradiction" inadvertently license this pluralistic approach without recourse to the conditions enabling it. Tracking the implications of such conditions for the work of art is indeed central to what follows. But what need to be stressed at the outset are the equally critical implications of the work of art in the very *enabling* of these global conditions. The concrete processes motivating this dynamic of reciprocity—the way globalization is materialized within and by contemporary art—are at the crux of this book.

This introduction outlines the logic at work here. Our first task is to sketch the ways in which the art world has dealt with the global problematic described above, crystallizing around the doubled valence of representation. I suggest that a founding paradox animates the art world's collective efforts to confront this question. To start with, if the art world has necessarily taken on globalization as a curatorial or thematic rubric, the art world is itself both object *and* agent of globalization, both on structural grounds (its organization and distribution) and in workaday practice. Indeed, in responding to the geopolitical and transnational preoccupations of the work of

many contemporary artists, the art world enlarges at once its geographically overdetermined borders and its conventionally Eurocentric self-definitions in the process.[10]

Take, for example, the work of Bani Abidi, who lives and works in both Karachi and New Delhi, received her MFA in Chicago, and has held residencies in Japan and the United States. Her incisive *Shan Pipe Band Learns Star-Spangled Banner* (2004) is a two-channel video featuring traditional Pakistani musicians squawking out a painful rendition of the national anthem of the United States on the shan pipe. The split—or is it a convergence?—between identity and culture, as formalized through two simultaneous projections, appeals cogently to discussions of hybridity, nationalism, and what was once called cultural imperialism. And yet in seeming to do little but "document" this musical performance in an ambiguously parodic vein, this canny work actually iterates such conditions through its own itinerant display in Stuttgart, San Francisco, New York, or Singapore.

Or consider Lonnie van Brummelen and Siebren de Haan's *Monument of Sugar: How to Use Artistic Means to Elude Trade Barriers* (2007) as it was encountered at the 2008 iteration of the Shanghai Biennale, "Translocomotion." In this mixed-media installation consisting of film, sugar, and documentation, the artists fashioned sugar into quasi-minimalist cubes in order to explore the protocols of international trade regulation, whereby exporting sugar as a "work of art" effectively thwarted payment of protectionist tariffs. The narrative intrinsic to this work cannot help but be read extrinsically against its reception on the ground in Shanghai, a port city with a long and fractious history of colonialism and the international trade relations standing behind it.

This is to say that the art world assumes the world-historical changes its objects or iconography projects, but effectively approaches the state of its historical forgetting in doing so. What it forgets is what made an art world such a distinct and singular "world" in the first place, held at some distance from the workings of something so banal as commodities in sugar. In the process of this forgetting, the art world naturalizes the condition of its apparent groundlessness as "global"—a sphere of influence generalized to the world at large—even as its penchant for the representation of global themes remains largely undertheorized.[11]

These opening comments might seem rhetorical gamesmanship of a type; but I would insist that this circularity is both historically and historiographically instructive. In the following section I argue that what is lost with this forgetting is not merely

Figure I.1
Bani Abidi, *Shan Pipe Band Learns Star-Spangled Banner*, 2004. Double-channel video. Courtesy the artist.

Figure I.2
Lonnie van Brummelen and Siebren de Haan, *Monument of Sugar: How to Use Artistic Means to Elude Trade Barriers*, 2007. Installation view, Palais de Tokyo, Paris. Courtesy the artists and Wilfried Lentz, Rotterdam.

a matter of identification with, or collective belonging to, that exclusive space called an "art world." My claim is that an older formulation of an art world is critical to retain if we are to treat the relation between globalization and contemporary art in the most conceptually workable terms, from its inaugural philosophical articulation by Arthur Danto in the 1960s to the notion of the art world as a network born of a cybernetic age. Not that I am suggesting we can go back to such a world, nor that we would want to if we could. Yet it is only after considering this notional art world as something *past* that I can properly situate the attenuated goals of this book, a deliberately partial approach to a topic that eschews the panoptic—or better put, global—responses the subject would seem to demand.

To such ends, toward the end of this introduction I introduce a phrase that dramatizes the book's stakes, followed by a reading of such interests through a single work of art. Rather than think about the "global art world," such as it is, as both a phenomenon of divisible sociological or economic import and through the imagery it stages and sponsors, I endeavor to treat *the work of art's world* as an intercessory or medium through which globalization takes place. This language gets at the work of art's mattering and materialization—a larger debate on the status of mediation and production—and the ways such processes lay bare that dynamic of reciprocity earlier described. A reading of Steve McQueen's 17-minute film *Gravesend* provides such an opening onto these worlds. For to speak of "the *work* of art's world" is to retain a sense of the activity performed by the object as utterly continuous with the world it at once inhabits and creates: a world Möbius-like in its indivisibility and circularity, a seemingly endless horizon.

Crisis of Representation

Let us begin with our current crisis of representation, an overused shorthand that takes on new meanings under the pressure of globalization.[12] The virtual shapelessness that is both condition and reflex of globalization has been met by crucial efforts on the part of artists, curators, and critics. Representation, in this context, means something appropriately multivalent. We shall see that the ways in which representation is addressed by the art world—as an institutional matter on the one hand and an

iconographic one on the other—raise a problem of scale methodologically homologous to some of the reigning debates on globalization itself.[13] To signal my argument: both approaches, critically important as they are, can at times seem too close to *and* too far from the subject of their analysis. They are too close in the way the art world has come to reflect on itself, mostly where its institutions are concerned (namely its biennials and art fairs); and too far in the imagined distance the art world maintains between its own working operations and the global iconography it circulates and sponsors (call it "globalism"). The question of these spatial conventions will prove more than suggestive for the following discussion; for their usage raises an issue of *critical* distance consistent with debates on globalization itself.

Representation, first and foremost, points to the topic's visibility (the fact that museums, galleries, critics need pay interest) and, with it, the representation of diverse artists, locations, and topics increasingly included in the institutions of contemporary art. It scarcely needs mentioning that this is no small thing, neither the opening of the art world to artists and sites historically excluded from it nor the extraordinary growth of its attendant "Geo-culture," the term Irit Rogoff uses to describe the international circuit accommodating formerly marginalized practices (by the art world's conventional standards).[14] We could hardly castigate this state of affairs out of hand, this art world expansion and the diversity of cultural perspectives it affords, even as we recognize the ambivalent, double-edged nature of many of its advances relative to the market. Who wouldn't value greater insight into the contemporary art of China, countries of the former Eastern Bloc, Latin America, Africa, and the Middle East, stemming from a variety of new geopolitical arrangements—whether the postcolonial or the postcommunist—and expanded networks enabling communication across time, difference, and distance? Who could continue to justify the overwhelmingly Eurocentric axis around which the art world historically ground and turned, where New York (maybe London) was the center and everything else the periphery: those awkward-to-the-point-of-offensive formulations that set the art of the West against the "artifacts" of the Rest? Little doubt that the reasons behind the opening of this world are as layered and vexed as the debates on globalization itself. That, in fact, seems very much to the point of such collective exercises, the exploration of this phenomenon on sociological grounds. But if we are all too aware of the economic motivations stimulating the ascendance of the global art world, this by no

means disqualifies the interest of, to take a random sampling, a Yan Fudong (China), a Lida Abdul (Afghanistan), an Yto Barrada (Morroco), a Bodys Isek Kingelez (Democratic Republic of Congo), or any other of the countless artists whose rise to international visibility over the last twenty years is in line with this new (art) world order.[15] (Kingelez's remarkable maquettes of fantasized cities, exercises in impossible scale, might well stand as allegories for global metropolises of the future.) On the contrary: this recognition compels an even closer examination of their works and the historicity of their appearance on the world stage.

On all counts, praise is due to a path-breaking group of internationally regarded curators instrumental in putting such questions into wider circulation. In part heralded by Okwui Enwezor's Johannesburg Biennale of 1997, and followed by his Documenta XI of 2002 (the first Documenta organized by a non-European), the Nigerian curator and one of the editors of the contemporary African art journal *NKa*, along with Hans-Ulrich Obrist, Daniel Birnbaum, Gao Minglu, Carolyn Christov-Bakargiev, Salah Hassan, Hou Hanrou, Carlos Basualdo, Catherine David, Gerardo Mosquera, and Francesco Bonami, to name among the most prominent, have been critical in the representation of a new geopolitical aesthetic, all the while mobilizing globalization's most commonplace technics to do so. It is hardly incidental that none of these curators were born in the United States, even if many of them currently work within its borders.[16]

The international focus each has brought to formerly underexamined corners of contemporary art making is coextensive with a much larger phenomenon and its collective reception: the excitement, consternation, and, at this point, mass fatigue surrounding the biennial as the preeminent space of the global art world. To be sure, if there is one thing more predictable than the long march of the global biennial circuit, it is the litany of complaints that trail in its wake. Whether in Tirana or Tierra del Fuego, so the refrain goes, these exhibitions routinely suffer from a fatal bout of sameness: same high-profile international curators, same batch of artists, same jaded art world audiences. Critics have plenty of reasons for their disaffection even as the biennial has, for some, come to represent that site in which local determinations contravene the neoliberal imperatives that sponsor many such productions in the first place. As some critical narratives hold, the biennial is that cultural form par excellence in keeping with the nomadic misadventures of global capital: it is at one

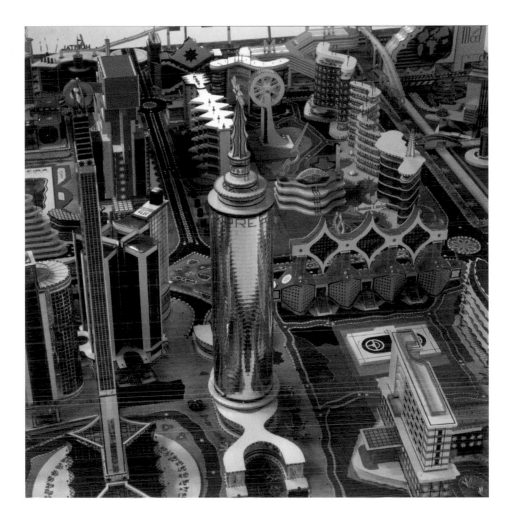

Figure I.3
Bodys Isek Kingelez, *Ville fantôme*, 1996. Courtesy the artist and the Pigozzi Contemporary African Art Collection, Geneva.

and the same time a "white cube" associated with "neoliberal denial" and a nexus of cultural self-determination and belated nation building.[17]

To take some measure of the alternately anxious and hopeful responses generated by the contemporary biennial, one need only narrate its relatively brief history as a cultural paroxysm of the modern nation-state, quickly followed by its global fortunes with the liberalization of markets in the postwar era. Charlotte Bydler discusses London's Great Exhibition of 1851 as preliminary to the internationalist dimensions of the modern biennial, its Crystal Pavilion a showcase for the advances of British industrial production.[18] This internationalist platform would serve as model for the biennials to follow. In 1895, only one such self-identified biennial was on offer, the grande dame that we all know as Venice; and back then, in keeping with the world's fairs of the nineteenth century, its *raison d'être* was to display the products of technological design rather than fine art as such. The establishment of Venice's national pavilions beginning in 1907 would set the tone for many large-scale exhibitions that followed, both as an organizing principle of frankly nationalist motivations and with a decisive industrialist genealogy. An exhibition such as the Carnegie International was founded as early as 1896 by the Pittsburgh industrialist Andrew Carnegie, whereas other shows (among which the history of the São Paulo Biennale, founded in 1951, and Documenta, established in 1955, prove especially instructive) were regarded as having a critical role to play in the work of recovery and nation building after World War II.[19]

By 1993, however, Thomas McEvilley could confidently declare in the pages of *Artforum International* the mounting irrelevance of Western biennials and large-scale exhibitions as signatories of a dying colonialism, suggesting that Venice and Documenta "occur in formerly imperial nations and reflect a Eurocentric history," whereas the New Delhi Triennial (established in 1968) and the Bantu Biennale (established in 1985) would appear "far more global in their reach than their Western equivalents."[20] McEvilley would argue, in an article engaged with the rubrics of postmodernism as well as the previous decade's multicultural imperatives, that many such "Third World biennials are sprouting with or without Western attention." (It bears saying that by "Third World" McEvilley seems to have meant anything outside the Euro-American West.)[21] Today such "Third World" biennials necessarily assume a variety of inflections and motivations, all at once local, regional, and transnational

in kind. Mine is not a book about biennials, however; so here I can only acknowledge these differences and gesture to scholars whose specific subject is the biennial as a cultural form. Yet if rough estimates today document the emergence of some 80–140 biennials and triennials since the 1990s, one could say (with obvious qualifications) that the historical imperative of nation building once emblematized by recurring international exhibitions has in many respects segued into what Karen Fiss has identified as the insidious propositions of "nation *branding*," in which the relationship between culture and tourism becomes paramount.[22]

That the biennial has more lately come to stand as a country's cultural point of entry into this global economy—its ambassador, so to speak—is signaled by the government-sponsored PR juggernauts that precede the official openings; by the phenomena of art fairs that *seem* to trail them; and by the clusters of transnational exhibitions opening within days of each other, as if to appeal to the itineraries of the traveling class. "Cultures can no longer be examined as if they were islands in an archipelago" a report from UNESCO suggested,[23] a formula that neatly justifies the institutionalized reflections on biennial culture taking the form of symposia, conferences, and shelves full of publications. A random example: in the fall of 2006, the Singapore Biennale ("Belief") and the 6th Gwangju Biennale ("Fever Variations") sponsored conferences that posed similar questions for virtually the same audience of art critics traveling the same biennial circuit. My point is not to discredit the specific insights that emerge from such discussions, born as many of them are of distinctly local reflection, but to draw attention to the routinization of these events, their status as standard operating procedure for the art world at large. In the case of "Belief," Singapore's first biennial offering, the annual meeting of the IMF and World Bank convened in the same city less than two weeks after the opening, going far to explain the exhibition's extra-aesthetic motivations, a point little avoided by the organizers themselves. As frankly acknowledged in the press conference by the National Arts Council of Singapore, the Biennial was a venture in "imagination capital," an altogether different genre of belief than that suggested by the exhibition's theme.[24]

To the point: the conferences and platforms that are obligatory at such events, featuring impressive cross-sections of curators and academics alike, typically dwell on the question of the continued relevance of such exhibitions, even as those conferences play parasite to them. The presence of such scholars in these forums, many of

whom may not have engaged the respective exhibitions as they appear on the ground, speaks to a specialized role consistent with the cultures of expertise in the global workplace; as Bydler has put it, these "cultural critics [are] wired to do their usual tricks as interpreters."[25] Hence the dizzyingly circular nature of the enterprise; and hence the skeptical view of many that such biennials represent yet one more layover in the lengthening itineraries of the global art market. This is part of what I mean when I say this first order of representation comes "too close" within the global art world. It is too close because it bears too proximate a relation to the institutions these forums are meant to interrogate; and too close as well as a matter of economic comfort, where the entanglements of either governmental or nongovernmental sponsorship mean that any claims to critical distance need be endlessly qualified. As a result, the will to reflect on such art world phenomena cannot escape its own mirror image, a globalizing *mise-en-abime* that incessantly reproduces its own representation even as it desires to stand outside it.

On the flip side of this equation, the second order of representation—the imagery of *globalism*—signals a relation to the art world that assumes a peculiar distance or separation from its métier, its habitus, even as the art world projects and naturalizes such geopolitical thematics. Since the 1990s at least, we have seen a good share of the aesthetics of Coca-Cola, flags, and checkpoints (N.S. Hashra, India); passports, barricades, and borders (Teddy Cruz, Mexico; Samira Badran, Palestine; Pavel Wolberg, Israel); global markets and travel paraphernalia (Ursula Biemann, Switzerland; Wang Qingsong, China). Some of the work is compelling, some of it less so. Perhaps unsurprisingly, an important investment in the iconography of the land—its obdurate materiality and presence—has appeared at the very moment when the most insidious mantras of globalization call for a "borderless" world of smooth flows, unimpeded international travel, and ever-expanding networks of limitless communication. In Biemann's work on the Black Sea, for example, a ten-part video doggedly tracks the geography of the Caspian oil industry, following its subterranean and above-ground trajectory as it makes its way west.

This engagement with the land represents an article of faith for the art world's global acolytes; but it is the image of the airport (and systems of transportation in general) that has become its summa.[26] And why shouldn't it: for what better means to convey the expediency of markets, the freedom (or more accurately, trauma) of

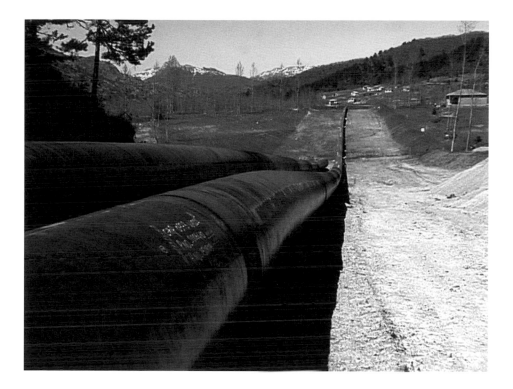

Figure I.4
Ursula Biemann, *Black Sea Files*, 2007, detail. Courtesy the artist.

placelessness, and the logic of both forced migration and tourist culture than the alienated climes of the airport? The kind of groupings that result from this iconography certainly contribute to the idea that "conflict" and "contradiction" are synonymous with the global question, but they don't quite capture the texture of these practices as singular statements in their own right, directed to specific geopolitical ends. Often the sum total effect of seeing gallery after gallery of such imagery—and thus understanding those practices through their representational interests alone—tends to generalize those interests. You could say that such shows *globalize* those interests, paradoxically confirming an ideological contrivance common to the rhetoric of globalization itself: that globalization homogenizes culture as it evacuates difference and distance. You can lump together an Andreas Gursky picture of a runway with a Martha Rosler photograph of an airport lounge, for instance, but the comparison would be spurious at best, the kind of category error art historians brush off as "pseudomorphism." Likewise, shots of cargo containers by Multiplicity (as in, for example, the *Solid Sea* project) are going to propose quite different things from an Allan Sekula series of photographs involving the same.

Whatever disparate issues and agendas such individual images raise and serve, taken together they mask a more fundamental, because materialist, relation to such representations. Here the example of the airport once again proves instructive beyond its glossy image in the iris prints that regularly turn up in museums and galleries. Miwon Kwon put it best when she observed that one's citizenship in the art world was measured by the number of frequent flyer miles chalked up in the service of the profession.[27] Several years ago I asked a well-known artist about his extensive international travel, and the staggering number of frequent flyer miles he sheepishly volunteered confirmed Kwon's thesis without his knowing it. A straightforward but significant point follows: the activities constitutive of the art world's horizon are indivisible from the activities of globalization itself. As such, we need to bridge the apparent distance maintained by its two orders of representation: between what the art world *does* (including its institutional rituals of self-reflection) and what it *exhibits as* "globalism." We have not quite reconciled the coexistence of such approaches, at once too close and too far, through anything like a theory or set of terms that persuasively mediate this distance—a means to account for the shift between proximity and separation. Indeed, what will become clear throughout this book is that the epiphenom-

ena that seem a given to our métier (i.e., travel) are in fact immanent to the processes we usually associate with the shifting transnational order.

I want to be clear that my admiration for such curatorial efforts is unwavering: they are not at all to be dismissed as bad reasoning—or even worse, bad faith. In this context at least, they provide an opening that can only be addressed with the luxury of two decades' worth of biennial viewing, reviewing, and reception history. They prompt an inquiry about the relationship between the world processes of globalization and the will to its representation within the art world. This is to take seriously, as I hope to show, the notion that the work of art actualizes or serves as the occasion for such conditions so much of the work is at pains to represent.[28]

The goal is as fundamental as recalling that globalization is *happening*; and that the art world iterates such processes as much as it represents their fallout, for good or for ill. In other words, we need to force the question of our own embeddedness in this world: how to confront the relation between globalization and contemporary art when we are both object of, and agent for, such processes.[29] At this juncture, a discussion of the art world and its historiographic meanings reveals just how far we might have traveled from that world—or might not. In speaking to a more specific vision of the art world theorized by philosophers and critics, we lay the groundwork for analyzing contemporary art's imagined state of groundlessness and depart from the representational interests that world is thought to sponsor, if at a distance.

What Is an Art World?

Some observations about the historiography of an art world are called for beyond its commonplace understanding as a generalized community of artists, collectors, curators, critics, and associated institutions and professionals. A more precise formulation identifies this world as a virtual space of both discursive and sociological separation, premised on a peculiar sense of distance, at once metaphorical and actual. Our point of departure is the canonical essay by Arthur Danto, "Artworld," published in 1964 in the *Journal of Philosophy*. Taking Warhol's Brillo boxes as his case study, Danto asked, after the eternal mandate of philosophical aesthetics: what separates a work of art from nonart, the readymade from the commodity? In the late fifties

and early sixties, when the art critical rhetoric of "art into life" was finding a captive audience in the Tenth Street galleries and cooperatives of downtown New York, Danto encountered a brave new world of objects in which the experiments of pop, assemblage, and the happenings seemed to challenge the very meaning of art. To determine what rendered the difference between these strange things and the "reality" against which they were set in relief, he argued that one needed to master "the *is* of artistic identification," and this could only be done in an "atmosphere compounded of artistic theories and the history of recent and remote painting."[30]

Somewhere between art and everything else, in other words, was an "artworld." "There is no artworld without those who speak the language of the artworld," he claimed, describing the "artworld" as a function of a very particular kind of context, a linguistic competency, a shared language. As he was to describe it in a later essay,

> The moment something is considered an artwork . . . it becomes subject to an interpretation. It owes its existence as an artwork to this, and when its claim to art is defeated, it loses its interpretation and becomes a mere thing. The interpretation is in some measure a function of the artistic context of the work: it means something different depending upon its art-historical location, its antecedents, and the like. And as an artwork, finally, it acquires a structure which an object photographically similar to it is simply disqualified from sustaining if it is a real thing. Art exists in an atmosphere of interpretation and an artwork is thus a vehicle of interpretation.[31]

Made compelling by its specific currency in a specific art world, a theory of art is what separates the work of art (a Warhol) from everyday reality (a soup can). This is a model of the art world as grounded in its lingua franca—the trading and consolidation of shared information—and the interpretations that follow suit. (The "interpretive" theory of art, as is has come to be known, will indeed later be treated by the philosopher George Dickie as an "institutional" theory of art.)[32] For the purposes of contemporary art, we need to underscore how information assumes a metaphorical dimension in Danto's essay that is subjected to a radical mutation decades later with the global art world. For Danto's art world, in fact, is *spatialized* as a very particular kind of world: rarefied, perhaps even sublime, held far above the crude workings

of the earth. "The art world," Danto writes, making pointed allusion to St. Augustine, "stands to the real world in something like the relationship in which the City of God stands to the earthly city."

Neither Danto's Augustinian touchstones nor his philosophical mode of argumentation may resonate with the habitués of today's art world, but the spirit of his argument is retained in one significant respect. In confronting the global question through the twinned logic of representation, today's art world assumes some critical distance from the crass workings of the everyday world down below. What goes missing is a particular approach to the work of art as something situated or sited; for implicit in Danto's thesis is the sense that the work of art, as a product of that world and its theories, mediates between the divine city and the real city below it. Only those conversant with this dialectic are equipped to understand the work of art's logic, effectively serving as its translators.

In the years following the publication of Danto's essay, the notion of the art world has been generalized to mean a social milieu, and an exclusive one at that. The linguistic competence presumed of citizens of Danto's art world is easily transvalued to Pierre Bourdieu's reading of cultural capital, whereby access to such languages signaled the socioeconomic stratification of this sphere of influence beyond the brute fact of filthy lucre.[33] The art world, no doubt, has thus come to be caricatured as the instantiation of a pecking order; and to be sure, clichés on the topic hold overwhelmingly to a vision of affluence or elites, from the privilege of collectors treating works of art as so much blue-chip stock to dalliances with fashion and the high life. Such issues were hardly taken up in Danto's analysis; nor were, as the anthropologist Albert Gell pointedly argued, the Eurocentric implications undergirding Danto's interpretive theory of art.[34] Neither sociology nor anthropology was Danto's point, of course, nor for that matter was a systematic theory of "high art" and "low" culture that his reading of an art world tangentially engages. But even without providing a quantifiable metric to track the art world's economic explosion, it's impossible to ignore the marked shift between the moment of Danto's philosophical articulation and the recent present in which economic and cultural interests grow ever more proximate. In short: signs were in place that this "divine city" and its languages were being brought down to earth; that the City of God was finding more direct correspondence to the world on the ground.

That shift is in part registered by the migrating status of a certain thinking about art; by a transition from language to information; and by the changing fortunes surrounding what Danto called the "*is* of artistic identification": the ways art is identified and has more recently been recruited in the service of extra-aesthetic institutions. In the tenth-anniversary issue of *Artforum International* dating from 1972, Lawrence Alloway called the art world a "network" or a system and spoke to the remarkable expansion of this system. His essay makes no allusion to Danto but shares with the earlier text a decisive attitude toward the internalization of an "art speak" or lingua franca, if in this instance geared specifically to a problem of media and mediation. In light of the flourishing media culture of the 1960s—the new readership for art magazines and the heightened role of commercial galleries—Alloway saw distribution play an increasingly vital role in the art world's changing constitution. He drew upon the then-popular discourse of systems theory and cybernetics to justify the art world's social organization and its expanding character. "The art world now is neither as clear nor as simple as it had been then," he wrote:

> Not only has the group of artists expanded in number but art is distributed to a larger audience in new ways, by improved marketing techniques and by the mass media. What does the vague term "art world" cover? It includes original works of art and reproductions; critical, historical and informative writing; galleries, museums and private collections. It is a sum of persons, objects, resources, messages and ideas. It includes monuments and parties, esthetics and openings, *Avalanche* and *Art in America*. I want to describe it as a system and consider what effects it has on art or our understanding of art.[35]

By "system" Alloway was clear that he was not equating the art world with a "regime" (the way in which the phrase "*the* system" bore autocratic implications in the 1960s) but with a mode of organization linked to the circulation of information within what he called "a negotiated environment."[36] He was likewise interested in the extent to which that information was itself a new kind of product. "What is the output of the art world viewed as a system?" he wondered.

> It is not art because that exists prior to distribution and without the technology of information. The output is the distribution of art, both literally and in mediated

form as text and reproduction. The individual reasons for distribution vary: with dealers it can be assumed to be the profit motive and with teachers it can be assumed to be the motive to educate, with the profit motive at one remove. Art galleries, museums, universities, publishers are all parts of the knowledge industry, producing signifiers whose signifieds are works of art, artists, styles, periods.[37]

Though the language of networks is critical to our present-day understanding of globalization, Alloway's pre-Web take on the subject nevertheless characterized the art world mostly as a *closed* system. The purported integrity of this system enabled the work of art to function as a coherent and autonomous thing within that "negotiated environment"—transparent to those who inhabited that system's still well-policed borders.

Alloway's theorization of the art world, in other words, continues to authorize the language and secret handshakes that grant membership into a closed society. But what happens when the world itself is progressively aestheticized as global spectacle, a culture of design and the image, not to mention the capital investments that everywhere seek a new audience for that image's distribution? What happens if ours is now an *open* system, and Danto's "atmosphere compounded of artistic theories" has expanded beyond measure in a virtual Babel of new languages, histories, and ideas beyond the native borders of the conventional art world? Is it still possible, ultimately, to separate Alloway's "negotiated environment" from the environment which would seem to encompass it, where the theories and protocols that were once the exclusive purview of the art world take on the status of a new cultural and mental labor?

A 2006 online article on cnn.com gets at the matter more plainly. Even in the tone-deaf universe that is the global ether, the essay broadcasts a largely celebratory account of the prospects of this new sphere. "Globalization, Technology Changing the Art World" blares the title. The article gives us the predictable boilerplate reading of those changes, checking off such conditions as the blurring between "high" art and "low" culture; greater collaboration between international museums; art being seen and sold on the Internet; and the rabid new markets for contemporary art, the key instance being a Hong Kong financier buying a Warhol portrait of Mao for some $US17 million. Numerous art world professionals are quoted, virtually breathless for their collective excitement. Breaking from the triumphal cant, John Baldessari's words come as a tonic: "I think what has brought the world together is prices. . . . That's

a cynical thing to say, but all of a sudden the auction houses have gone into China and India and Dubai."[38] The fact that such observations are transmitted through the Internet—cnn.com no less—shores up the peculiar art world tautology I have already addressed: it broadcasts its message of a dramatically different art world through the very medium essential to the enabling of such changes.

Clearly we are at a turning point in the art world's evolution, where even the critique of cultural capital seems woefully inadequate to capture the changes described. As a corrective to that, George Yúdice offers a powerful series of case studies that detail precisely how culture (and art, for our specific purposes) has come to serve as a vector for the flight of global capital, a thesis that by extension might regard the distance between the art world and something outside it as having been eclipsed. In *The Expediency of Culture*, he moves beyond the traditional claims about art's instrumentalization by the market economy to describe culture as a crucial sphere of capital investment, a discussion organized around the terms of art's "performativity" (a term that suggests both associations with performance art as well as economic motivations). "Art has completely folded into an expanded conception of culture that can solve problems, including job creation," he writes in his introduction.

> Its purpose is to lend a hand in the reduction of expenditures and at the same time help maintain the level of state intervention for the stability of capitalism. . . . Culture is increasingly being invoked not only as an engine of capital development . . . some have even argued that culture has transformed into the very logic of contemporary capitalism. . . . This culturalization of the economy has not occurred naturally, of course; it has been carefully coordinated via agreements on trade and intellectual property, such as GATT and the WTO laws controlling the movement of manual and mental labor (ie immigration laws), and so on. In other words, the new phase of economic growth, the cultural economy, is also political economy.[39]

Yúdice's "cultural economy" (a term which he distinguishes from Tony Blair's New Labourite rhetoric of the "creative economy") stems from "the expropriation of the value of cultural and mental labor."[40] The rapprochement between culture and community in the global era is "at the crossroads of economic and social agendas"; and the interests attending these divisions of labor—whether in the service of the

market or the motivations of social justice—are complicated to say the least. It should suffice to say that while we accept as a matter of course something called a "global art world"—and recognize the foundational importance of Yúdice's observations in the art world context—the effects of Danto's border war between the City of God and the City of Man linger on in the ways it has represented such global issues as something *elsewhere.*

At this point, then, we might take a page from one of the most cherished manifestos of the antiglobalization movement, Antonio Negri and Michael Hardt's *Empire* (2000). While the book itself is relatively quiet on the subject of art (the one art historical reference in the book's 414 pages is, quite appropriately, Serge Guilbaut's canonical *How New York Stole the Idea of Modern Art*), Hardt and Negri's standing in art world circles is unimpeachable: at Documenta XI, for example, Negri contributed an essay to its seminar and publication on democracy, and both have continued to publish widely in art world venues as well as contribute to conferences and symposia. Still, should we take seriously the book's energetic rhetoric of multitudes and Counter-Empire, we will need to grapple with its theory of immanence (a topic I address in the third chapter of this book). In light of our art world deliberations, the metaphorical expression of this immanence is found in a telling and uncanny turn of phrase: "This is the founding moment of an earthly city that is strong and distinct from any divine city. . . . We do not have any models to offer for this event. Only the multitude through its practical experimentation will offer the models and determine when and how the possible becomes real."[41]

In drawing down the Augustinian metaphor, bringing the Divine City back to earth, so to speak, Hardt and Negri appeal to a vision of practice on the ground. This ground, I argue in this book, is the work of art itself, its world. If Danto's earlier version of the art world looked down upon the "real world" as if from some celestial perch, we need now attend more closely to the work of art's world—its organization, its mechanics, its processes—from below.

The Work of Art's World

As a means to stress the enormity, or rather amorphousness, of the subject of globalization and contemporary art—and to acknowledge the forgetting of the art world

as one of its privileged symptoms—I place a certain emphasis on the word "world," at once noting the term's expansive philosophical pedigree and its more recent currency among critics and art historians. The concept of "world" has in the last decade surfaced in both curatorial and art historical endeavors to diverse and instructive ends.[42] Here I'm continuing an engagement with this notion as explored in my book *Chronophobia*.[43] In the chapter "Study for an End of the World" I wrote about the Swiss kinetic artist Jean Tinguely in terms that historically anticipate discussions on contemporary global media.[44] Tinguely's performance, which gave the name to the chapter, was broadcast on *David Brinkley's Journal* in 1962 and featured an unruly complex of kinetic sculpture staged not far from nuclear testing grounds in Nevada: the work's express purpose was to go up in a fiery explosion as an explicit commentary on the arms race. To think about the intersecting worlds that I argued Tinguely set into motion, I consulted Heidegger's "Age of the World Picture" to underscore something transitional about that moment, constellated in far-reaching debates around automation, cybernetics, and televisual media bedrock to the network society.[45] Describing the contours of Heidegger's argument, I wrote: "To be retained from this Heideggerean precis is the notion of the work of art as a world: its resonance as both an opening and *a process*, a 'how' rather than a 'what,' a 'worlding' in time as opposed to an enframing of a material thing in space." Tinguely's arsenal of media tactics foreshadowed a number of aspects we now identify through the lens of globalization. His was

> an end of a world measured strictly by the compass of national borders, now moving decisively towards new geopolitical reconfigurations shaped by emerging communications media *and* postwar America's example. Although positioned at the historical crossroads of Cold War politics, what this end anticipates, to borrow Fredric Jameson's precis on globalization, is "the sense of an immense enlargement of world communication, as well as the horizon of a world market."[46]

The ambition was to think of Tinguely's worlds as so thoroughly enmeshed that the geopolitical touchstones his performance evoked were wholly inseparable from the logic of the work's mediation.

Appealing to a notion of "world" out of which these observations emerge, I argue that contemporary art likewise registers its geopolitical interests through either a

literal or a metonymic enabling of such processes and their distribution. These tendencies bear significantly upon how to approach the analysis of culture and globalization: for to think these processes as continuous with, and immanent to, the work of art is to put some pressure on models so critical to historical discussions of art and politics. As suggested by Hardt and Negri's example, the philosophical traditions one associates with immanence—from Spinoza to Nietzsche to Adorno; from Bataille to Deleuze—throw into relief questions of production theorized within the long history of Marxist thought and the implications for "critical distance" that subtend it. To be sure, if immanence, according to Fredric Jameson, is "the suppression of distance" constitutive of postmodernism's spatial turn, how do we understand the actual or phenomenal distance supposedly abolished with globalization?[47] Laying claim to the oft-cited matter of "tension and contradiction" in the study of globalization and contemporary art may well have to do with thinking the status of production through the framework of such models, so that appeals to the dialectic might be bracketed relative to the geopolitics of immanence—and vice versa. To chart the *work* of art's world through these terms is to draw us closer to the shifting valences of these processes, and to understand form as above all *formative* in a dynamic of globalization that can only be thought as both relational and material.[48]

Unexploded/Gravesend

The English artist Steve McQueen's *Gravesend* (2007), a 35mm film running a little over 17 minutes, proves an inadvertent case study in this logic. It is an exercise in the recursion of such worlds, at once dispatched thematically—across time, space, and distance from a Kentish town to the Democratic Republic of Congo—but also *internally* relative to its treatment of form, sound, and vision. Hamza Walker introduces the work, whose topic is the global trafficking of a natural resource and the history of colonial violence that stands behind it.

> The subject of *Gravesend* . . . is Coltan, a mineral so valuable it is the new blood diamond. Short for colombite-tantalite, Coltan is an ore rich in tantalum, a metal used in capacitors found in a host of computer driven electronics. As a result, Coltan's price on the open market has surged some tenfold within the past decade. Eighty

percent of the world's supply comes from the eastern region of the Democratic Republic of Congo, many of whose mines are in the hands of Rwandan rebels.[49]

Coltan is indeed a node of the global economy, with ties extending from the black market for nuclear weapons—from Ukraine to Uganda to Ostend—to every form of recent communication technology, from the most rarefied to the most banal. That ubiquity—as well as its invisibility—is to the point of our own positioning relative to McQueen's work. Anyone who owns a computer has literally interfaced with Coltan; anyone using a cell phone is within its proximal orbit; anyone gaming a PlayStation has virtually touched it. First refined in Swedish chemistry labs in the nineteenth century, Coltan is prized for its superb conductivity. This ability to both transmit and forge connections at such a scale will bear certain implications for McQueen's work as both its tacit, organizing principle and the crux of its politics.

Critically, *Gravesend* does not in any way narrate such connections. The film takes its title from the southern English town in which Joseph Conrad's *Heart of Darkness* opens, the site from which Marlowe sets sail for the Congo. "The old river in its broad reach rested unruffled at the decline of the day," Conrad writes, "after ages of good service done to the race that people its banks, spread out in the tranquil dignity of a waterway leading to the uttermost ends of the earth."[50]

Gravesend's location on the south bank of the Thames points at once back to the venal histories of Empire and forward to that river's continued relevance for the contemporary market. This to-ing and fro-ing on temporal grounds—a refusal to stay put as a matter of neat chronologies—finds a spatial complement in the way the work drifts and cycles from one site to another: from the inside of a lab in Nottingham—a faceless scene of fluorescent and antiseptic ambience—to the shadowed mines of Walikale, a region of eastern Congo. It circulates, in other words, between the sterile and seemingly agentless arenas of industrial spectroscopy and the brutal and equally anonymous world of physical labor in mines and forests and riverbeds. The only "controlling" power is the mineral, unnamed in the film. In Coltan, as Walker writes, "lies the web of relations tying advanced industrialized nations to the remotest hand-to-mouth economies."

The historical back story to McQueen's film is telegraphed by a recurring image of a plant, its sentinel-like smokestacks set against a bloody sky marking the fatal com-

munion between colonialism and industrialization. Yet the web of relations sketched in this order of colonial and now global violence is without any prime mover that might either narrate or fix the images McQueen sets into circulation. Because it is a web, after all—that is, without obvious hierarchy or center—those relations appear to ramify across time and space without a singular human subject around which such relations ultimately cohere. As Walker and T. J. Demos have noted, among the most striking features of *Gravesend* is that it is "unapologetically abstract," a notion which Demos expressly elaborates in terms of the film's politics of ambiguity.[51] Noting the same tendencies if arriving at a completely different conclusion, a critic of the work charges that this abstraction diminishes the film's power; that a viewer needs an accompanying text to endow the work with greater historical, and presumably political, significance. "We are not at all sure where the actions occur or whether they proceed in the same geographical location," he writes. "We cannot even tell if the process shown is presented piecemeal or complete or, for that matter, if it is of any importance."[52]

Precisely: for what this writer treats as the work's liability may well be the mechanism of its critical potential, the sense that the orders of work it follows are held in suspension, both ubiquitous and largely invisible, like the unnamed resource it trails. Apart from the film's eschewal of any express political message, I would argue that McQueen's abstraction is decisively *materialist* in its unfolding and implications; it is through abstraction that McQueen flags the gross disparities that take place under global divisions of work, showcasing both their conjunction and their near-seismic fractures. These abstract tendencies stand in an allegorical relation to the ideologies of global labor as something frictionless and without respect to border and site—the fiction that globalization is actually "aspatial" and provides "a vision of total unfettered mobility," as Doreen Massey assails it—but ultimately expose the fault lines on which such stories founder.[53] On the one hand, *Gravesend* tracks the deadening rationality that claims globalization's influence is universalizing and equitable; on the other, McQueen's pervasively abstract means enable deeper connections to be drawn between worlds that symbolically and historically bleed into one another at points of tangency. What fascinates me about this film are the ways in which it is irreducible to linear narratives about globalization as such (indeed, the image of the factory—while taken at Gravesend—might well be anywhere); and how its circular organization—

Figure I.5
Steve McQueen, *Gravesend*, 2007, detail. 35mm film transferred to high-definition. Courtesy the artist and Marian Goodman Gallery, New York and Paris.

specifically when seen relative to the film that precedes it, *Unexploded*—is oddly consistent with the processes upon which it is trained. It is a film ostensibly about the materiality of global processes that both registers and decouples those processes.

Commissioned for the 52nd Venice Biennale, *Gravesend* follows immediately from *Unexploded*, a 54-second film that mutely surveys the details of a gutted building in Basra, Iraq, its damage wrought by an invisible, unexploded bomb lying deep within its devastated center. If not usually considered relative to *Gravesend*, *Unexploded* provides insight into the workings of the longer film as its own ground-level optic on globalization. In *Unexploded*, a ruined shell of architecture stands as a metonymic emblem for a nation brutalized, if still hanging on, by the "War on Terror." The compressed temporality of the film is equal to its abbreviated visual economy and the uncanny emptiness of its mise-en-scène. The camera moves from inside to outside in the space of eight cuts only, but a forensic level of visual detail is communicated (though such detail provides little in the way of narrative information).

Instead, *Unexploded* pictures a structure that is more hole than architecture, in which literal absences organize seven of the eight handheld frames. As the camera moves in closer, we glimpse a massive hole through another hole; baroque tangles of rebar crossing these gaps register the force of a detonation. Rays of light crack through like the distortions of a shattered oculus. But not only: if one can read an allegory of degraded visuality into this scene, the film likewise brokers a claim to visual transparency—the promise that inheres in exposing the workings of war on the ground. That an unseen, stillborn missile occasions this endless filmic loop dramatizes that world's dark potentiality, its mortal prospects. We are held in suspense at what might happen, or rather, *is happening*: for the perpetual threat of violence attending the scene is externalized through the repetition and circularity of the film itself.

Of course this reading of *Unexploded* hovers at the descriptive register alone. We learn nothing of the people who once occupied the building; nothing of their power or their privations; nothing of those forces responsible for the mass destruction; nothing of the context in which these circumstances were set in motion. We do not learn, for instance, that the building was most likely a Sunni stronghold in Basra; nor the institutional arrangements that enabled McQueen to get on site in the first place.[54] But the terms of this "hovering"—and the work's suspended ambience or narrative withholding—paradoxically engage a politics as concrete and as consequential as any explicit

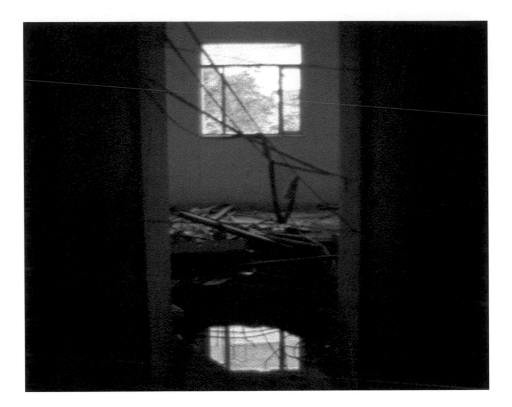

Figure I.6
Steve McQueen, *Unexploded*, 2007, detail. Super 8mm transferred to digital format. Courtesy the artist and Marian Goodman Gallery, New York and Paris.

rant on American hegemony and militarism. To borrow from Yúdice, we could say that form is an expedient resource in the making of a world picture; its prescriptive value consolidates an image of globalization consonant with the world-making processes *of* globalization itself.[55] The same is true for *Gravesend*, which gains in its already considerable semiotic force when read as adjacent to *Unexploded*. (Note that the bomb that is the absent center of the film is in part powered by Coltan—the very medium driving the global circulation of work in *Gravesend*.)

Gravesend begins to the soundtrack of a low-level hum with no inaugural image; a set of tongs is then seen removing raw material heated within a glowing orange cube. It is clear that we are in a laboratory of sorts, but who knows where and for what motivation? Instead we are left with increasingly abstract images: a close-up reveals a dull metallic surface in which rounds of the material, also fiery orange, cool down to an oxblood red.[56] On a null field, a small black circle in the upper left corner opens up, irislike, to reveal a larger image of processing. We then see a grid of circles in which a robotic arm is pictured in silhouette, its arm plunging in and out of these circles, one after another.

The buzz ceases and silence permeates. Before us is a subterranean theater in which jumbled roots and earth serve as repoussoir to a scene of deepening murk, the spade of a shovel occasionally breaking its surface. Lodged at the middle of a hole, two men, bent and shoveling, are the mechanomorphic analogs of the robot we just witnessed, seeking out the material in its unprocessed and crudest form. The contiguity as well as opposition between these spheres of work is reinforced by a series of montages, in which the use of dissolves suggests the intractability of labor relations that globalization is said to enact, producing a palimpsest of imagery that appears both indivisible and transparent on its surface. What follows is a sequence that implicitly charts the different economies of scale in the processing of Coltan: a scene of miners bleeds into images of a plant on the water; transitions back into details of hands chipping rocks with crude mallets; merges a ghosted image of a worker with a night sky, the same plant standing behind it; and reveals the unerring precision with which the material is refined in the laboratory, with measuring instruments and polished steel its industrial accoutrements.

The compositing of such images might *seem* to illustrate notions of flow, boundlessness, and capital circulation that are holy writ to celebratory accounts of globalization.

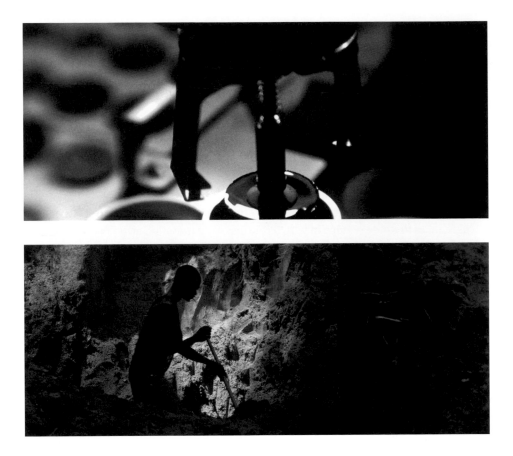

Figures I.7 and I.8
Steve McQueen, *Gravesend*, 2007, details. 35mm film transferred to high-definition. Courtesy the artist and Marian Goodman Gallery, New York and Paris.

Read against the global principles of flat-world apologist Thomas Friedman, however, McQueen's montage reads as an unintentionally pointed rebuke. "When the world goes flat," the journalist writes in one of many frothy paeans to globalization, "and you are feeling flattened—reach for a *shovel* and dig inside yourself."[57] That McQueen's pictures can be *seen through* initially seems to suggest we *stand in* a transparent relation to them. But the abstraction that occurs throughout both *Gravesend* and *Unexploded* radically complicates this fantasy of transparency, even as it forces us to look through it.

The film's abstraction, as I have claimed, mimes the production of the resource it tracks, both as a kind of well-oiled machine without subjective agency and a scene of flexible and frictionless manufacture, spanning and spinning weblike across the globe. McQueen's nonlinear structuring hence functions as both the impetus and alibi of the labor he trails, both the mechanism that sponsors such global connections and the image it is wont to circulate. In traveling from Gravesend to Walikale to Nottingham and back again, the film shores up the differential relations between production at each site precisely through the repetition, cleaving, and convergence of such images. The industrial processing to which the camera repeatedly returns is as clinical as the physical labor in the Congo is abject. Its near-sterile abstraction is the equal but opposite to the violence that recursively motivates it.

The double-sided nature of this abstraction, belonging to both worlds of work if failing to stay put in either one of them, reaches a crescendo in an animated sequence near the end of the film. The apparent crudeness of its formal means, effecting the look of the gauche or hand-drawn, disrupts the evenness of surface, sound, and form the film otherwise so studiously constructs. On a white field a line of the starkest black—a tributary of the Congo that might well read as a stream of blood—unwinds like an accelerating path into the imagined distance. As the line gathers in velocity and progressively overwhelms the field in skeins of black, a kind of Rorschach test for global times, a din of indistinguishable voices grows more voluble, like a radio endlessly scanning to find the correct frequency.[58]

The film closes with a sequence of more dissolves in which disturbingly beautiful close-ups of glinting water—perhaps either the Thames or the Congo, but we do not know—are set to a soundtrack that militates noisily against the sense of liquidity communicated by the images. Contravening these sparkling pictures, which allegorize the

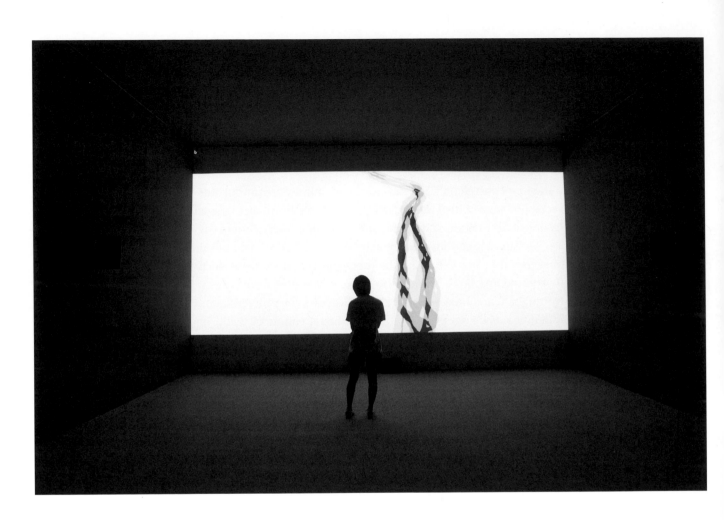

Figure I.9
Steve McQueen, *Gravesend*, 2007, detail. 35mm film transferred to high-definition. Courtesy the artist and Marian Goodman Gallery, New York and Paris.

promesse de bonheur of smooth passage and safe travels, we are left with the sound of friction, recalcitrance, and grit. The grinding, scraping, and pulverizing of something off screen—presumably the crushing of minerals in the manufacture of Coltan—endows the conclusion of McQueen's work with an ineluctable materiality and groundedness, the reverberations of which stay with us long after the *image* of global passage drifts away.

Gravesend showcases the stark inequities between two sites of work and the orders of production around which they turn precisely by iterating the conditions which make such inequities both possible and globally "palatable": a mode of circulation thought to be as smooth and deterritorialized as globalization has been trumpeted itself. On this count *Gravesend* follows *Unexploded* in its peculiar circulation of forms, their migration betraying a lethal itinerancy, especially because dispatched through the cool visuals of an abstract idiom. In *Gravesend*, abstraction encodes an image of work and manufacture comparable to the abstraction that structures the ruined architecture framed by *Unexploded*, a globalizing force in both the manufacture of this material and the destruction rained down on Basra; from inside the hygienic white cube of industrial processing to an equally hollow, because eviscerated, building in Iraq. A web of antinomies proliferates: the manufacture of Coltan is implicated in the underground of the global arms trade and also serves as the wellspring of global communications technology, a signatory of openness; it is, to follow one journalist, the "muck-raked counterpoint to the brainier-than-thou, environmentally friendly image of the high-tech economy."[59] The bombing of Basra finds its ideological alibi in George W. Bush's "democratic peace." Coltan links both together as an invisible medium in its own right—an allegory of globalization rendered plastic, mobile, and material. It is the brilliance of McQueen's work to show how these worlds are bound together by a shared operative mechanism, the double-sidedness of which registers that world's most trenchant material realities and likewise stages its ground-level interrogation.

Chapters

McQueen's example tells us something urgent about the actual matter of globalization and its materialization; of distance seemingly collapsed by the far-flung itineraries of

global capital and its restive logic; and about the cyclical violence that everywhere follows and precedes such manufacture. The worlds considered in this book are likewise regarded through terms process-bound and concrete. Four case studies of artists who came to international prominence in the 1990s open onto the formative dimension of such worlds. My subjects are hardly obscure, but I make no apologies on this count: their relevance is unimpeachable, given their lengthy reception and emblematic status for discussions of contemporary art. What emerges in the telling is that the work of each circumscribes its own kind of politics, whatever the ostensible narratives constructed by its respective author. By extension, each chapter is an injunction to complicate the relationship between the work of art's world and the art world as such: to worry about the relay between the two through thinking globalization as a world process. What constitutes an art world in this age is multivalent and multiple; and the task of giving form to that world reveals an equally doubled picture.

Shared issues, nonetheless, course throughout this book. Under the aegis of post-Fordism, the "postindustrial" society, and the rampant advances of "flexible" specialization, questions of mediation and communication technologies are bedrock to my investigations. Problems of labor—how artists make things in such a world—are pervasive by extension. And the audiences who both inhabit and create these worlds are similarly addressed. As such, the age-old question about the relationship between aesthetics and politics is central to what follows, but in forms that can no longer insist upon (as if they ever could) the stability of either referent in the couplet. In order to remain provisionally effective or convincing, these terms need to be constantly rearticulated with an eye toward the changing forms of mediation they presuppose.

The first two chapters variously broach issues of work and digital mediation as they inform the spatial politics of globalization. Chapter 1 concerns the painting of the Japanese artist Takashi Murakami, famous for its riotously colorful surfaces peopled with a host of cartoonish avatars, as well as his self-consciously nationalistic theories of "Superflat." Art historians typically link the notion of "flatness" with the modernist criticism of Clement Greenberg. Here, though, I focus on the pivotal role of Murakami's managerial ethos as well as his peculiar relationship to production techniques linked to Japan's economic prominence on the world stage (e.g., "the Japanese management system," "Toyotaism," or "just-in-time manufacturing"). Analyzing his work through the lens of post-Fordist production enables an understanding of the ide-

ologies of depthlessness and flexibility that chime with more celebratory accounts of globalization, in which "Superflat" takes part. What we learn is that the protocols associated with automotive technology in the 1970s are, perhaps, more important to the interests of globalization than the images of airplanes and airports that frequently turn up in the contemporary art galleries.

The following chapter takes up the work of the German artist Andreas Gursky, whose enormous prints of market floors, ports, and factories have been described through the iconography of the free market. What interests me in these pictures, though, is the process that is masked by the prospect, crystallized around what I'm calling his "ether" (an invisible medium once thought to fill and occupy space). In resuscitating this seemingly obsolete and mystified term, I focus on the internalization of distance in Gursky's methods, specifically the organization of far- and nearsightedness, perspective and scale. I address debates on the "postindustrial" society and its correlate in the notion of "postphotography." Processes of digital compression are thus considered; for I am interested in the relationship between the storage or artifacting of information and the representation of material goods and services to which Gursky's works often refer. What, I ask, might the former tell us about the latter relative to globalization's reigning debates on the eclipse of distance and the inequitable divisions of work in the "postindustrial" society? Along the way, Allan Sekula's work provides a counterpoint to Gursky's ethereal sensibilities.

The last two chapters concern new ways to forge the relationship between art and politics after 1989, through a different order of representation than that bound to identity as such. Chapter 3 treats the mixed media sculptural displays of the Swiss artist Thomas Hirschhorn, focusing on his monument to the seventeenth-century philosopher Baruch Spinoza. Hirschhorn's work dramatizes the importance of Spinoza's thought for contemporary social movements, particularly the philosopher's theory of immanence and his notion of *multitudo*: an irreducible ensemble of subjects organized around conflict. The logic of immanent cause has been treated extensively by Althusser, Étienne Balibar, Gilles Deleuze, and Paolo Virno, among others; we have already noted that it has found its most influential recent articulation in Negri and Hardt's *Empire*. I write that the organization and production of Hirschhorn's work, which appropriates a host of wildly disparate sources and trails the circuits of graphic design, overproduction, and new forms of mediation, internalizes this causal

logic as its sense of the world. Discussions of two Chinese artists—Liu Wei and Chu Yun—and the German artist Josephine Meckseper round out the interests of overproduction and temporality within contemporary art.

Chapter 4 concerns a strain of collective practice in recent art, what I'm calling "pseudo-collectivism," emblematic of a new crisis of representation surrounding the politics of visibility. Among others, I consider the Atlas Group (in effect, the artist Walid Ra'ad) and the New Delhi-based Raqs Media Collective (Monica Narula, Jeebesh Bagchi, Shuddhabrata Sengupta) relative to such "polycentric" organizations as the World Social Forum, asking what collective models are appropriate in light of a newly emergent figure of neoliberalism called a "consumer sovereign." There is a striking literature that tackles the fictive dimensions of recent art, including its collectives, through the terms established by Jacques Rancière in his formative *Politics of Aesthetics*. One has to address these arguments, which are powerful and convincing; but I'm also invested in more tactical forms of engagement. For pseudo-collectivism, I argue, is not only a matter of a political imaginary and its proleptic, even utopian, forms of address but a pragmatic response to the pressures of flexible specialization and the sovereign powers associated with this new individual subject. As allegorical ballast to this form of collectivism, this chapter calls upon the words of the Invisible Committee, whose anonymous tract *The Coming Insurrection* offers a trenchant critique of political representation within and by global culture.

As this chapter outline suggests, I am concerned with a different order of work that contemporary art might perform—with the *work of art's world* and not with the art world as such. There is a very real sense that art has a formative role to play in the processes, histories, and competing definitions of a new global order. This book departs from this last point as it forgets the art world that once foreclosed such possibilities.

1
The World Is Flat /
The End of the World:

Takashi Murakami
and the Aesthetics of Post-Fordism

My world foreshortened, flattening into a credit card. Seen
head on, things seemed merely skewed, but from the side the view was
virtually meaningless—a one-dimensional wafer. Everything
about me may have been crammed in there, but it was only plastic.
Indecipherable except to some machine.[1] —Haruki Murakami,
Hard-Boiled Wonderland and the End of the World

An Introduction to Post-Fordism

"DOBOZITE DOBOZITE OSHAMANBE." Though not quite as flat as a credit card, the sign on which these words appear is without volume or depth. Like many good signs—like many *effective* signs—it trades complexity for clarity, nuance for frankness. A flat-footed monument to exchange value, the sign plays with the format of your everyday logo if emptied of any specific meaning. There's hardly anything to look at, after all; and what is there is pretty much spelled out for you. Its elliptical shape spins the gaze in perpetual loops. The blue at its center—an unrelieved and thoroughly institutional blue—blocks access to any imagined space behind. With neither an image nor the trace of hands to disturb its pristine surface, the sign reads as at once opaque and superficial. It stares back like a dead eye.

And then there are those mysterious words in red—"DOBOZITE DOBOZITE OSHAMANBE"—orbiting the field in two neat arcs. They're nonsense words invented by the maker of the sign, the Japanese artist Takashi Murakami, who will become well known not just for paintings and sculptures but for a dizzying array of commodities: T-shirts and figurines; mouse pads and keychains; posters and watches; pneumatics and pillows; and, most infamously, Louis Vuitton handbags. In 2000, Murakami will likewise be acclaimed for an essay-cum-manifesto on contemporary Japanese art, pronouncing on the conditions of something he would call "Superflat." With this sign, however, the artist is far less articulate, collapsing the mangled pronunciations of a well-known cartoon character with Japanese slang for the interrogative "why?" (*doshite*). So while the message takes on the appearance of legibility, its actual meaning is indecipherable—except to some machine, as will prove the case for all of his work.

Admittedly this sign is not the most obvious place to begin discussion of Japan's best-known contemporary artist. In contrast to *Dobozite Dobozite Oshamanbe*, the vast majority of Murakami's work seems neither obscure nor illegible and traffics little in abstraction. The considerable literature devoted to his practice goes straight to the figurative and iconic, to colorful, graspable images and things and to some vision of "essential" Japaneseness, all very user-friendly. Of more typical works, riotously colored and peopled with cartoonish avatars, writers detail an unabashed kinship with manga (comics) and anime (animation) and the murkier worlds inhabited by

Figure 1.1
Takashi Murakami, *Dobozite Dobozite Oshamanbe*, 1993. Light box, 30 inches wide. © 1993 Takashi Murakami/Kaikai Kiki Co., Ltd. All rights reserved. Courtesy of the artist and Blum & Poe, Los Angeles. Photo: Joshua White.

the slavish followers of both genres, colloquially known as *otaku*.[2] Critics describe his acutely self-conscious riff on "traditional" Japanese painting, Nihonga, a style that emerged in the Meiji period (1868–1912) and in which he trained in school; and his not-so-secret fraternity with *kawaii*—the cult of all things cute personified by Hello Kitty and other plush confections.[3] The pop-cultural commodities bearing Murakami's signature are likewise surveyed. Venturing abroad in assessing the artist's influences, Warhol and Jeff Koons make their obligatory appearance. Nothing so blank as a sign would seem to augur Murakami's later fortunes.

It may seem odd to dispense with such references so quickly, and all the more so because they are supplied by the artist himself. In 2000, on the occasion of the wildly successful traveling group show he organized called "Superflat," Murakami published "A Theory of Super Flat Japanese Art," explaining this seemingly depthless work, both his and his peers', through its rampant commingling of past and present, art and entertainment. Into the mix he added the "lineage of eccentricity" from the Edo period to the present; "the strange style of timing structure in Japanese television animation"; Hokusai and the anime master, Yoshinori Kanada; Godzilla and the bubble economy.[4] The nationalist tenor of the essay was joined to an awareness of an emerging global art economy. And "that unique Japanese sensibility," as Murakami called it, was compressed into an image of flatness, a stage for any number of figures to act out their various dramas, whether habitués of the floating world or the demimonde of the comic strip.

No matter that flatness is a formal thing, a platform and structuring device. While flatness has been subject to countless misadventures in the art of the postwar era (one can barely mouth the word without raising the specter of Clement Greenberg), its role within globalization's more recent apologias demands a different kind of analysis.[5] This chapter considers the artist's excessive planarity through questions of management and production, work and working, updating Leo Steinberg's canonical reading of flatness as "a documentary surface that tabulates information."[6] For Murakami, there could be no approach more redundant than to address his love affair with commodity culture, but my ambition cuts deeper than this in a kind of forensics of flatness that probes the globalizing stakes of the works' making. I'm interested in the engine behind his spatial politics and what I'm calling its aesthetics of

The World Is Flat / The End of the World

post-Fordism—what Doreen Massey describes as the epoch's "depthless horizontality" continuous with a certain kind of historical forgetting.[7]

Some introductory remarks on post-Fordism are in order, While this might seem far removed from Murakami's universe of blithe flowers and winking jellyfish eyes, when we scratch the surface of his operations we find affinities between his practice and those linked to the new divisions of global labor, thematized by the narrative of Superflat. Diagnosing what British Marxists called the New Times, Stuart Hall lists post-Fordism's most salient features:

> A shift to the new information technologies; more flexible, decentralized forms of labor process and work organization; decline of the old manufacturing base and the growth of the "sunrise" computer based industries; the hiving off or contracting out of functions and services; a greater emphasis on choice and product differentiation, on marketing, packaging and design, on the "targeting" of consumers by lifestyle, taste and culture rather than by categories of social class . . . an economy dominated by the multinationals with their new international division of labor and their greater autonomy from nation-state control; and the "globalization" of the new financial markets, linked by the communications revolution.[8]

Of course these conditions stand in an inextricable relation to the historical meanings of "Fordism," Antonio Gramsci's 1930s thesis on the then-new technologies of mass production introduced with the Model T (also referred to as "Americanism").[9] In *The Prison Notebooks*, Gramsci famously confronted the transformation of labor in the wake of Ford's organizational innovations and Frederick Winslow Taylor's theory of scientific management, stressing the affective as well as material implications such models had for the laboring subject. "Taylor expresses the real purpose of American society," Gramsci wrote,

> replacing in the worker the old psycho-physical nexus of qualified professional work, which demanded active participation, intelligence, fantasy, and initiative with automatic and mechanical attitudes. This is not a new thing, it is rather the

most recent, the most intense, the most brutal phase of a long process that began with industrialism itself. This phase will itself be superseded by the *creation of a new psycho-physical nexus* [my emphasis], both different from its predecessors and superior. As a consequence, a part of the old working class will be eliminated from the world of work, and perhaps, from the world.[10]

If Fordism molded workers to the brute regimentation of the assembly line and mechanized the alienation of labor in the process, note that Gramsci's account was also predictive.[11] He forecast the creation of a new psycho-physical nexus beyond this manufacturing regime, something "both different from its predecessors and superior."[12]

The philosopher could scarcely have guessed just how right he would be, as confirmed by the crisis in Fordism that erupted with the global recessions of 1973. Nor could he have imagined the vehement debates trailing post-Fordism in the years that followed, all turning around a circuitous logic of *flexibility*. "The period from 1965 to 1973 was one in which the inability of Fordism and Keynesianism to contain the inherent contradictions of capitalism became more and more apparent," David Harvey writes. "On the surface, these difficulties could best be captured by one word: rigidity."[13] As opposed to systems of mass production and accumulation integrated along vertical lines and characterized by this "rigidity," two influential (if themselves much debated) models of production emerged, one describing an approach of "flexible specialization," the other one of "flexible accumulation."[14] Both have come to stand for a cluster of managerial practices in which parts are produced in different plants; new information and automation technologies enable the customizing of products for niche markets; and new labor bases (whether remote agents or so-called guest workers) operate outside the restrictions of nationalized and/or regulated environments. It is a *horizontal* distribution of production and manufacture, a flattening of the world of work that evacuates top-down paradigms of centralized management within nationally determined borders.

For Murakami, flexibility will prove continuous with the organizational ethos referred to as "just in time," "Toyotaism," "the Toyota management system," or "lean production"—names signaling innovations in management and fabrication introduced by the Japanese automobile manufacturer after World War II (if recently ex-

periencing a dramatic reversal of fortune).[15] While these references seem to appeal to Murakami's claim that his is a "unique Japanese sensibility," in fact it's the *global* proliferation of these models that captures the art's itinerant values—and an implicit spatial politics by extension.[16] And it's on this count that I treat Superflat as a peculiar confirmation of Gramsci's "psycho-physical nexus," unbundling that nexus in four sections. I begin by plotting the circulation of one of Murakami's favorite templates—a sign named DOB—to describe the flexible interests of his work. A close reading of the essay "A Theory of Super Flat Japanese Art" follows as the historical (or, more pointedly, temporal) justification for this new ethos. The remaining two sections divide into discussions of the factory and screen, macro and micro interfaces that render such values plastic. A heterogeneous cast of characters and sources—from Bill Gates to Pierre Bézier, from the factories of Toyota to the stamping plants of Renault—are as instrumental in constructing Murakami's world view as the Japanimation figures crowding his art. Underlying these concerns is an argument about digital media, contemporary art, and globalization: how digital protocols support Murakami's peculiar economies of scale.

Murakami's example makes plain that economics neither supersedes nor lies behind art or culture. Within the context of post-Fordism, many would argue that these terms are indivisible, because interdependent.[17] Hall again:

> If "Post-Fordism" exists, then, it is as much a description of cultural as of economic change. Indeed, that distinction is now quite useless. Culture has ceased to be, if ever it was, a decorative addendum to the "hard world" of production and things, the icing on the cake of the material world. . . . Through design, technology and styling, "aesthetics" has already penetrated the world of modern production.[18]

Perhaps the words of another Murakami, the celebrated author who opened this chapter, move us most quickly in that direction. Describing a world "as flat as a credit card . . . indecipherable except to some machine," the writer advances an unintended précis on the visual artist's system. For the credit card announces his speculative interests; the machine is as smart as a computer; and together they disclose the global horizon over which Murakami reigns as the most prominent art world avatar.

A Sign named DOB

To get there demands that we stay longer with *Dobozite Dobozite Oshamanbe*. In following this sign, which functions as both Murakami's system's trademark and mechanism, we gain ground in understanding his more famous practice as a painter. The sign was made in 1993 for "An Evening of Romance," an exhibition at Nagoya's Gallery Cellar that took a sidelong glance at a peculiar Japanese marketing strategy. As Murakami describes it, the show was "an inquiry into the custom of putting the emphatic suffix 'Z' and 'X' at the end of everything from beer to comic book titles."[19] When the artist's plan to make a room-sized neon sign failed to materialize for budgetary reasons, this oval sign encircled by a nonsense refrain provided a cost-effective solution. It first appeared as a flat board before transforming into a modest light box, like the kind in a neighborhood storefront. In keeping with the advertising issues proposed by the exhibition, Murakami ironically proclaimed the phrase "Dobochitedobochiteoshamanbe!" would "save Japanese Art."[20]

In an act of even greater abbreviation—of even greater branding, to follow the show's curatorial program—Murakami took the first three letters of this phrase to produce yet another sign without an apparent signified, something named DOB. DOB was born of two negative inspirations: the "Z" "X" advertising strategy of Japanese markets, and a Tokyo art scene obsessed with anglicizing word/image relations, following the example of Barbara Kruger and Jenny Holzer.[21] That both these artists were engaged in the trenchant critique of commodity culture was undoubtedly not lost on Murakami. Something about the convergence of these sources—the one markedly Japanese in its commercial inflection, the other addressing the local art scene's parasitic relationship to the New York art world—would resurface in his later work.

Thus the character DOB emerged after protracted discussions of signage and branding with both studio assistants and graphic designers. Murakami had introduced manga-inspired imagery into his work as early as 1991, but the appearance of DOB marked a decisive shift in his practice.[22] A smiling figure with a foot firmly planted in the Disney gene pool, "Mr. DOB," as he was now christened, displayed all the requisite elements of *kawaii*: saucerlike eyes with a fringe of lashes; a nose leveled to a mere bump; exaggerated anatomy in the form of outsized ears; and an open and sunny disposition. He would prove his own greatest booster, this DOB, a cheerleader

for his own cause. The letters "D," "O," and "B," for instance, correspond to his simplified features, with the first and last pressed to his ears and the "O" rhyming with the roundness of his face. The format would be repeated a number of times and in different media, each iteration generating greater visibility for this virtual semaphore.

Mr. DOB would, in effect, become an advertisement for an advertisement. Michael Darling, the curator responsible for bringing "Superflat" to Los Angeles, provides a brief on the character's iconographic sources: "Mr. DOB hints at a convoluted chain of events that begins with American occupation of Japan after World War II, the introduction of American (chiefly Disney) cartoons to Japan, the assimilation of American cartoon styles into their own distinctive cartoon culture."[23] But it is less the concatenation of these particular sources, according to Darling, than their distribution in the form of Mr. DOB that is at play in Murakami's work. "When Mr. DOB takes the form of a keychain ornament or plush toy," he writes, "his inherent critique is directed at the web of production and consumption that sustains itself on the wallets of consumers who are looking for mindless diversions that distance them from harsher realities."[24]

Murakami's marketing sensibilities are endlessly repeated in the literature on the artist, in which questions of consumption are paramount.[25] These writings, nonetheless, steer clear of *how* that desire for consumption is engineered. But to say that Murakami mimes the products of commodity culture is to risk tautology: to sidestep the fact that the artist is creating such commodities in the process of ostensibly aping them, whether works of art or pillows or handbags. For his part, Murakami speaks generically to this quest. "I set out to investigate the secret of market survivability," as he put it, "the universality of characters such as Mickey Mouse, Sonic the Hedgehog, Doraemon, Miffy, Hello Kitty."[26] Murakami may have found the perfect avatar for this survivability in the form of Mr. DOB, but the question remains: what *was* the secret driving its survivability, its covert mechanism, so to speak?

A statement by the artist describes his practice, if it betrays little of the larger system sponsoring it:

> Manabu Koga of Pepper Shop, who was in vocational school at the time, took my rough design and touched it up on his Macintosh, after which we decided to get the graphic designer Gento Matsumoto's help on the project. For the very first blocky "D" and "B" we used a font he had designed.

Afterwards, we gradually smoothed out the letters, making them more rounded. In the end, a lot of people contributed to making DOB the way he is today.[27]

Murakami would come to depend on a team of individuals in his work's fabrication, each with a unique skill set. By the time the Superflat phenomenon took off a few years later, the implementation of this model in Murakami's "Kaikai Kiki" factory would be wholly systematized. Of course, such strategies are fundamental to any technically sophisticated form of fabrication, but for Murakami they are not so much a symptom of his enterprise as its cause and effect. And rather than the hallowed traditions of painting, usually alleged to serve as the art historical impetus for Superflat, it is the realm of contemporary design and its instruments—most pointedly, the Macintosh—that serves as the platform for his post-Fordist aesthetic.

That operation would culminate in some of Murakami's most spectacular productions a few years later, which trade on the appearance of two-dimensionality as a kind of red herring to (or, perhaps, emblem of) the operations driving it. Significantly, DOB launches this trend. In 1996, in a tribute to Murakami's hero Andy Warhol, DOB appeared in a closely cropped portrait series that repeatedly announced his own "celebrity," *And then, and then and then and then and then*. It's a plainspoken composition by Murakami's often baroque standards. The square format of these acrylic paintings frames DOB's grinning, pneumatic face at a sharp oblique, but as one image passes to the next, the orientation of the head appears to shift slightly, as if animated. Colors change as well, from oxblood red to deepening shades of blue. Sometimes the ground looks as if it has been purposefully scratched; other times the surface remains clean and uninflected.

A clue to the working method that generated these pictures is suggested by the title. A string of empty adverbs linked by as many conjunctions, it foreshadows the unerring rhythm of Murakami's output, the on-and-on quality of chasing down a motif through endless iterations while refusing the linguistic inconvenience of verbs or nouns. Serial practices are hardly novel to the history of art; but the post-Fordist implications of this mode become unavoidable as his art winds its way around a progressively flexible path. Consider that, as one of many appearances DOB made in the late nineties, *And then, and then and then and then and then* ranks among his least prepossessing. It is far less sumptuous than *727* (1996), a dazzling, multipaneled

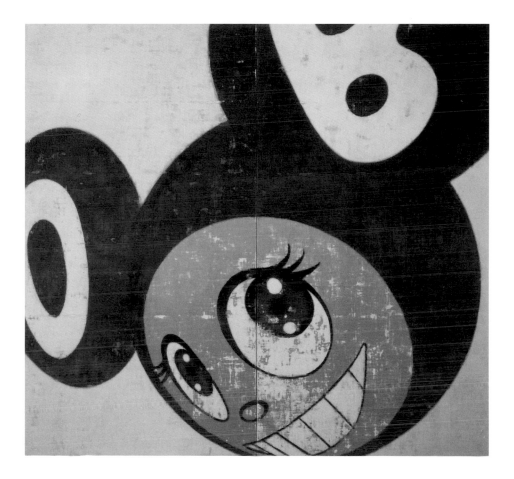

Figure 1.2
Takashi Murakami, *And then, and then and then and then and then,* 1996–1997. Acrylic on canvas mounted on board, two panels, 110¼ × 118⅛ inches (280 × 300 cm). © 1996–1997 Takashi Murakami/Kaikai Kiki Co., Ltd. All rights reserved. Courtesy of the artist and Blum & Poe, Los Angeles. Photo: Joshua White.

painting on linen that finds DOB speaking the rhetoric of Nihonga atop a surface of drifting nimbus. Yet it's on account of DOB's relative plainness here—or more accurately his representational emptiness—that *And then, and then and then and then and then* stands, paradoxically, at the threshold of Murakami's productive considerations.

In fact, at roughly the same moment *And then, and then and then and then and then* appeared, DOB would also morph into something more grotesque *and* dazzling, a spectacle of *kawaii* gone south and a tour de force of technical iterability. Whether taking the form of paintings, plastic figurines, or a newly favored medium—pneumatics—a number of Murakami's works from the period picture a DOB gone berserk in images barely restrained by their support. In the language of graphic design, the face of DOB "skinned" all manner of surfaces, with a mouth packed with rows of ragged teeth; a gorge painted blood-red; and a head covered with Argus-like eyes, some closed, some hooded, some impossibly dilated, each framed by little bladelike lashes. The new DOB had also gone multiple, as if undergoing some monstrous act of spontaneous generation, plastic values rendered promiscuous. He appeared less like a waggish avatar—the winsome offspring of anime, your own cuddly friend—and more like a genetic mutation, stretched thin to impossible proportions; splayed flat across countless picture planes; shattered over and around pools of color; pulled taut across globular surfaces. This formal flexibility—thematized by DOB'S infinitely elastic and fractured persona—would provide a ground irresistible to the many popular and art historical references Murakami could summon.

The Castle of Tin Tin (1998) offers metaphoric confirmation of this idea. In this monumentally perverse allegory of regeneration, Murakami repeats the multipaneled format of *727* with its allusions to Nihonga intact: The silver ground, flat as a board, retains the depthless planarity of a folding screen. In this case, though, DOB has sprouted bubblelike clusters of heads, elastic things morphing and twisting around an invisible axis and spouting fizzy rivulets of goo. The vortex around which these changes erupt dramatizes the generative capacities of Murakami's production—but to what end? To anyone missing the point, a spiral of pink fluid envelops the vortex as if to complete a virtual double helix, the money shot by way of manga. The fluid recalls the pornographic elements of two other works from the same year, the monumentalized spurt ushering forth from the life-size sculpture *My Lonesome Cowboy* (1998) as well as the more plain-spoken, if no less suggestive, painting *Cream*

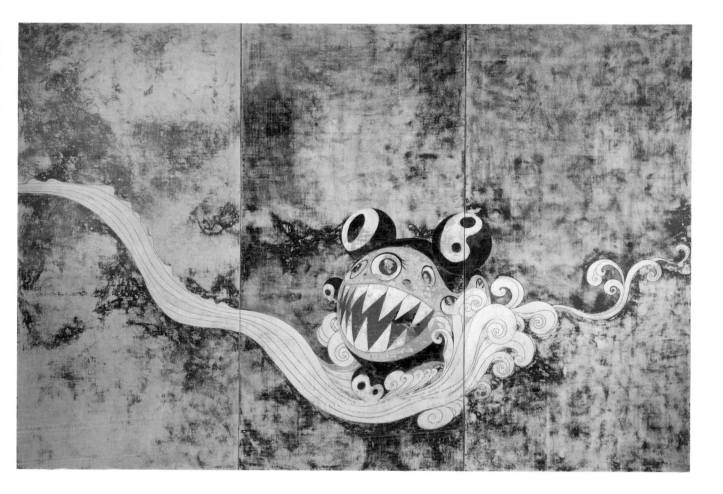

Figure 1.3
Takashi Murakami, *727*, 1996. Acrylic on canvas mounted on board, three panels, 118 × 180 inches (299.7 × 457.2 cm).
© 1996 Takashi Murakami/Kaikai Kiki Co., Ltd. All rights reserved. Courtesy of the artist and Blum & Poe, Los
Angeles. Photo: Joshua White.

(1998). But without diminishing any of these associations, you could just as easily argue that the work riffs on the apocalyptic drips of a Jackson Pollock, claimed by some as taking inspiration from "oriental painting"; or the exploding cosmologies featured in the anime classic, *Galaxy Express 999*. This is neither pseudomorphism nor free association at work, however. Murakami has granted extravagant hermeneutic license to such readings due to his works' flexibility.

A type of formal and thematic flexibility, then, allows DOB to undergo his most dramatic mutations as well as assimilate a staggering range of references, whether the creepy erotics of *otaku* culture, the sublime control of Hokusai, or the bland exuberance of Mickey. In economic terms, the conditions of flexibility resist being wholly committed to one program, one way of doing things, one all-important motif: appealing always to the particularities of an ever-changing market means being all things to all comers. Crucially, the most appropriate staging ground for this condition is a space that denies a singular point of view: that which, as writers on Murakami avow, is "devoid of perspective and devoid of hierarchy, all existing equally and simultaneously."[28] This space of flatness concedes to the interests of accommodation, reproduction, and customization, announced by a sign named DOB.

At this point we might recall that DOB was a sign before morphing into a brand-cum-persona, subject to infinite flexibility because emptied of stable information or reference. Like the most flexible sign of them all—the commodity—DOB was a sign whose meanings and values were radically arbitrary and ultimately mystified. It's a notion that converges seamlessly with Murakami's later description of Superflat as that which is "not bound by limits, not connected to the system, not filled with information. It is a blank slate."[29] If DOB is Murakami's alter ego, his investment in the political economy of this sign warrants greater scrutiny. The essay "A Theory of Super Flat Art" provides the narrative to this psycho-physical nexus.

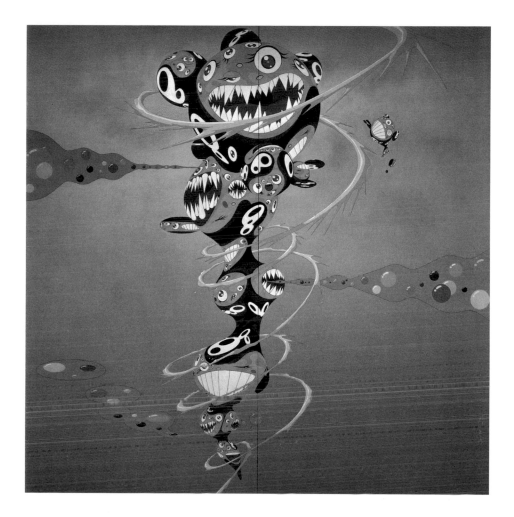

Figure 1.4
Takashi Murakami, *The Castle of Tin Tin*, 1998. Acrylic on canvas mounted on board, two panels, 118⅛ × 118⅛ inches (300 × 300 cm). © 1998 Takashi Murakami/Kaikai Kiki Co., Ltd. All rights reserved. Courtesy of the artist and Blum & Poe, Los Angeles. Photo: Joshua White.

History Is Flat

The motivation for my works comes from the idea that I want all these things to be bound together and flattened, so they're all the same.[30]
—Takashi Murakami

So far we have followed the migrations of a sign named DOB and have established the basic contours of Murakami's working method. An empty sign is an unfixed thing, a medium through which any number of motifs are assimilated, reproduced, and distributed. DOB is emblematic for Murakami not merely for its manga-inspired turn but more importantly because, given its multiple iterations in a diverse range of media, it taps into his liberal and, one wants to say, liberalizing coordination of marketing techniques. How this practice is advanced by the artist's theory of Superflat—its vision of both history and time specifically—is critical to understanding one aspect of his spatial politics and contemporary art in its post-Fordist guise.

Reading Murakami's essay exclusively in spatial terms misses something important to the workings and controversies of globalization: the shifting valences between the time/space ratio that mark its historiographic emergence. Yet the essay implicitly confirms Doreen Massey's formative critique of globalization imagined as a "depthless horizontality"—a world quick to forget its historical and temporal imbrications no less than its material grounding. In a text that careens wildly from the Meiji Era to the bubble economy, Murakami effectively levels historical and temporal distance in a push to contract *geographic* distance, the endpoint being a world of ever-quickening surfaces.

The essay was written on the occasion of the group show that originated in the Parco galleries in Tokyo in 2000 before traveling abroad. "Superflat" appeared at several venues in the United States beginning in 2001, including the Museum of Contemporary Art gallery at the Pacific Design Center in Los Angeles (MoCA); the Walker Art Center in Minneapolis; and the Henry Art Gallery in Seattle. This introduction to Murakami's vision of contemporary Japanese art featured over twenty young artists, a number of whom would achieve a certain art world celebrity in their own right. (Murakami would in the following years provide critical support to emerging Japanese artists.) The international visibility of Superflat was bolstered by a number of

other Euro-American exhibitions devoted to contemporary Japanese art—"Tokyo pop," it was called—and the attention steadily directed to the burgeoning Asian art market after the 1990s.[31]

"Superflat" was the name that stuck for most Western audiences. Like the best trademarks, it appealed to multiple constituencies, evoking the worlds of design, architecture, and media as much as that of art; and communicating the heady rush of something mobile and expedient in the universal language of digitalia, like a superhighway or a superconductor. This was work that spoke as loudly to the "screen generation" as to connoisseurs of traditional art history.[32] But what was ultimately "super" about Superflat was the formal flatness that linked past and present by transcending the particularities of either historical or contemporary Japan—and from much farther afield, as it turns out. The Superflat approach was two-pronged, seeking first to establish some continuity between contemporary Japanese visual culture and the past, namely Murakami's training in Nihonga;[33] and tacitly elevating the worlds of anime and manga to the same plane as Japan's art historical traditions. And in its rampant allusion to, and poaching of, motifs from abroad—mostly the art and popular culture of the United States—Superflat's transnational aspirations belied its ostensibly nationalist rhetoric.

The head-spinning quickness with which Murakami travels between past, present, and future in the essay is suggestive for his working method. "We want to see the newest things," Murakami begins. "That is because we want to see the future, even if only momentarily."[34] He then introduces the Japanese art historian Nobuo Tsuji, whose book *The Lineage of Eccentricity* will inform the artist's theorization of Superflat. Tsuji examines six artists with "expressionistic tendencies of the Edo period" whose "shared characteristic was the production of eccentric and fantastic images."[35] The works of these artists are amply illustrated in Muramaki's exhibition catalog, including an eighteenth-century folding screen and an obsessively detailed map of China. Yet Murakami notes an odd reference in Tsuji's text, in which he "implies a similarity" between the historical material and contemporary "manga and poster art."[36] The remark spins a host of associations. On the one hand, Tsuji's lineage included the historical painters Murakami had studied and admired at university; and on the other, Tsuji's ideas correspond perfectly to the artist's own obsessions with "the strange style of timing structure in Japanese television animation."

As Murakami explains it, the shared emphasis on planarity in both genres is a function of the relative velocity of images—their timing. The virtual speed of the image and how quickly it organizes the response of the viewer stems from the pictorial evacuation of depth.

> I thought that perhaps the way that a picture controls the speed of its observer's gaze, the course of that gaze's scan, and the subsequent control of the information flow might well match well with the artists' concepts that Tsuji described in his book. It was from that hypothesis that my theory of "Superflat" was born. All of the "eccentric" artists shared a certain structural methodology, in which they created surface images that erased the interstices and thus made the observer aware of the image's extreme planarity.[37]

To erase the "interstices" of the image and level perspective in the process is to accelerate the image's visual consumption, to endow it with the qualities of both immediacy and proximity.

Importantly, the medium itself *resists* this sense of virtual speed, as much as Murakami would argue it produces it. Such is the case with the work of one of his heroes, the anime master Yoshinori Kanada, best known for the feature *Galaxy Express 999* (1979). In Kanada's example, the scheduling demands of television animation called for an accelerated rendering process, with the effect of the final product often looking ruptured or jittery. Kanada exploited these limitations to thematic advantage, creating visions of shape-shifting and metamorphoses (explosions or volcanic eruptions) that appropriated the temporal stutters inherent in the medium. These narrative "hiccups" in Kanada's work do not so much reveal the *continuity* of the historical picture Murakami paints, as the artist would claim, but its radical eclipse or abbreviation.

Massey is especially helpful in parsing the promiscuous history and temporality of Murakami's essay. She sets out to "question the habit of thinking space as surface" in part so that "thinking the spatial in a particular way can shake up the manner in which certain political questions are formulated," a point of no small interest for an artist whose politics seem hedged at best.[38] One of her most relevant insights concerns "the temporal convening of space."[39] The phrase describes how geographic distance has been coded as temporal and historical lag—and thus recruited in the

service of colonizing narratives and policies relative to "underdevelopment," the "developing" world, and the "civilizing missions" of imperial conquest.[40]

Where globalization is concerned, one narrative around "the temporal convening of space" comes to dominate. The time/space ratio is now collapsed into the alternating figure of "instantaneity/depthlessness": the myth of a world in which platitudes about the 24-hour news cycle are repeated *ad nauseam* and time is seen as an undifferentiated block, a singular and indivisible present.[41] From Fredric Jameson to David Harvey to Anthony Giddens, the notion of time/space compression is central to theories of globalization; Massey will flag the tropes of instantaneity and interconnectedness informing its popular accounts. She notes that "from a world structured and preoccupied by history, we have landed ourselves in a depthless horizontality of immediate connections. . . . In its most extreme form this view of the current state of things is an imagination of instantaneity—of a single global present. In this formulation, temporality becomes impossible."[42] This "depthless horizontality" is founded on what Jameson, in his work on postmodernism, might call "the waning of historical affect" or historical "deafness."[43] That frictionless sense of time is betrayed by the artist's scattershot historical references marking the lineage of Superflat, that is, Murakami's paradoxical *inability* to think space historically.[44] "That 'the new depthlessness' poses problems for thinking historically is without doubt," Massey writes, "but it also poses problems for thinking *spatially*."[45]

Murakami's twinned discussions of Nihonga, first, and the contemporary art market, second, confirm these problems. For many critics, Murakami's perpetual acknowledgment of Nihonga is taken as his baldest engagement with Japanese tradition. I can do no justice to the complexities of Nihonga here, which are largely beside the point of my argument in any case, but even the most sweeping account of Nihonga reveals that this so-called traditional "movement" was no simple continuation of an untroubled past, whereby Japanese nationhood is understood as a hermetic and immutable given.[46] Murakami's historical quotations, bluntly put, are themselves imbricated in the deepening web of modern statecraft, a point only reinforced by his discussion of contemporary Japanese art.[47]

In the section called "Changes in Art," for instance, Murakami speaks to the vicissitudes of the international art market as implicated within postwar geopolitics. "The art boom in Japan," he notes, "began with the economic growth of the late 1960s. . . .

Though Japanese painting had been pushed into near extinction with the importation after World War II of art theories from the West, this generation turned to it in a search for Japanese identity. At the same time within the art establishment a hierarchy was being constructed that attempted to stabilize prices."[48] Murakami is obliquely alluding to one small facet of Japan's postwar economic miracle.[49] But just as quickly as he advances his claim about the art of the 1960s, he abruptly shifts to discuss the art market of the 1980s and its relation to a troubled economy. The phoenixlike rise of the Japanese economy would be matched by its equally vertiginous decline at the end of the eighties: the dramatic plunge of the Nikkei index following the collapse of the "bubble economy."[50] With the combined forces of financial liberalization and changes in Japanese monetary policy, the conditions were only ripe for an economic downturn.[51]

In light of Muramkami's thinking on flatness, the popular image of the bubble economy merits consideration, the phrase evoking the frothy success of the market as supported by nothing more than air, an impossibly precarious thing swollen to vacuous proportions. But Murakami sees this economy as bearing surprisingly beneficial consequences for the arts:

> Though one effect of the bubble economy of the 1980s was that prices throughout the industry rose too high, another effect was that discount travel brokers such as H.I.S. appeared, lowering the primary hurdle to travel abroad. As a result, Japanese traveled around the world and were able to see famous works for themselves. Information about the art market abroad also entered Japan, making Japanese aware of the imbalance between the world price standard and current Japanese prices.[52]

This enabling of Japanese travel worldwide and the gathering of information about the international art market were critical developments for the aesthetics of post-Fordism. "Leaving the development of these travelers' tastes aside," Murakami writes, "the Japanese painting and Western painting industries were only interested in the money game, and were taking great pains to protect the system and its organizations. In the end, the existing art industry collapsed with the bursting of the bubble economy. 'Art' had begun to disappear."[53] Here the rhetoric of money games and the

world price standard has thoroughly trumped Murakami's earlier aesthetic considerations such that art itself (and its historical industries) is on the wane. The collapse paves the way for the material coordination of his practice, both in Tokyo and New York and a place called the Kaikai Kiki Factory.

The inexorability of the story being told, its down-the-slippery-slope way of reasoning, is strikingly consonant with the artistic phenomena it surveys. It's a narrative that justifies the historical emergence of Superflat on strangely ahistorical grounds, from Nihonga to the bubble economy, from Hokusai to Hello Kitty, licensing the operations of a flat world in the process. The ground is now prepared to track these operations as situational, first from the actual sites of Murakami's production and then to its digital, if just as material, interface.

Kaikai Kiki: The Post-Fordist Cottage Industry and Friction-Free Capitalism

Let me explain the scene I saw the moment I fused those many windows into one.[54]
—Takashi Murakami

How to give concrete form to a practice that fuses many windows on the past and present into one? What does that scene look like? Given our reading of Superflat, it comes as little surprise that the question of international markets—and a canny manipulation of American conceptions of Japaneseness—figures heavily into his work's production. Those conceptions find material impetus in the workings of Murakami's "factory," and an organizational mandate that one of Murakami's heroes, Bill Gates, would call "friction-free capitalism," which will itself take as its point of departure Japan's "just-in-time" system. What such links suggest for Murakami's work as a "painter" is the foundational if strangely repressed role digital media play in the globalization of contemporary art.

In an interview from 2000, the moment the Superflat phenomenon was breaking, Murakami outlined his strategies for international market survivability in a kind of winking parable about consumption.

1. First, gain recognition on site (New York). Furthermore, adjust the flavoring to meet the needs of the venue. 2. With this recognition as my parachute, I will make my landing back in Japan. Slightly adjust the flavorings until they are Japanese. Or perhaps entirely modify the works to meet Japanese tastes. 3. Back overseas, into the fray. This time I will make presentation that doesn't shy away from my true soy sauce nature, but is understandable to my audience. At present I've made it through the first gate in pretty good form.[55]

It's a humorous statement in its heedless commingling of metaphors, which range from the military (parachute landings) to the culinary ("adjust the flavoring"), all of which add up to a market philosophy premised on stereotype. Like the sign DOB, whose chief attribute was its capacity for emptiness and thus flexibility, these references target audiences in the United States, Japan, and elsewhere, allowing for the greatest degree of accommodation in the process. Depending on the reader/viewer—depending on the specific market, in other words—some cues resonate in more meaningful ways than others. "True soy sauce nature," for example, reads as a self-ironizing statement to most because it is ridiculously essentializing, the reduction of national character to condiments. On some, though, the irony may be lost, mistaken as a matter of false belief, foundering on gross clichés surrounding "Japaneseness."

Both positions are tenable due to Murakami's itinerant sensibility. The coming and going between the United States and Japan—the overseas "fray" and the domestic—destabilizes any fixed point of reference for his production and the work's consumption. No doubt the traveling artist is the motor of the global art world. We have naturalized the idea that artists variously perform the roles of ethnographer, migrant, tourist, or nomad: as James Meyer has described this last persona in particular, that nomadic guise might assume either a lyrical or critical pose in reflecting on the terms of site and place in contemporary art.[56] The difference with Murakami is that neither stance is taken up as a mode of representation or critique but is instead systemized at all levels of his operations. The artist's predilection for international travel is less at issue than the decentralizing and itinerant tendencies ramifying throughout his production.

Take his factories as the most immediate site of this logic.[57] In 1995, Murakami founded the "Hiropon" factory in Asaka city, a drab suburb about an hour outside

The World Is Flat / The End of the World

of Tokyo. Like many of Murakami's conceits, the name "Hiropon" has come to assume several ambiguous meanings: according to one account, it conjoins the terms "hiro" (the word for hero) and "pon" (the sound for an explosion, which also means "tired"), resulting in a hybrid phrase roughly translating to "tired hero." Whatever its actual or fabulous meanings, Murakami's studio was subsequently rechristened the "Kaikai Kiki Factory," after the names given to two anime-inspired characters spun off from DOB about the same time. ("Kaikai" was blue and gendered masculine; "Kiki" pink and feminized.) As sited in Asaka, Kaikai Kiki was a series of low-slung bungalows, occupying a large grassy plot neighbored by a small pottery plant, open for operation 365 days a year, 24 hours each day. Each building was assigned a different task in the production of Murakami's work: a painting studio of several small rooms, for example, contained one room devoted to the laborious task of mixing color for Murakami's rigorously keyed palette. A larger building was divided into three spaces: one housing a computer design studio, with its banks of CPUs and screens flashing; another given over to business and management; a third, a conference room. Yet another building was dedicated to shipping and crating.

While writers point consistently to Murakami's fascination with Andy Warhol and *his* Factory to justify the parodic name, something more fundamental separates Murakami's contemporary studio from its real industrial paradigm. For the historical factory embodies the architecture of Fordism, presupposed as that system is on vertically integrated systems of production.[38] Murakami's techniques, on the other hand, call to mind a strange hybrid in which the specialized skills of the artisan—a cottage industry—meet up with the office park. You could say that the division of labor at Kaikai Kiki resists vertical organization; work is dispersed and decentralized not only across the multiple bungalows of his Asaka studio, but throughout Japan and, progressively, across intercontinental date lines.

A wholly systematized way of thinking—a philosophy, even—guides that organization. Murakami frequently cites the management style of Bill Gates in the running of Kaikai Kiki, such as the practices discussed in the Microsoft founder's *Business @ the Speed of Thought: Succeeding in the Digital Economy*.[59] In his bestseller of 1999, Gates advocates the implementation of business strategies consistent with the technologies his corporation introduced, noting that while the information society has existed for several decades, managerial practices lag far behind. In other words, the

changes in production that the computer made possible have completely outpaced the methods of the businesses that stand to reap their benefits. Largely absent from these enterprises, Gates writes, is the fully integrated use of the Internet to manage their transactions. Such modes of communication are critical to what Gates calls "friction-free capitalism," defined as "a concept . . . that digital processes can remove most of the friction in business transactions by removing middlemen."[60]

Indeed *Business @ the Speed of Thought* reads as a postscript to a post-Fordist brief. In one chapter Gates cites the Japanese automobile industry and its pioneering efforts to merge industry with the protocols of the coming information age. The acceleration of the productive process—from conception to realization—is at the base of this phenomenon. "Few industries illustrate the twin pressures of collapsing time and improving quality better than the automobile industry," Gates writes.

> Japanese auto designs in the 1980s appeared fresher and their quality improvements more frequent than in American cars because Japanese automakers could take a car from a concept to mass production in three years. American automakers typically took four to six years and their costs were higher.[61]

Describing the uses of computer-aided design and manufacture (CAD/CAM) in the rise of the Japanese automobile industry, Gates provides nothing so much as a tacit précis on the Toyota production system.[62] Indeed Taiichi Ohno's system was devised to meet the specific needs of changing markets on a provisional basis, turning around two innovations suggestive for Murakami's working method: the famous "just-in-time" system (*kanban*) and what he called "automation with a human touch (autonomation)."[63]

The *kanban* ("tag") is the heart of Toyota's operating method; it is a piece of paper or a signal that carries three levels of information (pick-up information, transfer information, and production information) that circulates "vertically" and "laterally"—that is to say, "within Toyota itself and between Toyota and the cooperating firms."[64] The *kanban* system was developed to "coordinate the flow of parts within the supply system on a day-to-day basis," by "dictating that parts would only be produced at each previous step to supply the immediate demands of the next step."[65]

The other innovation, "autonomation," as opposed to mere "automation," suggests "transferring human intelligence to a machine."[66] In practice this means that

workers are given the power to stop production should abnormal situations arise, which would be untenable in earlier systems of mass production. As a more general concept, though, the notion suggests that the deadening rationality typically associated with automation—the laborers coming to resemble a robotic workforce—has been leavened by a sense of agency, at once humanizing the production process while responding to the market contingencies of those processes. In recognizing as well as supporting the convergence of these processes, industry and automation are accorded a new flexibility.

For Gates's nontechnical business manual, the specificity of such protocols is less significant than their economic successes. There's some irony in noting the circuit through which Murakami might have received this information, recalling the temporal and spatial leveling advanced by his own thesis on Superflat. In the feedback loop logic of information systems, a managerial style of Japanese origin finds cogent articulation in the words of Bill Gates, which are in turn passed on to Japan's most celebrated contemporary artist. Whether called lean production, post-Fordist production, just-in-time production, or Toyotaism, these models are allegorized by Murakami on both extramural and domestic levels, from the far reaches of an international art market, in which the artist shuttles back and forth between his studios in Tokyo and New York and his galleries elsewhere, to the in-house operations of the office park, with its endless flow of information and flexible teams of assistants.

But if the "factory" itself is the most obvious interface of his process, maybe even a distraction in the larger scheme of Murakami's enterprise, it is around the digital that a post-Fordist agenda is foundational for the artist. Notwithstanding the considerable charms of his Japanimation personas, whether Kaikai or Kiki or even DOB, the seemingly abstract domain of computer graphics offers the clearest because most global perspective on a Superflat worldview. Traveling the path of the "Bézier curve," we arrive.

Bézier Curves and Economies of Scale

Though writers on Murakami acknowledge his use of the computer through repeated references to Japan's "screen generation," they do so only in passing, as if the computer's

generative capacities were free of significance beyond its putatively neutral status as an artistic "tool." The point raises a larger issue as to how the relationship between art and digital media is generally treated within the criticism of contemporary art and globalization beyond mention of the network society, "infoscapes," and associated rubrics on the information economy. Yet without engaging such protocols, even at the most rudimentary level, we remain tied to methods of analysis that cannot adequately address the works' material processes and their globalizing implications. One might resist calling Murakami a digital artist as such; but this chapter has gone to some lengths to demonstrate his internalization of the computer's worldview. Just as the history of oil paint comes freighted with its own epistemological agendas (not to mention its ideological ones), so too does a recent narrative about things digital. When conjoined to the rhetoric of traditional media like painting, Murakami's digital protocols take on marked significance as they relate to his economies of scale, a phrase that assumes a doubled valence in this context.

Whatever the critical silence on Murakami's work in computer graphics, the artist is plainspoken about its uses, though hardly preoccupied with its connotations. In the back pages of the fascinating book *Summon Monsters?*, many individuals involved in his varied operations—from well-known fabricators of life-sized anime figures to the tireless young artists working in his studio—testify to the day-to-day practices of Kaikai Kiki. A member of Murakami's digital drawing staff, the artist Chiho Aoshima, discusses making the templates that enable the itinerant flights of a DOB or a Kaikai Kiki across a range of media. She highlights the use of vector graphics in his art, whether in his paintings, pneumatics, T-shirts, or sculpture. Murakami's programming language is critical for satisfying the tenets of Superflat; that language does not just fulfill those tenets but *actualizes* them. I cite Aoshima at length to capture the texture of her observations:

> Most of Takashi Murakami's recent paintings have been done on a template composed of Bézier-type vector lines. I'm the one in charge of producing the template data, for which I use Adobe Illustrator 8.0.
>
> There are a number of guidelines that have been set up for producing these templates, based on the know-how established by the previous artist at this post, Mr. Irabu. I create the templates for each painting, making minor changes to these guidelines.

The basic procedure begins with me receiving a hand-drawn sketch from Murakami. By this point in time, the dimensions of the painting and the canvas have already been decided, so first the base gesso is dried so that it no longer will expand or contract. I then precisely measure out the canvas to an accuracy of 1 millimeter. Even a deviation of a few millimeters may be enough to cause the structure of the painting to have to be altered, so I do this step very carefully.[67]

Aoshima speaks of the meticulous work of creating digital templates; the basic models archived by the "previous artist" who held her current post; and Murakami's original sketch, which serves as the starting point for the seemingly endless variations of his manga-inspired personas. The accompanying illustrations reveal catalogs of the same motifs plotted in grids, with each unit containing a slightly different iteration of a familiar character—perhaps attenuated or compressed or multiplied as if expressing the range of its graphic possibilities.

What's striking about Aoshima's description is that the projected dimensions of the painting (or whatever the given substrate) are *independent* of her digital drawing. The "dimensions of the painting and the canvas have already been decided" in advance, that is to say, freed from design issues rigidly fixed to its material support. This, then, is a matter of scale, but a counterintuitive notion of scale premised on flexible configurations. For if scale is a relational concept, a shifting and proportionate relation based on otherwise fixed measurements (size), Murakami's methods suggest that scale is now infinitely elastic, because the variables are infinitely flexible. Aoshima's job as digital draftsperson is to scale an already existing template (that is, one of Murakami's preexisting motifs produced as a digital file) to the ever-shifting dimensions of a new work, whose actual support might be a monumental picture plane, a soccer ball, a purse, or a T-shirt. In the language of CAD, her role is to "skin" the various interfaces of Murakami's art and product.

Crucially Aoshima highlights the importance of a "Bézier curve" in this process:

The digital drawing I do for Murakami is comprised of scanning a pencil-drawn sketch and tracing the scanned artwork using Bézier-type vector lines. Once I have traced the entire sketch, I print out the artwork, return it to Murakami, and wait for his corrections. . . . Once Murakami returns his red-inked corrections, I scan and retrace the corrected area. We repeat this back and forth process 20 or 30 times.[68]

Discussion of the Bézier curve might seem little more than a factoid for Murakami completists, but the formula is a critical tool in his Superflat arsenal. And so we need to return briefly, perhaps surprisingly, to a postwar history of automobile manufacturing, decidedly non-Fordist at that, to stress the interests of such techniques for globalization.

Named after the French mechanical engineer Pierre Bézier (1910–1999), the Bézier curve was first employed in the production of automobile design in the late 1960s. The Renault corporation, for which Bézier worked, sought an efficient means to design and manufacture cars with especially smooth profiles. In the early days of CAD/CAM, efforts to draft such curves proved approximate, failing to conform to the exacting standards of the machine shop. Bézier formulated a novel equation for generating such curves using only four points. Its output is a parametric, cubic polynomial curve with two end points and two control points. These control points, which do not lie on the curve, define its tangents and can absorb the breadth of its modifications.[69]

The economy of Bézier's elegant system leads to the flexibility of its applications, the most famous being Adobe Illustrator, a vector graphic program adapted and then commercialized from PostScript protocols circa 1986. A basic, but critical, lesson follows: in contrast to raster graphic programs such as Photoshop, vector graphics are not organized around bitmaps but through points, lines, and curves. The most striking difference for the theory and practice of Superflat is that raster graphics are resolution *dependent*, vector graphics *independent*. Because raster programs generate images through bitmaps, the quality of the image is continuous with the concentration of information in each pixel: The more bits stored in a pixel—and the more pixels themselves—the higher the resolution of the image. File size, in this instance, trumps scalability. On the other hand, the images that result from this type of information loss are all too familiar. In such pictures, the underlying architecture of the image emerges as so many ragged and stuttering pixels, the armature of the bitmap stripped bare of its concealing information.

The following chapter on Andreas Gursky treats information storage within raster programs as producing its own spatial politics, quite different from Murakami's, to be sure, but equally charged for questions of contemporary work and production. For if raster graphics live and die on the quality of their resolution, the equal but opposite is true for those based on Bézier curves, in which information is not fixed to anything

so rigid as a bitmap, nor determined by anything so inflexible as the quantity of its pixels. Rather, since Bézier programs are resolution *independent*, the information that is generated through them is infinitely scaleable.

For Murakami's vision of Superflat, the consequences of this scalability are fundamental and wide-ranging. Deploying such graphics answers his acknowledged motivations in "market survivability" through a radically expansive economy of scale: it enables his work's friction-free movement across media, eclipsing the distance between his painting and the range of his other products. The data contained in a template based on vector graphics can skin any surface; it can be scaled up or way down to conform to the contours of any medium; it can be stretched to the thinnest and most taut proportions or compressed short and wide; it can be repeated and reiterated as new products, as personified by self-generating and shape-shifting avatars such as Mr. DOB. What disappears with this "infinite" scalability are those formal qualities that militate against flatness: volume, depth, modeling, perspective.

Such gains in scalability amount to strides in flexibility for consumer as well as producer, meeting the demands of niche markets outside the once rarefied climes of the art world: teenage girls and anime fans and those traveling the *kawaii* or the Lolicon circuit. On the other side of the economic spectrum, it is highly suggestive that such digitally sponsored effects are applied *analogically* to the surface of Murakami's principal artistic output in painting. Pace Taiichi Ohno, we could call it Murakami's "autonomation with a human touch." Recall that the artist's use of digital technics finds its principal expression in the flatness of the painterly medium, where the meshing of Macintosh and silkscreen is effectively disguised by a seamless application of acrylic—and cloaked in a humanist mantle by extension. Murakami's flexibility hence translates into a trafficking between analogical and digital worlds. In merging the two he gets both. His world strives for the global conditions of flatness materialized by the Bézier curve, even as the work insists upon its place within the lineage of Japanese painting.

Coupled with the humanist rhetoric of painting, Murakami's reliance on the Bézier curve points to the *loss* of actual scale in the conditions of contemporary art making—in spite, or rather because, of the seemingly infinite scalability of his practice.[70] For his art's ability to go anywhere, and be anything, independent of the physical requirements of size and the specificity of markets proclaims its faith in the mounting

irrelevance of those coordinates that ground such relations in time and space. Super-flat furnishes the origin myth of this irrelevance.

Ends

Supposing that the planet earth were not a sphere but a gigantic coffee table, how much difference in everyday life would that make? Granted, this is a pretty far-fetched example; you can't rearrange the facts of life so freely. Still, picturing the planet earth, for convenience sake, as a gigantic coffee table does in fact help clear away the clutter—those practically pointless contingencies such as gravity and the international dateline and the equator, those nagging details that arise from the spherical view.[71]
—Haruki Murakami

In *Hard-Boiled Wonderland and the End of the World*, the author Murakami tells the story of two split realities, separated through the literary devices of alternating narratives and the switching of authorial voices. Not long before one protagonist—a kind of human computer known as a "Calcutec"—drifts into the twilight haze of an endless sleep, the image of the world takes on radically new proportions. "My world foreshortened, flattening into a credit card," he observes. "Indecipherable except to some machine."

For his part, Takashi Murakami fashions a world from a deliberately nonspherical perspective, one that dispenses with such "pointless contingencies" as the international dateline and the equator as well as the concrete particularities of time and space. This postspherical world is a post-Fordist world, a psychophysical nexus in which flatness reigns as imperial contrivance.

2
Gursky's Ether

In *Salerno* (1990), a picture by the German artist Andreas Gursky, the southern Italian city is an image full to the bursting. Fashioned of clustered geometries and topographies as composed as stage sets, the city is meticulously ordered and strangely pristine, tamed of the bustle and noise you might expect of a harbor setting. In the lower half of the image, two parallel sections set at an obtuse angle support hundreds of cars, disturbingly neat lattices of mostly white threaded by skeins of red and blue. Each section obeys some hidden organizational mandate; and each vehicle is presented with implacable graphic clarity. All those windshields, tires, and headlights are rendered with the staunch regularity of a stamping machine. But not quite. Because this language recalls the manufacturing theories of a Ford or a Taylor, its descriptive value, let alone its contemporary relevance, is not on the mark, as the previous chapter on Murakami would suggest. It is true that the rhetoric of labor might seem the most fitting exegetical mode here—we are staring at a port city, after all—but the scene depicted is ultimately too frictionless to be captured by such metaphors, which appeal to heavy industry and the machine shop.

Along the middle register, positioned at an acute angle to the rows of cars in front of them, bands of cargo containers stack as cheerfully as building blocks in a harmonious spectrum or red, orange, brown, blue, tan, some white. We don't need to worry about what they contain (cars are the obvious answer), just as we needn't identify their far-flung destinations. Whatever their freight or itinerary, their place in the image serves to *pixelate* the landscape before us, organizing the middle ground with the rational exuberance of a bitmap. As the eye travels to the unbreached surface of the water, a low-slung structure in white punctuates the vibrant array, as if to afford a brief visual pause. Stationed at the approximate center of the picture plane, the building is among the larger objects in the photograph, comparable in size to the sleek black freighter perpendicular to it. Yet the structure fails to hold our attention. Instead its presence betrays the virtual slipperiness of the picture, its refusal of optical traction. It throws the photograph's alloverness into stark relief.

The eye glides unimpeded to where buildings amass into an unbroken profile ranging across the mountains. Domestic life presumably cleaves to this space while the workaday sphere presumably thrives front and center (we can only make such assumptions since there is no human presence in the image to suggest otherwise). By the same token, those buildings lend themselves to a kind of dogged atomization.

Figure 2.1
Andreas Gursky, *Salerno*, 1990. C-print, 170 × 205 × 5 cm (framed). © 2011 Andreas Gursky/VG Bild-Kunst, Bonn/ARS.
Courtesy Sprüth Magers, Berlin & London.

A strange exercise: one might patiently enumerate all the structures in the picture, whether waterfront properties tinged by the creep of age, or cinderblock apartments speaking generic modernism, or convents or civic edifices slotted among the folds of the mountains or tucked in near the bay. To account for these buildings and parse their details is to wrestle with the photograph's animating paradox. Even at a remote distance, the buildings are relentlessly intelligible, as if everything faraway were close to hand.

This ritual demonstrates a condition that runs throughout Gursky's work of the late 1990s. That is, no matter just where things are plotted relative to the standard co-ordinates of foreground, middle ground, and background, nearly everything seems available to the same inexhaustible visuality, a condition scarcely relieved by the conventions deployed to signal far-awayness. Perspective does less to communicate distance than it dramatizes the depthless depth of the image. The picture strikes a balance between its alloverness of vision and its radical compression of space. Note, for example, how a paved road in the front left corner, separated from the lot by a corridor of scrub, veers too sharply off the framing edge. Its curve is so excessively at-tenuated that the road appears to tip toward the front of the picture plane rather than recede away from it. Consider too how a channel of asphalt, positioned to the left of a bank of cargo containers, reads as an impossibly vertical, vertiginous rush. And look how cloud cover wafts amid mountains at the rear of the picture, as if to spell out some distance in between. But here even phenomena as numinous as clouds are registered with a strangely graphic crispness, like a prop devised for a winter pageant or an amateur theatrical production.

So while an image of drifting cumulus should evoke the conventions of atmo-spheric perspective, in *Salerno* it appears otherwise. No matter the distance implied by the picture's virtual recession, the city is laid bare with an uncanny constancy and evenness, as if everything was equalized by some invisible and ambient wash. No focal points structure our response to the picture, because the resolution is nearly ev-erywhere the same. And in refusing any singular point of view, it likewise rejects any sense of agency constructing it; as Peter Gallasi aptly describes it, Gursky's photo-graphs "obliterate the contingencies of perspective."[1] Little wonder, then, that the art-ist called his aesthetic vantage point that of an "extraterrestrial being."[2] It's as if some alien presence, collecting all the visual data its unearthly prospect affords, could only fail to discriminate among the miscellany down below.

Like so many photographs by Gursky, the scene of *Salerno* trades on a virtual eclipse of distance, a phrase that will become increasingly controversial as this chapter goes on. The picture is a textbook example of the photographer's aesthetic of the 1990s. There is, as many have noted, its monumentality: at six feet high by seven and a half wide, its scale is akin to that of history painting. Jean-François Chevrier has described the "tableau form" in Gursky and contemporary photography, a point taken up by Michael Fried as the most recent iteration of modernism's anti-theatrical tradition.[3]

In line with Gursky's escalated format, which conveys the gravity of public address, the work also confirms what Emily Apter calls "the aesthetics of critical habitats."[4] For Apter, this phrase captures the geopoetics of contemporary art, particularly in the work of William Kentridge and the Australian poet John Kinsella, who respectively engage problems of postcolonial cartography and "radical pastoral." In the case of Gursky, we could generalize this geopoetical orientation in terms of the welter of international scenes that make up his archive, many of which traffic in a kind of communal *jouissance* that stands as code for the teeming heteronomy of the world. Work and play are the iconographic touchstones of some of his best-known pictures. On the one hand there are the stock markets in Chicago, Shanghai, and Tokyo, their floors featuring antlike clusters of humanity hustling in the service of global capital: in *Chicago Board of Trade II* (1999), for example, the geometry of the trading floor takes on a dynamic rhythm as the visual field is punctuated with yellows, reds, and blues. Sites of industry also assume a pivotal role: how immaculate, how pleasingly ordered, the Siemens factory, with its trolleys and its roundels of wire placed just so, and its spiraling cables as cheerfully arranged as party streamers! Gursky is equally renowned for his images of global spectacles and commodities, the rewards and recreation alleged to await us after a hard day of work. The wan interior of a Prada boutique, the roiling mass of a rave, and the tawdry gratifications of a 99-cent store may well correspond to very different rungs of the socioeconomic ladder, but that also seems to the point of Gursky's practice. Their sum total effect provides a visual primer of the world market.

And then there is what we might call Gursky's detailism, the peculiar "reality effect" achieved by the God's-eye view typically cast down on his varied scenes of the late nineties. When the phrase *l'effet du réel* first appeared in literary criticism

Figure 2.2
Andreas Gursky, *Chicago Board of Trade II*, 1999. C-print, 205 × 335 × 6.2 cm (framed). © 2011 Andreas Gursky/VG Bild-Kunst, Bonn/ARS. Courtesy Sprüth Magers, Berlin & London.

Figure 2.3
Andreas Gursky, *Siemens, Karlsruhe*, 1991. C-print, 175 × 205 × 5 cm (framed). © 2011 Andreas Gursky/VG
Bild-Kunst, Bonn/ARS. Courtesy Sprüth Magers, Berlin & London.

in 1968, courtesy of Roland Barthes, it described the reality-making strategies of the nineteenth-century novel, in which an accumulation of detail did less to advance any ostensible plot than to produce a kind of narrative ambience, an atmosphere.[5] For his part, Gursky indulges a surfeit of descriptive possibility, excess piled on excess. As we have seen with *Salerno*, everything in his pictures is visually available; everything—whether buildings or cars or tarmac or trees or cargo containers—appears with diamantine clarity.[6] This degree of exactitude is achieved through Gursky's well-known use of digital compositing: it would be impossible to get it all in through "straight" photography alone.[7] Its result is such that the viewer scrambles to take in all the information on offer, information that, we shall see, will occasionally betray its productive underpinnings.

As in chapter 1, one aim of this discussion is to address the production of such images and their literal and ideological fallout, the implications of which go straight to a controversy around globalization. "Late capitalism" is the shorthand often summoned to explain Gursky's divided reception, but analyses tend to stall at that point. Just what is it about these pictures that is at once so powerful and so disquieting, producing a sense of dislocation in the viewer who might nonetheless be compelled by the richly detailed spectacle? Gursky's technics and their results amount to a different version of spatial politics than Takashi Murakami's, but one no less rife with questions about contemporary world making.

The task is straightforward enough: to consider his photographs of the late 1990s through their complex recruitment of analogical and digital means and the peculiar spatial ambience they conjure in the process. First mining the requisite narrative about Gursky's photographic lineage, I consider the wider implications of the media that enable him to achieve his work's smooth, near liquid spatiality, taking a brief detour into a contemporaneous project, Allan Sekula's *Fish Story*, as a point of comparison. Gursky's study with Bernd and Hilla Becher is well-trod terrain in the literature on this very well-known artist; writing on digital manipulation in his art is standard operating procedure. But what we discover along the way is a thesis on work under globalization—and an allegory about space relative to photographic and digital media. It is an argument about the competing values accorded the material and the virtual in the world of contemporary work, typically signaled by the phrase "the postindustrial society."

One needn't know much about Gursky's process to understand that digital media are essential to the power of his art. By focusing on scenes of markets, manufacture, and consumption, occasionally punctuated by spectacles of leisure, he indirectly engages their protocols as they "globalize" finance, entertainment, and consumer culture. Still, for all of the detailism one associates with Gursky's work, these photographs can hardly be deemed reportage in any conventional sense, even if they have internalized the habits of the documentary tradition. No one turns to a picture by Gursky for its documentary value.

But perhaps Gursky's works *are* a realism for current times, of a highly qualified type, projecting a world in which the availability of everything for visual consumption tallies with the *seeming* availability of communications and the market. And maybe the way to track this sensibility is through the invisible connective tissue that binds all of his details together. For what ultimately gives his subjects their formal punch—what endows his scenes of airports, Nike stores, and John Portman hotels with a distinctly chilly frisson—is, as my accounting of *Salerno* would have it, a kind of ambience, an atmosphere in its own right.

It's the "invisible hand" that guides all of Gursky's subjects.[8] It's the unseen fluid that moves around and between, lubricating relations between people and things while seeming to banish distance as a mere inconvenience. It's the crystalline envelope that equalizes all it contains, as if, to recall Marx, "all that is solid melts into air." What Gursky gives us, in a word, is what used to be called the "ether," a substance of no particular substance and a dream of transparency, everywhere and nowhere all at once.

How to Make a World Picture: Gursky's Inheritance

An ethereal proposal such as mine might seem odd given our contemporary and material investments. At least since Einstein's revolution in quantum physics, the ancient notion of the ether has been a largely discredited phenomenon.[9] The ether was a substance thought to fill all of space: to follow the 1934 edition of the *Concise Oxford Dictionary*, it was "a subtle elastic fluid permeating and filling the interstices between particles of air and other matter, a medium through which light-waves are propagated."[10] For scientists, the "imponderable matter" that was the ether amounted to a

category error. Because this invisible thing could neither be observed nor quantified, it was considered specious data when compared to the hard information required by scientific method. Yet as Joe Milutis has argued in his exhaustive study on the topic, the ether has returned with a vengeance. He describes it as "a mediating substance between science, technology and spiritualism" and charts its strange reappearance in the occasionally converging realms of mysticism and cyberspace.[11] For Milutis, the logic of all things ethereal finds varied expression in a range of contemporary phenomena, whether in the ubiquitous rhetoric of the Ethernet or the search for the numinous that is the New Age.

Our discussion tracks one version of this story as told by Gursky and a peculiar question of mystification, if hardly of the Aquarian sort. What I have in mind is not just an academic exercise but a practical matter that can be summed up as follows: *how* do you make a world picture? How to represent the workings of the world as being fluid and smooth or fractured and discordant; efficient and close to hand or grossly asymmetrical, stricken by distance and disparity? Gursky's inheritance proves critical in this regard: no discussion on the artist is complete without recourse to his training under Bernd and Hilla Becher at the Düsseldorf Kunstakademie. I recount this history to chart the distance traveled between the once brave new world of work represented by the Bechers—an archive of industry—and that projected by Gursky's escalated imagery, under the aegis of globalization.

The story of these relations is a charged one for the contemporary art world. Norman Bryson refers to Gursky's photographic genealogy through the psychoanalytic optic of the family romance (he calls it a "family firm") and anoints him as heir apparent to an episodically troubled bloodline.[12] Born in 1955, the son (and grandson) of commercial photographers, in 1977 Gursky attended the Folkwangschule in Essen, then considered the premiere school for studying photography, where he trained in the fundamentals under Michael Schmidt. The reputation of the school was in large part due to the presence of Otto Steinart, whose notion of *subjektive Fotografie* was a "humanized and individualized photography," meant "to capture from the individual object a picture compounding to its nature."[13]

By 1980, however, Gursky departed for a radically different camp, going on to study with the Bechers at the Düsseldorf Kunstakademie, especially influential due to the presence of Joseph Beuys. There Gursky began using five-by-seven-inch and

four-by-five-inch view cameras in accordance with the teachings of the Bechers, who would encourage him to search for an appropriate motif along the lines of their own experiments in photographic serialization. This is to say that Gursky's tenure at Düsseldorf unofficially qualified him as a member of the so-called Becher School, the loose-knit group of renowned German photographers, including Thomas Struth, Candida Höfer, and Thomas Ruff, that trained under the couple and began drawing international attention in the 1980s for their large-format photography.[14]

From the late 1950s until Bernd Becher's death in 2007, the Bechers famously undertook a program of tracking and amassing what they called "nomadic architecture" or "sculptural typologies." They trained the gaze of their large-format camera on the scenes of industrial and vernacular architecture throughout Europe and North America, including structures as mundane as blast furnaces, water towers, silos, and lime kilns. Critics note that their apparently seamless aesthetic is made possible by the unstinting orthodoxy of their production methods. Each image is presented frontally in black and white; each structure is photographed around the same time of day—and in the same season—to guarantee a consistent and even quality of light and surface; each photograph—grainless, stolid, clinical—is evacuated of human presence and any suggestion of narrative, projecting the air of the affectless and detached.

Like many of the conceptual artists with whom they were associated, the Bechers' unswerving formal resolution is organized around their serial habits; a peculiar engagement with the interests of photographic deskilling; and what Benjamin Buchloh has deemed that era's "aesthetic of administration," the impulse to order and organize their output in a manner recalling the logic of bureaucracy.[15] When row after row of such buildings are displayed as grids, or when those images appear in the pages of books all identically formatted, the classifying mandate is inescapable. But what renders this typological drive especially *archival*—with its implication of historical distance—is slightly different. In calling the objects of their typologies "sculpture," the Bechers imply something about the precarious status of their content, as if the structures they systematically record sat on the borderline between functionality and outmodedness. "Sculpture" serves as code for an aesthetic drained of use value. The Bechers' twinned notion of "nomadic architecture" confirms the point. Bernd Becher frequently recalled the closure of mines and then blast furnaces in his native region as suggestive of such "nomadic," tendencies, underscoring these buildings'

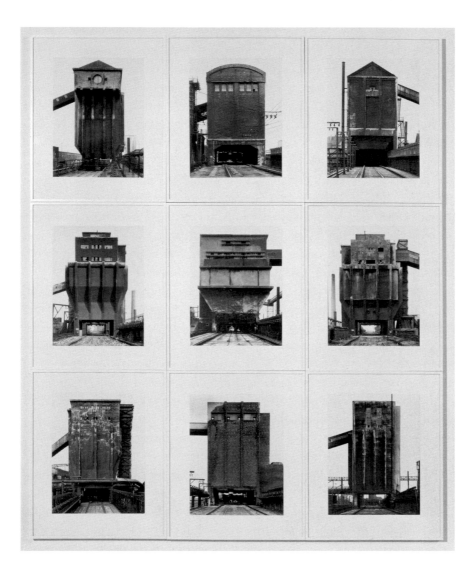

Figure 2.4
Bernd and Hilla Becher, *Coal Bunkers, Germany, England,* 1965–1999. 9 black and white photographs, 68¼ × 56¼ inches. Courtesy Sonnabend Gallery, New York.

"comparatively short life."[16] "Industrial architecture is . . . nomadic even if it is not taken along but left standing until it eventually disappears," he once remarked. "After it has been used for 50 years, parts are sold and parts are demolished."[17]

This interest in outmodedness reaches back to yet an earlier photographic tradition. Around the 1870s, as Allan Sekula, Abigail Solomon-Godeau, and others have argued, photography was recruited to service the burgeoning pseudo-sciences of eugenics and phrenology and the respective interests of power that advanced them.[18] While free of the ideological and racializing taint these historical practices suggest, the Bechers' aesthetic follows on the objectifying imperatives of the 1920s, such as the Neue Sachlichkeit of Albert Renger-Patzsch.[19] But the most consistent point of reference is the work of August Sander, whose typological project *People of the Twentieth Century* documented seven types of German people, including "The Farmer," "The Skilled Tradesman," "The Woman," "Classes and Professions," "The Artists," "The City," and "The Last People" (homeless persons, veterans, etc.). The project was formalized in the 1920s, but the photographs were taken between 1892 and 1954: together they make up a record of those worlds variously entangled with, and succumbing to, the pressures of modernization.[20]

The Bechers' photographs of "anonymous sculpture" exhibit a comparable archival sensibility, if with a notably late-modernist mandate. If Sander recorded peoples whose livelihoods were under industrial threat around the turn of the twentieth century, the Bechers look to the demise of such conditions nearly a hundred years after the fact. They do so not through the presence of human actors but through architecture alone, an observation of critical importance for Gursky's later spatial politics. For the "sculptural" objects represented by the Bechers serve as virtual proxies for those actors, embedding the activity of their absent agents within actual sites of manufacture and production: a blast furnace in the Ruhr, for instance; or disappearing iron mines in Charleroi or a gasometer in Jersey City. Blake Stimson describes the proxy status of these images in terms of the subjects' *comportment*, an anthropomorphizing logic that allies the seemingly blank-faced quality of the Bechers' inanimate imagery with the conventions of nineteenth- and early twentieth-century portrait photography to which the practice refers.[21] To this point, we should add that the "sculptural typologies" exhibit surprising range within each genre of "sculpture" represented: each structure is accorded a singular, place-holding status by virtue of

the caption provided and some site-specific differences (a half-timbered house in the Siegen industrial region, for instance). In other words, no matter how uniform the manner of the Bechers' photographic presentation, these "anonymous" sculptures retain a sense of their geographical sitedness, a condition made possible by the rigor of the Bechers' archival sensibilities.

By the conclusion of this chapter it will be clear that the archive takes on vastly different meanings for Gursky, and not just because he would depart from the literally typological approach of his mentors. The ether will have much to do with this transformation, along with a controversy over what a contemporary archive might contain relative to new media and information. To argue as much requires confronting both the ontological as well as the behavioral status of Gursky's art, the line it straddles materially, historiographically, and affectively between the analogical means producing the photograph and the digital protocols that alter it. The increasingly porous border between the two means of image production will prove coextensive with another fault line of sorts, thematized by the subject matter of his art.

In short: I am speaking of the ways in which the relative stress placed on modes of industrial *and* postindustrial work—the alternations between the factory and the trading floor and all points in between—crystallize around media. If photography is the industrial art form par excellence, what are we to make of the incursions of digital media that have progressively co-opted photography's role in the staging of the world picture? This is not a matter reducible to questions of medium, a technologically determined history that sees the digital as triumphant upon arrival. Gursky's work advances an ethereal allegory about both the meshing of, and the conflict between, these terms. The basic mechanics of his production and its spatial connotations demand scrutiny. They are located somewhere, we might say, between the pixel and the point of light.

The Pixel and the Point of Light

Gursky first began adjusting his images digitally in the early 1990s through the most popular of all raster-based programs, Adobe Photoshop. Initially he restricted its use to superficial incident: cleaning up random blips in the photographic process;

Plate 1
Steve McQueen, *Gravesend*, 2007, detail. 35mm film transferred to high-definition. Courtesy the artist and Marian Goodman Gallery, New York and Paris.

Plate 2
Takashi Murakami, *The Castle of Tin Tin*, 1998. Acrylic on canvas mounted on board, two panels, 118⅛ × 118⅛ inches (300 × 300 cm). © 1998 Takashi Murakami/Kaikai Kiki Co., Ltd. All rights reserved. Courtesy of the artist and Blum & Poe, Los Angeles. Photo: Joshua White.

Plate 3
Andreas Gursky, *Salerno*, 1990. C-print, 170 × 205 × 5 cm (framed). © 2011 Andreas Gursky/VG Bild-Kunst, Bonn/
ARS. Courtesy Sprüth Magers, Berlin & London.

Plate 4
Allan Sekula, "Panorama: Mid-Atlantic, Middle Passage," *Fish Story*, 1995. Voyage 167 of the container ship M/V *Sea-Land Quality* from Elizabeth, New Jersey, to Rotterdam, November 1993. Courtesy the artist.

Plate 5
Thomas Hirschhorn, *Spinoza Monument*, 1999. Courtesy the artist.

Plate 6
Chu Yun, *Constellation No. 3*, 2009. Installation view at "Breaking Forecast: 8 Key Figures of China's New Generation Artists," Ullens Center for Contemporary Art, Beijing, 2009. Courtesy the artist and Vitamin Creative Space, Guangzhou.

Plate 7
Walid Ra'ad/Atlas Group, *Already Been in a Lake of Fire: Notebook Volume 38* (plates 57–58), 2002. Archival inkjet print, 44 × 78¼ in. © Walid Ra'ad. Courtesy Paula Cooper Gallery, New York.

Plate 8
Raqs Media Collective, *There Has Been a Change of Plan*, 2006. Courtesy the artists.

correcting gray scale; fine-tuning depth of field. Soon these occasional enhancements gave way to a more systemic reliance on digital protocols. Objects might be eliminated to achieve a greater sense of symmetry; color could be adjusted to produce a dynamic palette; scenes could be radically altered through elaborate compositing. On this last point, Gursky continues to print his images from celluloid negatives (indeed, the story of the Grieger photo lab in Düsseldorf could occupy the space of a book), but his method of compositing images was wholly and thoroughly digitized. Margaret Sundell writes cannily of this process and the effects it sponsors:

> This effect (most obvious in works like *99 Cent* and *Rhein II*, 1999) is achieved by photographing a scene of deep space, scanning the image into a computer and dividing it into horizontal bands, adjusting objects near the vanishing point so that their resolution matches that of objects in the foreground, and then pasting the whole thing back into its original configuration. The results are twofold: First, atmospheric perspective is eliminated; second, things that originally lay one behind the other now lie next to each other on the same spatial plane.[22]

Distance, to follow Sundell, is metaphorically stamped out in Gursky's process, so that things positioned far away, or behind one another, now seem to exist "on the same spatial plane." A kind of depthless horizontality results from compositing bands of digital information into one seamless whole.

Acknowledging this facet of Gursky's reception, as any account of his process must do, raises a signal if banal point: digital manipulation is par for the course in the range of contemporary photography. It could be reasonably argued, in fact, that photography has shed its secondary status in the art market due to the pervasiveness of digital media. Jeff Wall, Gursky's Düsseldorf peers, and countless others exploit digital manipulation to great narrative and formal effect—and with seemingly less stigma surrounding their hybrid technics than Gursky's. Few of these artists seem as linked to the rubrics of "post-photography," a term which, for better or worse, carries the charge of being something "less than" the photographic, a weak simulacrum of the nineteenth-century medium that plays parasite to its reality effects.[23] But Jorge Ribalta reminds us that claims of the "death of photography" and the rise of the "post-photographic era" present a false dilemma to the media critic. The worry over

photography's demise, he points out, "paradoxically reproduces the ontological essentialism it declares itself against."[24]

For Gursky, the spatializing or globalizing associations of digital photography might well be at the crux of the matter, not a controversy about medium as such. On this count, it is relevant that the image typically thought to have inaugurated the "post-photographic era" was the 1982 cover of *National Geographic* picturing the pyramids of Giza in misty profile, the actual distance between two pyramids magically reduced in order to fit the vertical orientation of the cover.[25] By 1989, 150 years after the invention of photography, the *Wall Street Journal* speculated that close to "ten percent of all color photographs were being digitally retouched or altered."[26] That same year, photography societies began issuing statements about digital manipulation in earnest: the Associated Press seemed ready "to adopt a policy that 'the content of a photograph will never be changed or manipulated in any way.'"[27] In short, what was initially considered a novel device now assumed Orwellian implications, so that the "truth-telling" capacity of the photograph and its putative transparency would henceforth be held in suspicion.[28]

Of course, a host of thoroughly naturalized conventions (hand coloring, cropping, composite printing, montage, etc.) have long constituted photography's illusionistic repertoire, whatever the medium's literal inscription in the real, its physical grounding as what many, following C. S. Peirce, identify as the "index." A few words on photographic indexicality follow shortly, but we need only state the obvious at this juncture: photography's hybrid status came well in advance of the introduction of digital technology. For his part, Gursky treats the deployment of digital technics as uncontroversial, even as he recognizes the epistemic shift it suggests for the medium as such. "Since the photographic medium has been digitalized," he observes, "a fixed definition of the term 'photography' has become impossible."[29]

Rightly, Gursky's most nuanced critics weigh in on the issue not because they sustain any naive faith in the transparency of the photograph as an uninflected document, but because of his works' ambiguous positioning at the crossroads of a history of photography, seemingly at odds with the forms of reportage out of which it stems. Comparing Gursky's practice to the serial and conceptual experiments of a Dan Graham or Ed Ruscha, Alex Alberro lambastes his art on the grounds of its fetish for

technique and its penchant for grandiosity: the exercises in photographic deskilling cultivated by that generation of sixties artists are travestied at Gursky's hands.[30] Norman Bryson writes on Gursky's place within the German tradition that includes the Bechers and their now-famous students. The practice is problematic "not because it is bad for photographers to use computer enhancement," Bryson observes,

> but because Gursky's taste for the photogenic is so hard to square with the firm's original project: the need to present the social through the logic of totality, the commitment to cool, objective analysis and to a historical-materialist perspective. Each of these strategies depends for its authority on photography's truth effects and its unique way of accessing the real through the index. Erode the indexical and you have something else again: a highly contradictory aesthetic, going in one direction toward Frankfurt School analysis of mass culture, and in another plunging headlong into the picturesque.[31]

Bryson regards Gursky's work as a tangle, his imagery conflicted between its contemporary means and its historical origins and ends. The issue, as Bryson plainly puts it, is not merely about using computers, but how the artist's picturesque detailism is crossed with an almost Adornian hauteur, all to deeply unsettling effect. In Bryson's reading, a rhetorical slide occurs between the use of "computer enhancement" and the "photogenic" quality of Gursky's work. What Bryson seizes upon—as does Michael Fried, if to different ends—is how the eroding of the index in Gursky's imagery plays to this peculiar sliding or unsettling. The question of the index seems tantamount to a metaphysics of photography: since the 1970s, increasingly rancorous debate over the term has preoccupied historians of photography.[32] My point is neither to unpack these lengthening arguments nor to testify to the correctness or misrecognition of a Peircean reading on the part of art historians. What concerns me is how the sense of the image's "physical connection" to its spatial coordinates might influence the production (and reading) of a world picture.

In treating Gursky's work as a mode of absorption, for example, Michael Fried underscores the perceptual habits undone by a virtual loosening of something like an index. "The extent of the manipulation varies from work to work," he writes,

but in all cases there is a consequent loosening of the connection between the picture itself and its real-world source or origin, which is to say a loosening, verging in certain pictures on total dissolution, of the "indexicality" that traditionally, and with particular emphasis since the 1970s, has been considered photography's primary identifying trait. . . . The loosening of indexicality is in Gursky's art equivalent to a severing from any originary perceptual experience.[33]

What is being severed here, at least for the immediate purposes of this chapter, is that sense of material grounding that photographic inscription provides, and a perception of things as place-bound by extension. You could call Gursky's a negative phenomenology of a type. Whereas the Bechers never failed to remind their audience of place through their captions and the unstinting geometry of their comparative method, in Gursky, on the other hand, the claims to location on representational grounds are unsettled by the photograph's dislocation from its real-world coordinates. We might well be looking at an image of a hotel lobby in Atlanta, a racetrack in Hong Kong, or a port in Salerno, but the index has been effectively "disembedded" from its site, to borrow Anthony Giddens's term for the transitioning time/space ratios characteristic of globalization.[34]

To repeat: this is not about hard and fast rules of media—the triumph of the binary code over the analogical—but about a mixed ontology and the affective associations that precede each medium and trail in its wake. It is about the controversy that ensues in this mixing, and how it reaches to the politics of contemporary work.

Put another way, there's an ellipsis between the camera and the computer, the pixel and the point of light, that shores up this widening contradiction. The space filling this ellipsis is the ether.

The Ether, Then as Now

It turns out that some version of this dilemma preexisted the invention of digital technology by at least a hundred years, yoked to a widespread convention about space and capital. Before returning to Gursky's work and its ethereal sensibility, let me outline the most general contours of this discussion within political thought and sociology.

The convention around which so many of these narratives pivot reduces to the dualism of the material and the seemingly dematerialized, the industrial and the postindustrial: the obdurate presence of people and things versus the ambient and invisible substance that we have named the ether. Unpacking this narrative allows us to trace the critical dilemma that follows Gursky's practice, that is, over whether his "images serve as a critical allegory of late capitalist anomie or whether they are simply another instance of it."[35]

We could start with the following statement which, in taking on the received wisdom around property, seemingly pits the material world against an ethereal contrivance.

> Nothing seems more natural than to begin with ground rent, with landed property, since this is bound up with the earth, the source of all being, and with the first form of production of all more or less settled societies—agriculture. But nothing would be more erroneous. In all forms of society there is one specific kind of production which predominates over the rest, whose relations thus assign rank and influence to the others. It is a general illumination which bathes all the other colours and modifies their particularity. It is a particular *ether* [my emphasis] which determines the specific gravity of every being which has materialized within it.[36]

In this passage from the *Grundrisse*, Marx puts the lie to one of classical economics's first principles. As a David Ricardo might argue, landed property, the earth and agriculture, are at the bedrock of the market. Land appeals to the gravity-bound, material resources demanded of any society's drive to primitive accumulation: it satisfies further the territorial imperatives that animate a theory of ground rent and the sovereignty of a nation-state contained by physical borders. Marx's rejoinder, as such, might initially read as surprising, even as it anticipates the major problematic of *Capital*. He regards such reasoning as erroneous, a naturalizing of the natural. In language that might seem at some remove from the materialist analysis of production, Marx describes capitalism in terms of a "general illumination" and furnishes the privileged metaphor for speaking to its ubiquitous and insidious workings: the ether.

The reader of Marx knows that such turns of phrase, of seemingly melodramatic cast, are what lend his writing its occasionally fractured and darkly emblematic

power. This is to say that his literary nods to the mystical capture the psychology, superstitiousness, and, more to the point, false consciousness of the subject of capital, whether the irrational nature of commodity fetishism or what he and Engels deemed the "nursery tale" of the "spectre" haunting Europe in the *Communist Manifesto*.[37] For this reason, the ether and its associated metaphors enjoy a peculiar place in Marx's writing. The citation from the *Grundrisse* dramatizes that capital's founding logic is itself ambient, premised on circulation itself, not any material thing of singular and intrinsic value but nonetheless possessing the power to endow such things with a "specific gravity." The "general illumination" that is the ether comes to stand as a principle of general equivalence, whereby value is necessarily relative to a market that requires infinite expansion if it is to proliferate. It is only when such material resources are "illuminated" within this system—"modifying their particularity"—that they are assigned either a privileged or disadvantaged position within capitalism's scaleless scale.

This type of mystification is the beating heart of commodity fetishism. A century and a half after the fact of the *Communist Manifesto* (or, as much to the point, after the birth of photography), such ethereal metaphors prove remarkably durable within the literature of globalization. As Douglas Kellner has noted, Marx and Engel's famous passage in the *Communist Manifesto* strikes a chord with the world market's neoliberal mandate, highlighting the *dematerializing* aspect of capital's processes of abstraction and speaking to *everywhereness* itself as both its precondition and the guarantor of the global market's viability:

> All fixed, fast frozen relations, with their train of ancient and venerable prejudices and opinions, are swept away, all new-formed ones become antiquated before they can ossify. All that is solid melts into air, all that is holy is profaned, and man is at last compelled to face with sober senses his real condition of life and his relations with his kind. . . . The need of a constantly expanding market for its products chases the bourgeoisie over the entire surface of the globe. It must nestle everywhere, settle everywhere, establish connections everywhere.[38]

While capital's demand to "nestle everywhere, settle everywhere" and "establish connections everywhere" is foundational to canonical accounts of imperialism (*the*

highest stage of capitalism, according to Lenin), its success hinges alternately on its groundlessness, seemingly unmoored from both the territorial and material. (Consider, for instance, the free-floating currencies of the early 1970s, progressively delinked from the gold standard.) The invisible movement between the grounded and the groundless is the work performed by the ether.

But if the ether's "general illumination" is imagined to bathe all social relations in an ambient and allover wash, its distribution on the ground is anything but equitable. Depending on the force of its "specific gravity," a radically striated geography follows. David Harvey observes that the classical formulation of uneven development is best understood in spatial terms; for capital accumulation and expansion require territorial dispossession if capital is to stabilize. Dispossession of earthbound resources and land enable capital to "settle everywhere."

> Capitalist activity is always grounded somewhere. . . . Diverse material processes (physical, ecological as well as social) must be appropriated, used, bent and reshaped to the purposes and paths of capitalist accumulation. Conversely, capital accumulation has to adapt to and in some instances be transformed by the material conditions it encounters.[39]

At a moment in which the triumphal cant on globalization might have us believe otherwise, Harvey reminds us of capitalism's territorial requirements, whatever its ethereal conceits.

In bringing such observations up to the more recent present, it's important to note that the ether and its cognate metaphors might accommodate opposing stances on contemporary work, whether the viability of labor in the twenty-first century, the triumph of the postindustrial society that trades in informatics and the service economy, or the very "end of work" foretold by the likes of Jeremy Rifkin.[40] Take the standard narrative on the postindustrial society, in which the qualifier "post" sounds as punctual, abrupt, and final as the "post" in post-photography. (As Ribalta puts it in a comparable formulation, "statements about photography's death, so characteristic of the early and mid-1990s, are the aesthetic equivalent to Francis Fukuyama's 1989 statement about the end of history.")[41] In 1973, the very moment the crisis in Fordism struck with the global recessions, the sociologist Daniel Bell diagnosed the advent

of a professional economy as a profound rupture from the industrial paradigm organized around the axis of production and machinery. In *The Coming of Post-industrial Society*, he insisted that he was speaking of a "transitional" moment[42] and that the proliferation of "posts" in contemporaneous social studies ("postmodern," "postcapitalist," "post-Marxist") was not to be understood in necessarily fatal terms, although the rhetorical effect has been the opposite in its most reactionary formulations. In his chapter "From Goods to Services" the factory worker and the laborer generally are presented as endangered species, their fate ineluctably tied to an embedded paradox of historical materialism. "If one takes the industrial worker as the instrument of the future, or more specifically, the factory worker as the symbol of the proletariat, then this vision is warped," Bell notes. "For the paradoxical fact is that as one goes along the trajectory of industrialization—the increasing replacement of man by machines—one comes logically to the erosion of the industrial worker himself."[43] What came to replace the figure of labor was an emergent professional worker. "A post-industrial society," he notes, "is based on services. Hence, it is a game between persons. What counts is not raw muscle power, or energy, but information."[44]

Not surprisingly this thesis has come under strenuous attack by Marxist critics; for Bell's detractors, the degree of his argument's abstraction betrays as much an ideological shortcoming as a methodological one.[45] While the sociologist was not claiming anything so absurd as the idea that manufacturing would disappear altogether under these new conditions, his account has the effect of *naturalizing* the shift through a spatial turn of sorts, where the postindustrial society he forecasts likewise does away with all that is fixed, fast frozen, and solid. Critically, in both *The Coming of Post-industrial Society* and *The Cultural Contradictions of Capitalism* this shift is characterized in terms of an "eclipse of distance." "While the initial changes are created by the new forms of transportation and communication which bring people into ready contact with each other in innumerable ways," Bell writes, "the 'eclipse of distance' is not only the foreshortening of time and space in flying across continents, or in being in instant communication with any part of the globe by television or radio, it is also, as regards the *experienced* time of the person, an eclipse of social, aesthetic and psychic distance as well."[46]

Bell's position more or less anticipates the "End of History" that Fukuyama heralds in 1989;[47] and indeed the notion of a postindustrial society has the staying power

of a cultural dominant: naturalized as everyday speech; taken as transparent in the world of work; and given ample airtime from figures across the ideological spectrum, whether Vaclav Havel, Bill Clinton, or the Unabomber.[48] Here the metaphor of the ether (or something like it) communicates the liquidity, movement, transparency, and new climates of information. When, for example, the sociologist Zygmunt Bauman writes on our contemporary age in terms of "liquid modernity," he stresses the "remarkable qualities" of fluids (nonsolids and gases), their lightness and capacity for accommodating stress and change.[49]

A century and a half after the *Grundrisse*, then, the ether and its cognates would be rehabilitated as a new kind of imperial metaphor, variously deployed to nuance, lament, lambaste, or even continue the Marxian project, and appealing to the ether's immanent potentiality as *communication*.[50] Fredric Jameson furnishes a prescient description of this turn in his analysis of culture and finance capital: "Globalization is rather a kind of cyberspace in which money capital has reached its ultimate dematerialization," he writes, "as messages that pass instantaneously from one nodal point to another across the former globe, the former material world."[51]

Capital conflated with communication results in a new world of value based on information, unencumbered by the gross materiality of people and things. Just how one weighs in on this issue will complicate any notion of politics as usual. You couldn't find two thinkers as different from Bell as Michael Hardt and Antonio Negri, but listen to their take on the ether as described in *Empire*:

> Ether is the third and fundamental medium of imperial control. The management of communication, the structuring of the education system, and the regulation of culture appear today more than ever as sovereign prerogatives. All of this, however, dissolves in the ether. The contemporary systems of communication are not subordinated to sovereignty; on the contrary, sovereignty seems to be subordinated to communication—or actually, sovereignty is articulated through communications systems. In the field of communication, the paradoxes that bring about the dissolution of territorial and/or national sovereignty are more clear than ever. The deterritorializing capacities of communication are unique: communication is not satisfied by limiting or weakening modern territorial sovereignty; rather it attacks the very possibility of linking an order to a space.[52]

The ether, by this reasoning, is at once the vehicle of Empire and offers the potential instrument of its undoing. Decoupled from any particular order of place, insubordinate to the territorial requirements of the nation-state or sovereign power, the everywhereness of the ether might well provide the means for insurrection from *within*, paradoxically because, in its ubiquity and ambience, it implicitly banishes any such notion of a *without*. This controversial position might forge a politics based on media activism or, alternately, regard the workings and movements of the world as without friction or striation. For to claim that there is no "without"—to suggest, in a manner of speaking, that there is no *outside* to the new global order—amounts to declaring that no distance can be maintained from the machinations of its markets. And while this notion provides a mechanism for the radical tenets of counterempire, it might also converge with the smug triumphalism of the postindustrial society.

Hardt and Negri's reading, founded on a philosophy of immanence, necessarily takes on this debate. The question of "immanent cause" will be considered in detail in the following chapter on Thomas Hirschhorn. For the time being, acknowledging their thinking on the ether might well, pace Marx, "illuminate" a certain aspect of Gursky's aesthetic and its productive mechanism: namely its implicit attitude to material things; its totalizing perspective on space; and its "eclipse of distance" through the techniques of *compression*.

At this point we return to Salerno to understand how such things work on the ground. A detour around Allan Sekula's *Fish Story* proves constructive. This is not to trade "theory" for empiricism, mind you, or the global imaginary with its material instantiation, but to spell out the indivisibility of these very same conditions.

Salerno II: Containers

The economy of Salerno is mainly based on services and tourism, as most of the city's manufacturing base did not survive the economic crisis of the 1970s. The remaining ones are connected to pottery and food production and treatment. . . . The port of Salerno is one of the most active of the Tyrrhenian Sea. It moves some 7 millions of tons of goods a year, 60% of which is made up by containers.[53]

This information about Salerno, courtesy of Wikipedia, would seem to offer ample evidence in support of Bell's thesis. We are told that the city's current economy is based on goods and services, as its manufacturing industries were crippled in the recessions and stagflation of the 1970s. The entry also provides a convenient caption for Gursky's monumental photograph. Here vision is cast imperiously across the picture's crystalline surface, saturated like a postcard; and that alloverness of vision represents the good life pledged by the postindustrial society. Should anyone miss the point, a field of cargo containers telegraphs an unavoidable message. Whether primed for transport across the Tyrrhenian Sea or waiting to be stocked or refurbished, the containers index a world market operative everywhere and elsewhere.

Yet just as it's unrealistic to think we might learn too much about Salerno from this digital brief (the larger Wikipedia entry gives some information on Salerno's strategic position in World War II and tells us something about the region's premodern fortunes), one is equally hard pressed to imagine how Gursky's photograph might transmit literal information about the site.[54] But as I suggested at the beginning of this chapter, Gursky's work is a peculiar document of global times, if not what you'd call a "critical realism."[55] Through the ether, his work internalizes the logic of a world system to the point where its processes are thoroughly and indivisibly naturalized. It is, for this reason, important to speak to those conditions that his work renders invisible.

Earlier I remarked that the scene of Salerno's harbor lacks bustle and noise, free of the presence of longshoremen who move tonnage and product. Given the example set by the Bechers, this nonpresence is significant. The absence of such a workforce appeals to a doubled historical logic, pointing backward to a polemic about labor in southern Italy and forward to the question of its erasure under globalization. When, for instance, Gramsci wrote in *The Southern Question* of the labor relations between northern and southern Italy in 1926, he gave, as Edward Said noted, "paramount focus to the territorial, spatial and geographical foundations of social life."[56] He acknowledged, in short, the ways in which social striation is geographically coordinated, how the interests of the land and the sea, the urban and the rural, amount to an occasionally frictional politics.

Without such figures within Gursky's contemporary image, the movement of the harbor would seem as smooth as the ebb and flow of the tide, an invisible and

ineluctable process relieved of grit, territory, or agency. The picture functions in this light as the logical outcome to earlier pronouncements by Bell, who in the essays collected in *The End of Ideology* could not see the demise of the political viability of the longshoremen come fast enough. In this text of 1962 (that is, a decade before *The Coming of Post-industrial Society*), Bell devotes an entire chapter to what he sees as a particularly corrupt sector of the American workforce, detailing the backroom relations between the International Longshoremen's Association (ILA) and dirty politicians as a "racketeering industry."[57] The reading implicitly and proleptically authorizes his subsequent thesis on the postindustrial society and the emergence of a professional class that advances it.

It's no coincidence that Bell's appraisal is roughly contemporaneous with postwar developments in the shipping industry, all of which turn around the developing technologies of the cargo container and their larger implications for the world of work. Sekula provides the most powerful account of these changes in his photographic and textual essay on maritime capital, *Fish Story*, a work six years and thousands of sea miles in the making: "the third in a cycle of works about the imaginary and material geographies of the advanced capital world."[58] As he writes on the evolution of the cargo container,

> [in the 1950s] management experts in the shipping industry were beginning to dream of a fluid world of wealth without workers. . . . By 1956, experiments with containerized cargo movement had begun in earnest. By the 1970s the very contours of seaports had changed. The intricate pattern of finger piers, resembling intestinal villi, had given way to the smoothed-out rectangularity of container storage yards.[59]

Sekula parses the historical meanings of the maritime imaginary and documents the conditions in which international longshoremen work today, from Gdansk to Ulsam to Rotterdam, San Diego, Hong Kong, Veracruz, and the mid-Atlantic. No surprise that his isn't the worldview suggested by Gursky's: *Fish Story* registers the conditions under which maritime capital is actualized as *spatial*, perspectival and material. Paradoxically, the cargo container serves to index this logic, in spite of its

generic form and the history of its design. The container, we learn, was designed to standardize the movement of goods internationally and to render such workings smooth and efficient through something like a homogeneous platform.

In opposition to such designs, take the photograph that appears on the cover of *Fish Story*. The stern of an American cargo ship, *Sea-Land Quality*, is directed at the horizon. Charting its course across the ocean, it also plots the space of the image, with cargo containers serving as units in a virtual perspectival grid.[60] Against a horizon just out of reach, the image tracks the contingent visuality of those on board as well as the ambient conditions encountered. The sea is the color of lead, and there's some chop and spume on the water, with uneven cloud cover to match. The photograph is entitled "Panorama. Midatlantic," which, if unspecific in naming the ship's precise coordinates, speaks more to the actuality of place than any picture by Gursky. A few pages on in the book, a suite of three images (#32–34), also taken from the same ship mid-Atlantic, document the "conclusion of search for the disabled and drifting sailboat Happy Ending," an American sailboat lost at sea along with its owners.[61] The pictures are even more radical in their perspective than the photograph gracing the cover: sight lines are vertiginous and skewed, crossing the vertical and horizontal axis, and the presence of a human actor endows the image with a sense of scale missing in Gursky's picturesque tableaus. Finally, the accompanying narrative of an American couple lost in the middle Atlantic (the husband's body will be recovered on the *Happy Ending*) reminds us of the mortal prospects of maritime space. The sea is a fatal drink, not the liquid utopia of the ether.

For such reasons, the cargo container becomes a certain place-making emblem for Sekula, a proxy; and it is indeed the case that such containers play a recurring role in the iconography of globalization. Ranging from Gursky's *Salerno* to the *Solid Sea* project of Multiplicity to images by Edward Burtynsky, the container has come to stand as a visual shorthand for the dynamics of transnational markets. But Sekula means not to validate this role so much as to countermand the legend of what he calls a "*fluid* [my emphasis] world of wealth," presumably floating along the mythos of the ether:

> My argument here runs against the commonly held view that the computer and telecommunications are the sole engines of the third industrial revolution. In

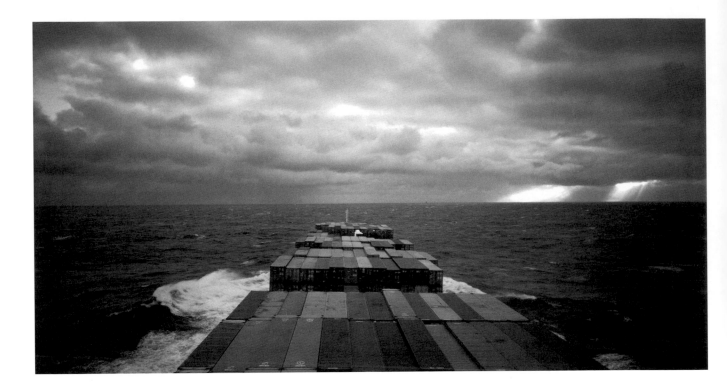

Figure 2.5
Allan Sekula, "Panorama: Mid-Atlantic, Middle Passage," *Fish Story*, 1995. Voyage 167 of the container ship M/V *Sea-Land Quality* from Elizabeth, New Jersey, to Rotterdam, November 1993. Courtesy the artist.

Figure 2.6
Allan Sekula, *Fish Story*, 1995. Conclusion of search for the disabled and drifting sailboat *Happy Ending*. Voyage 167 of the container ship M/V *Sea-Land Quality* from Elizabeth, New Jersey, to Rotterdam, November 1993. Courtesy the artist.

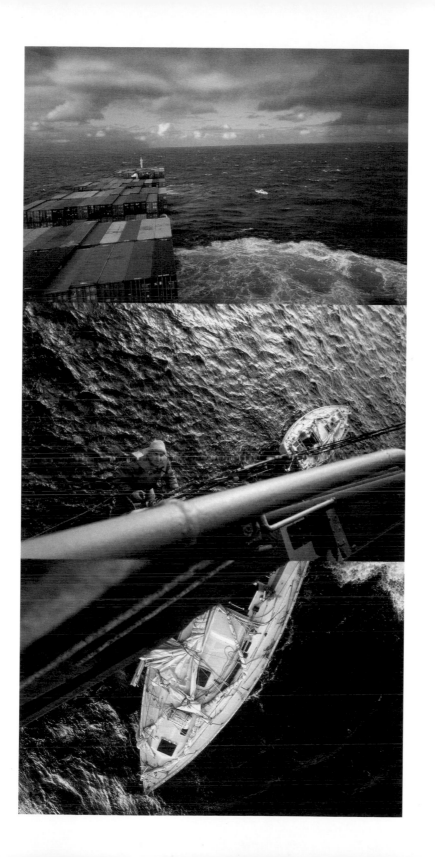

effect, I am arguing for the continued importance of maritime space in order to construct the exaggerated importance attached to the largely metaphysical construct "cyberspace," and the corollary myth of "instantaneous" contact between distant spaces. I am often struck by the ignorance of intellectuals in this respect: the self-congratulating conceptual aggrandizement of "information" frequently is accompanied by peculiar erroneous beliefs: among these is the widely-held quasi-anthropomorphic notion that most of the world's cargo travels, as people do, by air. This is an instance of the blinkered narcissism of the information specialist: a "materialism" that goes no further than the body.[62]

Sekula's project thus looks to the sea *not* to dramatize the compression of space by global markets, but rather to restore the distance eclipsed by the ethereal imagination:

> In the imagination, e-mail and airmail come to bracket the totality of global movement, with the airplane taking care of everything that is heavy. Thus the proliferation of air-courier companies and mail-order catalogues serving the professional, domestic, and leisure needs of the managerial and intellectual classes does nothing to bring consciousness down to earth, or to turn it to the direction of the sea, the forgotten space.[63]

To bring consciousness down to earth and to remember such forgotten spaces in turn: this is the ambition of Sekula's project. In *Fish Story* the heaviness of material relations resists sublimation into the ether. I mean to do the same in closing, reversing the ether's fluid processes and thus illuminating its "specific gravity."

Desublimating the Ether; Containing Information

Desublimating the ether entails a brief review of my argument, paving the way for some final technical and aesthetic considerations. At the start of this chapter, a reading of *Salerno* described how the equalization of focus throughout Gursky's work announced a new kind of allover image, making everything remote proximate and close

to hand. Gursky's practice was then considered in light of its mixed ontology. Somewhere between the analog and the digital, a narrative stretching from the *Grundrisse* to *Empire* was captured by the figure of the ether. Capital circulation is coextensive with the ethereal imperatives of the postindustrial society. Gursky's work stands in mimetic relation to this principle in both its narratives and its making.

This is to say that his means are coextensive with the content of much of his art: a new world of work and its commodities in "global" times. There's an even more fundamental way this functions for Gursky: the *affective* compression of distance in his pictures is tantamount to a literal and technical compression of data.

A striking image of perhaps the global icon par excellence—or rather a collection of such icons—schools us on the matter. A hygienic display of 198 Nike sneakers is presented in a photograph of roughly six by twelve feet. In a composition similar to Gursky's picture of a Prada store, six shelves of the colorful trainers are presented with near-taxonomic precision to showcase the range of product on offer. The organizational logic of the image is writ large, blunt, and plain. Geometry and seriality are its principles; a fluorescent pall its general illumination.

The image does not appear out of nowhere, however. Similar pictures pay formal homage to minimalism: Donald Judd at the shopping mall. But it seems more to the point that this genre of Gursky's imagery is a peculiar misrecognition of the lessons taught by the Bechers. The blankness, evenness of lighting, objectivity, and frontality of this picture amounts to a comparative study in Nike morphology. A different order of "comportment" than that presented by the Bechers' nomadic architecture, the image trumps their archive of industry by giving form to a new kind of market. One feature of this market is that its products are available *everywhere*; hence one needn't travel *anywhere* to document the phenomenon. The NikeTown in Berlin or Shenzhen trades in the same product as its flagship store in Seattle. Certainly NikeTown online compresses the vast geographies that stand in between such locations.

The image is compressed, though, not only because it announces the eclipse of distance mythologized as both the postindustrial society and the new world market; and not only because it collapses an assortment of related things into a single image, an invisible grid in which each shoe is neatly slotted and made the object of an omniscient visuality. Its archival sensibility transcends the notion of a "mere" collection

Figure 2.7
Andreas Gursky, *Untitled V*, 1997. C-print, 182 × 440 cm (framed). © 2011 Andreas Gursky/VG Bild-Kunst, Bonn/ARS. Courtesy Sprüth Magers, Berlin & London.

of things, something so reductive as a group of physical stuff classed under a unifying rubric or typology. Rather, it is compressed because of the data used to construct it; and it is archival, by extension, due to the containing of *information.*

And as with *Salerno*, the image is not completely seamless in spite of its initial appearance. There is, first, the deliberate play of perspectival inconsistencies. Both ends of the lower shelf recede too quickly to square with the frontality of the picture plane; and the reflection of shoes on the floor is wholly and unapologetically implausible. This, one might argue, is Gursky's art, his poetic license. It is unquestionably the case that his more recent work has theatricalized these spatial distortions to monumental and sometimes hallucinatory effect. Yet in attending more closely to the photograph—and to many of Gursky's photographs from the 1990s—one finds occasional eruptions in the ether, mechanical hiccups that belie the images' operative as well as ideological program.

In drawing nearer to the surface of these pictures, we confront the processes lying behind their ethereal sensibility. Here and there among the Nike sneakers, or the mass ornament of the trading floor, one sees small clusters of stuttering pixels. As with so many images we see on the web—jpeg files haphazardly traded, scanned and reproduced *ad infinitum*—these random bits of visual noise disclose the armature organizing the image. They bring close to hand the material substratum of a virtual thing, rubbing up against the image's otherwise invisible surface to expose it as something as constructed as it is concealing. We encounter these accidental mosaics on a daily basis, but in Gursky's photographs their presence, as something uncanny and irrepressible, alerts us precisely to the manufacture of that ambience. We noted that Gursky began using Adobe Photoshop mostly for the purpose of editing his images. In works such as *99 Cent*, the digital medium is generalized throughout due to the compositing of multiple images; scintillating shelves of stuff are as fractured as the bands of information composing them. The places where these protocols assert themselves shed light on the problem of compression relative to digital information, and in turn bear upon the legend of distance—bluntly put, the *alleged* eclipse of distance—made possible by digital technologies.

In the previous chapter on Murakami, the scalelessness of the vector graphic was at the crux of a Superflat worldview, facilitating an economy of scale consistent with the niche-market values of post-Fordism. By contrast, a raster-based program is the

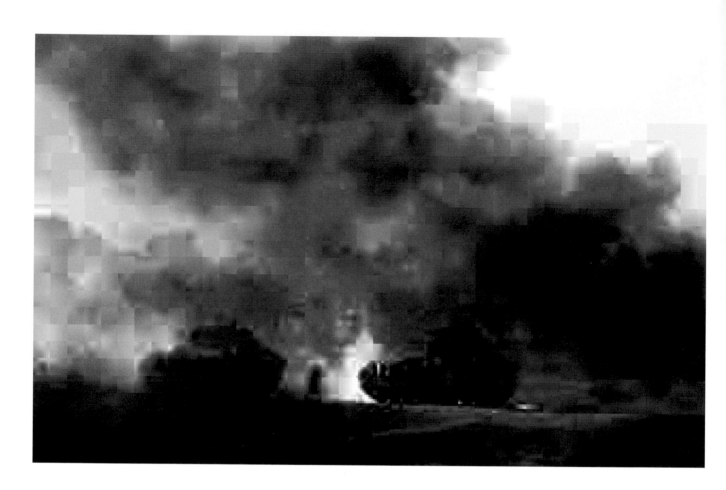

Figure 2.8
Thomas Ruff, *jpeg wio1*, 2004. Chromogenic print with Diasec, 74 × 111 inches (framed). © 2011 Thomas Ruff/VG Bild-Kunst, Bonn/ARS. Courtesy David Zwirner, New York.

ideal choice for Gursky, better suited to capturing the tonal range of the photograph. Here the on-off matrix of the binary code best approximates the gray scale of the photograph. But what these passages of errant pixels reveal is the loss of data that results through certain acts of digital compression. Any novice of computer graphics will tell you that this is the result of lossy compression known as an "artifact," a data error that results when an algorithm discards information too unwieldy to be processed.[64]

The loss of information as betrayed by these artifacts is by no means irrelevant to our discussion. We are reminded that not all data can be compressed or contained, neither put in the cold storage of a library nor in an abandoned mine shaft parading as a subterranean archive. And we are reminded, as well, of the materiality of such data—of the forms in which information travels, to be sure, but also how it can be degraded and destroyed, marking a break in the flow of communication demonized as entropy. Artifacts denaturalize the transparency of the postindustrial image by breaching the ether, a point made intentionally (and critically) by Gursky's Düsseldorf colleague Thomas Ruff.

In his jpeg series beginning in 2001, Ruff will make a virtue of these compression accidents by sourcing the web and blowing them up to portrait scale. Note that his subject matter is for the most part restricted to places, spaces, sites of cataclysm and the blankness of nature. Ruff gives us monuments of global capital—the Pearl Tower in Pudong or skyscrapers in Dubai, for instance—as he reveals scenes of devastation (an atom bomb, a ruined building in Iraq). But he also gives us forests and glaciers of an uncanny digital comportment, unruly nature organized and trained to the protocols of the grid. Made in the wake of the September 11 attacks on the twin towers, the jpeg series is, as Bennett Simpson describes it, "an allegory of dispersion."[65]

Applied to Gursky, I take this phrase to mean that the dispersion of information is virtually synonymous with the dispersion and mediation of site. These twinned conditions are premised on the mystifications of the ether. But the presence of digital artifacts in Gursky's work derealizes the content of his imagery as so much self-evident and unalienable product. Rather, the pixel—a seemingly hermetic and invisible container of sorts—disgorges its precious cargo as so much irrational, material excess. The general illumination that is the ether cannot but contain its worldly fallout.

3
Perpetual Revolution:

Thomas Hirschhorn's Sense of the World

"I want my art to appropriate the world."[1] What could Thomas Hirschhorn, a Swiss artist whose sprawling sculptural displays have garnered considerable attention over the last two decades, mean by this particular desire for the world, its appropriation as art? What is his particular sense of this world: the raft of globalizing associations his words seem to evoke? You would not be wrong to wonder how his art squares with our earlier preoccupations. No vector graphics or raster grids here. No dalliances with the post-Fordist or the ethereal. No two-channel video installations or monumental C-prints that are the global art world's stock in trade.

What we are struck by, instead, are manic accumulations of degraded media: cardboard, aluminum foil, printed matter, packing tape, junk. We are struck equally by the violent collisions his works sets into motion. Pop culture squares off with the revolutionaries. The architecture of commodities and communications media—display cases and kiosks—bleeds into the spaces of the sacrosanct: altars and monuments. Images of suicide bombers are collaged with fashion spreads, devastated flesh tangled with airbrushed bodies. Or witness the fallen heroes of modernism take on the brassy sheen of mass culture celebrity. It all seems a vast, unprincipled blur, an endless plateau of junked references and failed communications, perverse affinities between the most heterogeneous cultural actors. Here the world is too much with us and we are implicated in the mess.

It's on account of this "mess" that I want to make a claim for Hirschhorn's work stemming from its generative mode of production. My argument is that his work is mobilized around a world whose causal and temporal logics are immanent and perpetual, materializing, to borrow from Gilles Deleuze, "relations of speed and slowness, of the capacities for affecting and being affected," coterminous with the world-making processes of globalization.[2] What this gloss signals is an argument about mediation, materialism, overproduction, and consumption: a primer on how to work *with* and *under* such conditions as our worldly horizon. In the last two chapters, we considered art by Murakami and Gursky in a completely different register from what will interest us here, but not, it bears saying, in a different sphere of work. We charted how Superflat both internalized and projected a just-in-time worldview, playing to that world's profligate economies of scale; and we tracked how Gursky's complex recruitment of photographic and digital media made for an uncanny ethereal ambience, consistent with narratives on the "eclipse of distance" that licensed the coming

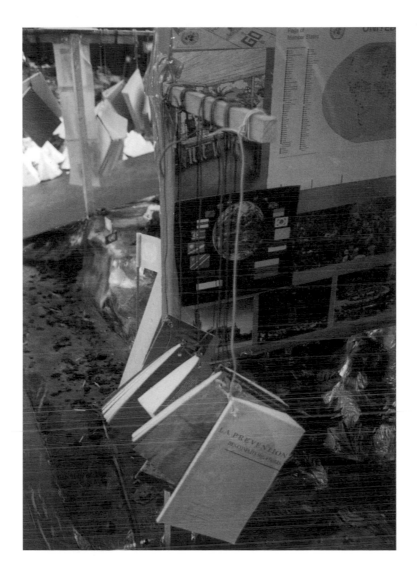

Figure 3.1
Thomas Hirschhorn, *United Nations Miniature*, 2000. Courtesy Museo de Arte Contemporáneo de Castilla y Léon, Léon.

postindustrial society. In both instances, a question of immanence was flagged as undergirding the various controversies shored up by their respective spatial politics. Hirschhorn's work, on the other hand, positions such interests front and center, if by means that paradoxically eschew the notion that such interests can assume stable or monolithic form.

To move us in this direction, two quotations, by rather different thinkers, frame the horizon of worldliness that informs Hirschhorn's project:

If I were one of the celestial bodies, I would look with complete detachment upon this miserable ball of dust and dirt. . . . I would shine upon the good and the evil alike. . . . But I am a man. World history which to you, dispassionate gobbler of science, to you, book-keeper of eternity, seems only a negligible moment in the balance of time, is to me everything. As long as I breathe, I shall fight for the future.
—Trotsky, "On Optimism and Pessimism"[3]

Whatever the mind understands under a form of eternity it does not understand from the fact that it conceives the present actual existence of the body, but from the fact that it conceives the essence of the body under a form of eternity.
—Spinoza, *Ethics*[4]

Maybe it seems too strange, too dissonant, to introduce Hirschhorn's work with these citations: the first by the principal theorist of permanent revolution; the second by the author of the *Ethics*, written in the golden age of Dutch capitalism. But who is the odd man out here? An exiled Russian revolutionary; an excommunicated Jewish philosopher; a Swiss artist living in France? Is this the company of fellow travelers? Perhaps separated by too much time and space, this triangulation of figures seems a tenuous constellation of indefinite futures. Their collective profile seems to beg the question of the more contemporary phenomena under discussion—of the relevance of such voices to more recent, that is, globalizing, ends.

The ambition of the following is not to assimilate one position into another in some monstrous dialectic, but to see such figures, following Spinoza's formulation "non opposita sed diversa," as not opposed but different—in the service of thinking the ground-level movements of globalization.[5] In the alternation from politics to phi-

losophy and back again one grasps not only Hirschhorn's trajectory as an artist but his project of forging connections in light of a new global order. To call this a "perpetual revolution" undoubtedly invokes Trotsky's injunction to "permanent revolution," and the pun is intentional. As prompted by new readings of Spinoza after 1968, Hirschhorn's work suggests a continuous binding and unbinding of relations that appropriate the world in which his work circulates, where the blockages and flows and recalcitrance of information play handmaiden to the relentless cycling of commodity production—and, so it turns out, vice versa.

For this reason I stress the temporality of Hirschhorn's production and its unruly processing of material. The character of this movement—its causality—animates a connection to the mechanisms of globalization in excess of the interests of its iconography. Following the connective interests of this practice, this chapter also touches on the work of a younger generation—the German artist Josephine Meckseper, the Chinese media artists Liu Wei and Chu Yun—as more attenuated responses to questions of overproduction. For if globalization would make worldly consumers of us all, consigning us to an abject form of agency I discuss in the following chapter as "consumer sovereignty," production never lags far behind. Production, to the point, precedes it; and Hirschhorn is a most canny observer of such dynamics. In line with the last two chapters, our way into this debate is through the art's *work*: what it does and how it does it.

Some background notes on Hirschhorn move us in the direction, mostly having to do with the interests of graphic design, as well as the strangely circuitous route he will take in coming to his practice as an artist. As both philosophers and critics have recognized, it is his work on Spinoza that will ultimately provide the occasion, if by no means the endpoint, for such reflections.

Hirschhorn with His Critics

Let me begin with three general observations on the work Hirschhorn's art performs, pulled from the now copious literature on the artist:

1. Hirschhorn works all over the place—in red light districts, in housing complexes, in blue chip galleries and fast-food restaurants, anarchist bookstores, bars,

town centers, the back of a truck, lobbies of universities, and museums. He works, in other words, in a startling range of sites. Some of the places he works are rarefied, others abject. A square in the resolutely bourgeois city of Münster, for example, becomes the site for a mock window display: peering through its windows, we see peace signs fashioned from crumpled foil, or alternately, the glittering fetish of a Mercedes Benz logo. Or take the minimalist cool of a museum bookstore, as slick as the objects it trades. For an exhibition staged at the Guggenheim Museum SoHo entitled "Premises," Hirschhorn produced a makeshift structure called *VDP—Very Derivated Products* inside and outside the museum shop: this was, as he described it "a souvenir shop for culture."[6] Contrast this, finally, with a sidewalk outside a sex shop in Amsterdam, where the trade in a different kind of object relation prevails. Here a monument to Spinoza is situated "somewhere on the side" of the street, a place where "garbage is placed in the morning, before pick-up."[7]

2. He works with an equally profligate range of materials, accumulations that bear some mimetic relationship to things out there in the world (an airport, a sculptural monument, a watch, a kiosk, a tree) but whose representational force is held in check by the sheer excess of the matter itself. Cardboard and more cardboard; packing tape and yards of aluminum foil twisted into gargantuan tears; plastic sheeting; the cheap grain of the handheld video tape; mannequins; ads ripped from magazines and editorialized—or rather defaced—with red ink, marks crawling like viruses; reams of printed matter; banners and T-shirts. All junk, in other words, but junk of a decided art historical legacy. On the one hand, the accumulation of this found material, first as flat surfaces displayed on walls, tables, and floors, and then increasingly spatialized to assume sculptural form, finds precedent in avant-garde collage, montage, and graphic design.[8] The Schwitters of the Merzbau, for instance, provides an important model, as do the Russians. Figures of the postwar moment—a Beuys or Warhol—grant further insight into the proceedings as well, a strange hybrid of social sculpture crossed with Warholian blankness.[9]

Alongside such degraded media, there's an immoderate recourse to language as well. Stacks of books with daunting titles—philosophy and critical theory mostly—clash with scraps of paper bearing a casually scripted hand. The weightiness of critical reflection—Bataille, Gramsci, Nietzsche, Deleuze, tracts on globalization—is tempered by the poignancy, even bathos of the fan's note. "Thank you," many of these

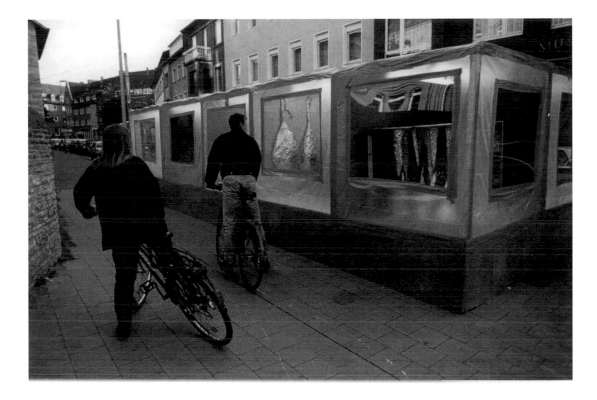

Figure 3.2
Thomas Hirschhorn, *Skulptur-Sortier-Station*, 1997. Courtesy Musée National d'Art Moderne, Centre Pompidou, Paris.

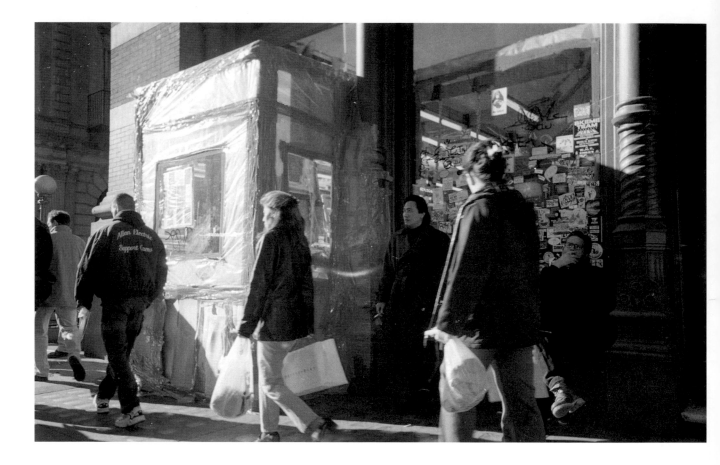

Figure 3.3
Thomas Hirschhorn, *VDP—Very Derivated Products*, 1998. Courtesy the artist.

Figure 3.4
Thomas Hirschhorn, *Spinoza Monument*, 1999. Courtesy the artist.

read, "merci." Or maybe even "Aidez-moi, svp"—a resonant expression for both its desperation and politesse. In three groups of works, variously designated as altars, kiosks, and monuments, that language will be deployed to express the fan's love for various historical figures. The artist Otto Freundlich, murdered by the Nazis, receives a tribute worthy of Princess Diana. Candles, flowers, stuffed animals vie for space alongside crudely scripted messages on cardboard composed on tape in blocked letters. Directing, bleating, hawking, these signs register multiple languages, cacophony, prolix noise.

3. And finally, as if to square the omnipresence of his projects—their worldliness—with the proliferation of his recycled media, critics have turned to the thematics of globalization to describe his art. The touchstones of Coca-Cola and passports are summoned to explain his practice, which, as one writer put it, "critiques modern globalism and the consumerist excesses that accompany it."[10] By this reasoning, a work such as *World Airport* produced for the Venice Biennale (1999) makes literal this global complaint. Like the cargo container, the airport is a figure of geopolitical movement—or displacement. Hirschhorn's presentation of 24 model airplanes on a foil-covered runway, like Gursky's representation of such global commodities as Nike sneakers, might appear to be stamped with this worldly imprimatur.

Site, junk, the global: these are fundamental categories in the reception of Hirschhorn's art, unavoidable in contending with the masses of stuff that threatens to overwhelm. But the inventory does not add up to anything like a practice or method— a means to account for the welter of his egregiously disparate productions—so much as the kind of pluralist sensibility we have tried to avoid in this book. But for all of Hirschhorn's places, materials, and cultural references, I want to argue that his is neither a poetics of trash nor an address to site nor a rant about globalization. Nothing so fixed as any of these relationships, which imply a stable (or static) communication between sender and receiver or a seamless convergence between code and message, image and text, site and its history. To speak of the formal qualities of these objects sounds strange as well but, it turns out, is centrally important. Form is formative. The work seems calculated to spin vision into relentless perpetuity, the eye scanning and reading and barely assimilating all that's on offer; and this notion is instructive for the questions of transparency the work raises. For Hirschhorn's work is no more site-specific than it is *about* philosophy; it is no more installation than it is *about*

Figure 3.5
Thomas Hirschhorn, *Otto Freundlich-Altar*, 1998. Courtesy the artist.

Figure 3.6
Thomas Hirschhorn, *World Airport*, 1999. Courtesy the artist.

globalization. What such readings do is hypostatize representation or theme, even medium, at the expense of the work's activity or process: they are content to rest with the discrete image of each sculptural display as an inert, lumpen totality. The ephemeral character of his materials should suggest something otherwise, an art in which transience and motility are not "mere" properties of his media—we would want to resist essentializing or romanticizing such media—but flag the interests of processing in its larger organization.

Something of this movement will become clear in tracing the artist's formation. While Hirschhorn's time in the Swiss army has been discussed elsewhere, here a brief on his work in design is telling.[11] These episodes will dramatize an object lesson on the timeliness of his media and the future stakes for the artist's appropriation of the world.

Marx with Design

We might start with Hirschhorn's decision to become a graphic designer in the early 1980s, not an insignificant detail for recent discussions of global culture. The processes and implications of contemporary design have already been alluded to in these pages, whether directed to the project of nation branding or to the niche-driven ethos of lifestyle "cultures" sponsored by post-Fordism.[12] Murakami's example makes such implications all too plain. For the Japanese artist, the political economy of the graphic sign—its economy of scale—is premised on its infinite flexibility.

Such would seem the point of Hal Foster's *Design and Crime*, a book whose vehemence is broadcast by its title. Foster assails the emergence of "the world of total design," as "only achieved in our pan-capitalist present." While noting modernist precedents in the world-making claims to integrate art and life in both Art Nouveau and the Bauhaus, he finds that the reign of contemporary design

> ranges across very different enterprises (from Martha Stewart to Microsoft) and it penetrates various social groups. . . . For today you don't have to be filthy rich to be projected not only as designer but designed—whether the product in question is your home or your business, your sagging face (designer surgery) or your lagging personality (designer drugs), your historical memory (designer museums) or your DNA future (designer children).[13]

The pervasiveness of this phenomenon is symptom and cause of its worldly market. "Just when you thought the consumerist loop could get no tighter in its narcissistic logic, it did," Foster writes. "Design abets a near-perfect circuit of production and consumption, without much 'running room' for anything else."[14]

The diminishing space of this "running room"—the struggle to gain any distance from design's imperial mandate—finds a peculiar confirmation in Hirschhorn's work; indeed, it's allegorized in his own education. A couple of decades prior to Foster's discussion, Hirschhorn would maintain some faith in design's radical potential. The means to communicate the ideas he saw expressed in worker's protests and demonstrations found its utopian promise in the flat "displays" of graphic design. He attended the Schule für Gestaltung in Zurich for this very reason, its pedagogy approximating the doctrines of both the Basel School of Design and the Ulm School in Germany. In the postwar history of graphic design, both Basel and Ulm come closest to filling the role of the Bauhaus. Basel was the epicenter for reasoned, measured design: "type and stripe," strong perpendiculars, gridded surfaces, sans-serif typography, all telegraphing the legible and transparent, punctual as the face of the clock.

After graduating in 1984, Hirschhorn briefly worked at the atelier Grapus in Paris, the design collective whose political affiliations he found sympathetic. Grapus was founded in 1970 by Pierre Bernard, Gérard Paris-Clavel, and François Miehe (Bernard had spent time in Warsaw, where he trained in the modernist design proposed by Henryk Tomaszewski) and eventually disbanded in 1991. The lineage is meaningful for our contemporary explorations as its three founding members came together in May of 1968 at the École Nationale Supérieure des Arts Décoratifs, where Miehe was a student leader. Aligned with the Parti Communiste Français, they were among the most active forces in the Atelier Populaire, the graphic collective responsible for designing the broadsides plastered throughout Paris during those heady spring days.[15]

Though it is tempting to read Hirschhorn's Grapus affiliation as formative, it is, perhaps, by means only of a *negative* identification. The association shouldn't be pressed too much on biographical grounds because, whatever lessons he absorbed there, his tenure with the studio was short-lived: the artist reports that he quit after a half-day of work.[16] Although Hirschhorn was not naïve about the collective's organization, he recalls that he was impatient with its hierarchies and dissatisfied with the way in which politics was being sold as a bill of goods. Designing for Grapus—

and by extension the PCF—was no better, as he put it, than designing advertisements for "yogurt."[17]

Audacious though the remark is—putting the interests of the Communist Party on the same rhetorical footing as yogurt, both neutralized through the ideological transparency of the graphic sign—it has the virtue of illustrating a central problem for any artist laboring under the long shadow not only of 1968 but by now of 1989: that is, the ways in which this kind of medium, the carrier of radically different types of information, can be mobilized to temporally specific purposes as the usual bait and switch of co-optation sets in. If once rooted in the interests of the PCF, the design house later turned its instruments to completely different ends, effectively swapping out content while preserving the means that distribute such wildly disparate materials. This is, in other words, the implacably grim reality of a "world of total design," in which, to repeat Foster's words, "design abets a near-perfect circuit of production and consumption, without much 'running room' for anything else." Hirschhorn will put it more bluntly: "You can't outsmart capital," he notes. "Capital always wins."[18]

As both a political and aesthetic position, these words can't help sounding defeatist, announcing the failure of revolutions supported by members of Grapus circa 1968. But they also seem par for the course in the perpetual revolution of Marxist thought from that period forward—both its abandonment, renovation, critique, and mutation, and the ever-proliferating efforts to read politics against the grain. Perhaps the realpolitik of Hirschhorn's statement follows from that acknowledgment. The circuitous logic of the typographic sign will open onto other recursive possibilities.

Indeed, the words found on yet another graphic "display," plastered over every available surface in my old neighborhood in San Francisco, highlights a more specific facet of this problem. In this context at least, they register the seemingly counterintuitive path Hirschhorn's work will take: "The philosophers have only interpreted the world, in various ways; the point is to change it." Here another communication, even more fundamental than Trotsky's, puts a different spin on this problem. Marx's eleventh aphorism in the *Theses on Feuerbach* was an opening salvo to the hard work of historical materialism: a call to one-up the abstractions of the dialectic, to sublate Hegel himself. For Hirschhorn's purposes, the appearance of this message, delivered through means recalling the lessons of his design background, is especially charged. When he complained that designing for Grapus and its PCF interests was no better

than advertising "yogurt," he was impugning the instrumentality of so much graphic design. Because, whatever their presumed ideological differences, the modernist prerogatives of a Zurich, on the one hand, and a Grapus, on the other, nevertheless converged in their faith in the legibility, transparency, and stability of that medium.

The flyer broadcasting Marx's words implicitly participates in this conflicted scenario. "We have a world to win," it entreats its passersby. In wholly internalizing the traditions of the Bauhaus, the Soviets, and the Swiss, it also inherits, by proxy, the endlessly substitutable uses to which those traditions were put. As Hirschhorn's parting words about Grapus suggest, the only perpetual thing in this mode of communication was the substitutability of the graphic sign. The free play of the signifier could just as easily peddle free markets as it could socialism.

On the other hand, the actual message on the poster raises a certain suspicion about Hirschhorn's work: that it will move in the opposite direction from what the aphorism exhorts. From the time he left Grapus, Hirschhorn's art would progressively engage philosophy to the exclusion of politics as such. He would collaborate frequently with philosophers and poets, among them Marcus Steinweg, Sebastian Egenhofer, and Manuel Joseph, whose integrated texts and lectures have found their way into numerous works by the artist.[19] And beyond these extensive engagements, Hirschhorn's four-part series called the *Monuments* pays tribute to several thinkers, most of whom fall squarely on the side of the speculative tradition. A neighborhood in Avignon, populated mostly by North African immigrants, became a site to commemorate Gilles Deleuze. For the *Bataille Monument*, made on the occasion of Documenta 11, an old Mercedes taxicab whisked visitors away from the official site of the exhibition to a Turkish neighborhood in Kassel; in the courtyard of an apartment complex, one could make use of an exhibition space, a library, a TV studio, and an imbiss.

That these monuments make use of the inhabitants of working-class, immigrant neighborhoods seems to position them as community-oriented arts initiatives, site-specific in nature. For this very reason they have come under some criticism as a form of art world "slumming," as though the individuals integral to the day-to-day operations of each project were made the object of a kind of ethnographic scrutiny. Hirschhorn appears to sidestep the matter altogether by renouncing the works' claims to politics, along with his frequent protests that he is not a "social worker." But

Figure 3.7
Flyer, International Socialist Organization, San Francisco, 2003.

Figure 3.8
Thomas Hirschhorn, *Deleuze Monument*, 2000. Courtesy DRAC Provence-Alpes-Côte d'Azur, Aix-en-Provence.

Figure 3.9
Thomas Hirschhorn, *Bataille Monument*, 2002. Photo: Werner Maschmann. Courtesy Gladstone Gallery, New York.

if such works aren't political, he will also repeatedly state that he works "politically," the adverbial qualifier drawing a virtual line between what the work ostensibly represents and what it practically does.[20] The figure who allows us to move toward that model—the thinker who will emblematize Hirschhorn's sense of the world—was, in fact, the first subject to be commemorated in his monument series: the Portuguese-Jewish-Dutch philosopher Baruch Spinoza.

Spinoza with Empire

So why Spinoza? By what feint might this "savage anomaly," as Antonio Negri has called him, tell us something about Hirschhorn's practice? Sebastian Egenhofer and Marcus Steinweg have addressed Spinoza in the "integrated texts" accompanying Hirschhorn's work. Egenhofer has written a philosophically exacting account of the altar in which "the precarious materiality" of Hirschhorn's work is explored relative to its "lateral" extension (its phenomenal image or form) and the "vertical" or genetic dimension that is its production. His larger interest is in positioning Hirschhorn's sculpture in relation to "post-abstract art since the 1960s" and in the process demonstrating, in a Spinozan turn of phrase, how the altar is "a material locus for the production of a truth."[21] What Egenhofer rightly insists upon in his essay—and I follow his lead here—is that Hirschhorn's "Spinozism," such as it is, is *not* about influence or reading as such. "There is no Spinozan influence on Hirschhorn's work," he writes, "no effect of reading. . . . All of Hirschhorn's works have as much and as little to do with Spinoza as the 1999 Spinoza Monument."[22]

All the same, Spinoza cycles through Hirschhorn's practice both allusively (that is, by means of concrete reference) and, of greater importance here, immanently. With the first iteration of the *Spinoza Monument* (1999; figure 3.4) the artist takes an awkward, rather pathetic sculpture of the philosopher and sets it in the relentlessly louche St. Annenstraat neighborhood in Amsterdam. About three meters high and five meters in length, the monument was made for the group exhibition "Midnight Walkers and City Sleepers," in which artists were asked to produced works in the notorious red light district. Standing along a canal near a sex shop, it represents the philosopher holding a book and standing on something like a rock, emerging from water.

At the base of the sculpture was one of Hirschhorn's "integrated videos," some books by and about Spinoza, and photocopied excerpts from Spinoza's *Ethics*. Two banners, green for "reason," red for "desire," waved over the scene; flowers were strewn at the philosopher's feet; foil-covered letters crudely broadcast his name. The monument was illuminated by neon tubing, the energy of which was supplied by the adjacent sex shop. Over the course of its short life—it was up for about two weeks—the work would be subjected to various public "interventions." Vandalism, in short. Someone saw fit to outfit the philosopher in a baseball cap; an artlessly placed scrap of porn found its way onto his open book; and a condom was stretched over the quill pen clutched in the philosopher's hand.

In 2009, ten years after the first iteration of the *Spinoza Monument*, Hirschhorn would revisit the philosopher in Bijlmer, a neighborhood in the southeast of Amsterdam about forty-five minutes by train from the city's famous historical center. Called a "festival" rather than a monument, this project was not linked to any biennial or art fair nor to the usual stomping grounds of Amsterdam tourism. Far from the gentle charms of canals and row houses—or even the salacious pleasures of the red light district—Bijlmer is set around a complex of modernist apartment blocks. The neighborhood has a conflicted reputation, stemming both from its Surinamese demographic (many citizens of Holland's former colony settled in Bijlmer after the bloody coup of 1980) and as the site of the crash of an El Al jet, a disaster that has been the subject of heated conspiracy theory.[23]

This more recent Spinoza work featured stagelike architecture consisting of a library, an Internet room, a documentation center on Bijlmer (with information and videos about the crash), and a lecture platform. A makeshift bar stood nearby. Not far off was a football field and a race track, the flats in plain sight. To the left, a stack of monumental books towered over the proceedings: the *Ethics* took on the stature of a billboard, its gargantuan profile plainly visible as one trained in from the center of Amsterdam. And an empty husk of a car was blanketed in pins, curios, and rafts of junk, the frenzied accumulations of a devoted follower.

We'll return to the site of the *Bijlmer Spinoza Festival* near the end of this chapter. What needs to be stressed here is how the abbreviated shelf life of both Spinoza works might appear an uncomfortable flouting of the Marxian imperative, Hirschhorn having taken leave of a communist design house to make work about dead philosophers. With

Figure 3.10
Thomas Hirshchorn, *Bijlmer Spinoza Festival*, 2009. Lecture/seminar by Antonio Negri. Amsterdam, 2009. Photo: Vittoria Martini. Courtesy the artist.

Spinoza, however, one begins to grasp the artist's speculative gambit. Hirschhorn might appear to have fled the streets for the ivory tower—a sentiment commonly expressed in the charge that his art is didactic and intellectually overburdened, the province of academics and art world insiders—but the generative sensibility underwriting his work, its peculiar causal and temporal model, is one that, to follow the philosoper, will "come from below."

A brief on the philosopher of immanence allows us to follow such connections. Excommunicated as a heretic from his Jewish community in 1656, Spinoza is best known as the author of the *Ethics*, a book which through its carefully measured, five-part Euclidean system proposed a rigorous, quasi-scientific method for the achievement of happiness and freedom. From its beginnings, opinion has divided dramatically over the book's complexities, both its mode of exposition and its political motivations. To survey Spinoza's dense and varied reception is to confront a figure variously described as both an atheist and a "God-drunk Romantic," the theorist of the multitude or the chosen philosopher of Henry Kissinger.[24]

By the 1960s, the recuperation of Spinoza's *radical* enlightenment was in full swing.[25] With the appearance of *Reading Capital* in 1968, Louis Althusser and Étienne Balibar laid claim to Spinoza's materialism, in which the philosopher came to occupy a place in the interpretation of Marx formerly held by Hegel. Here, Spinoza's systematic theory of knowledge was thought to augur a scientific theory of ideology. Spinoza outlined two models of human knowledge corresponding to two registers of temporality. The first, the *ingenium*, was arrived at through experience, the senses, the base world of everyday reality and its appearances. Because conditioned by an immediate and reactive response to the world—*under the aspect of temporality*, as Spinoza would describe it—this was understood as an inadequate mode of cognition. The second model treated knowledge as "established or produced in thought through a form of immanent and structural critique."[26] In contrast to the *ingenium*, this was knowledge generated *under the aspect of eternity*. For Althusser and Balibar, the reading of knowledge organized into these two divisions provided a template to think the difference between ideology and materialism. "The first man ever to have posed the problem of reading, and in consequence, of writing, was Spinoza," they wrote.

And he was also the first man in the world to have proposed both a theory of history and a philosophy of the opacity of the immediate. With him, for the first time ever, a man linked together in this way the essence of reading and the essence of history in a theory of the difference between the imaginary and the true.[27]

As Christopher Norris argues, Spinoza rejected "all versions of naïve or 'metaphysical' realism" and thus insisted "that truth was entirely and exclusively a work of theoretical production, i.e. that the only criteria for truth were those arrived at through an immanent critique or a structural analysis of the concepts in question."[28] Althusser's criticism of orthodox dialectics, plotted along strictly teleological lines, would perhaps find its most Spinozan inflection in his reading of an "aleatory materialism," a radically contingent materialism elaborated in his posthumously published *Philosophy of the Encounter*.[29]

But of even greater importance in this context are writings by Deleuze and Negri, whose respective analyses shed light on Hirschhorn's causal turn relative to globalization. Spinoza lays down his thinking on causality as the first definition of the *Ethics*. "By that which is self-cause," he writes, "I mean that whose essence involves existence; or that whose nature can be conceived only as existing."[30] Spinoza's notion of *causa sui*—cause of itself, immanent cause—is indivisible from what he calls God, a radically nontheistic conception of the Divine. God, rather, is nature, broadly understood, that is to say, *substance*: "that which is in itself and is conceived through itself."[31] It is "the substance consisting of infinite attributes, each of which expresses eternal and infinite essence."[32]

Deleuze, among many others, seized on the striking monism of immanent cause:

And only God is a cause; there is only one sense and one modality for all the figures of causality, although these figures are themselves infinite. Understood in its one sense and its single modality, the cause is essentially immanent; that is, it remains in itself in order to produce (against the transitive cause), just as the effect remains in itself (as against the emanative cause).[33]

To declare that God is the immanent cause of the world is to reject what Warren Montag has called "not only every dualism of spirit and matter, but also the dualisms of

unity and diversity, of the temporal and eternal."[34] Immanent causality implies that existence is self-production; being is becoming. A Spinozan theory of time, as such, collapses the immanent with that which is "to come," conceived, to borrow the philosopher's formulation, "under the aspect of eternity."[35]

The practical consequences stemming from this causal model inform a reading of individual bodies and the types of social interaction produced in their encounter. Spinoza's reading of substance is effectively a rejection of free will and its attendant metaphysics of subjectivity. Beings are rather conceived as "singularities," a function of affect rather than identity. Deleuze describes Spinoza's "ethology" relative to the lines of force, movement, and energy between such singularities and their velocities:

> A body affects other bodies, or is affected by other bodies; it is this capacity for affecting and being affected that also defines a body in its individuality. You will define an animal, or a human being, not by its form, its organs, and its functions, and not as a subject either; you will define it by the affects of which it is capable. Affective capacity, with a maximum threshold and a minimum threshold, is a constant notion in Spinoza.[36]

The collective knowledge and productivity erupting from these singularities has been described as a form of constituent thought—and constituent power.[37] In the intractability of these relationships—intractable because each an attribute of substance—Deleuze detects in Spinoza a "laying out of a common plane of immanence on which all bodies, all minds, and all individuals are situated"—in other words, the multitude.[38]

In the last decade, the notion of *multitudo*, most thoroughly explored in Spinoza's last work, the *Tractatus Politicus*, has been renovated in the interests of counter-Empire. In the late 1960s and 1970s, the multitude was a flashpoint in debates around Italian workerism, a history I can only glancingly acknowledge.[39] For Negri and Hardt's *Empire* more recently, the multitude is the ever-generative force under global capital whose internal composition is differential—an *inessential* constellation of singularities organized around conflict, radically distinct from Hobbesian notions of the "People," authorized in consensus and upheld in support of nation-state ideologies.[40] The productive capacity of the multitude, rather, is systemic and

autopoietic—not unlike the informational networks emblematic of the processes of globalization. The association proves meaningful for those fighting neoliberal global- ization: as Negri writes, "In becoming power, the multitude generates. Generation is not something that precedes the multitude but on the contrary is something that belongs to it, that defines it in constituting it."[41]

In the last chapter, I addressed how Hardt and Negri seize upon the ether as a potential vehicle for the liberating possibilities of globalization, a contested position to say the least. If this notion of the ether is read through and with the "revolutionary plane of immanence," one implication is an absolute and inescapable compression of distance—critical, geopolitical, and otherwise. It is a space "without much 'run- ning room,'" as Foster would say in another context, "for anything else." Here, then, the spatial politics we've discussed in the last two chapters have come to a precarious head, a knife's-edge alternation between the "eclipse of distance," as foretold by Bell, and the revolutionary plane of immanence as advanced by Spinoza's contemporary readers. Here the fabled "tension and contradictions" animating the art world's de- bates on globalization see Hegel squaring off with Spinoza, Marx beyond Marx. Once again this dissonance has its uses. That these terms are so proximal—spoken within the same breath, occupying the same literal and discursive orbit—is itself emblematic of Hirschhorn's productive interests. Taking a page from Spinoza, this mode of work- ing will have markedly practical consequences where questions of time and causality are concerned.

Time with Production

To draw a line from Spinoza to Hirschhorn is to see the radically conflicted connec- tions Hirschhorn's art would make as coextensive with a world to which it is imma- nent, one from which "there is no escape" as he would put it, because, to repeat him yet again, "you can't escape capital. Capital always wins." Hirschhorn's organization of media—its ferocious juxtapositions and its agglutinate sensibility—confirms not only his temporal and causal prerogatives as Spinozan, but their implications for what the artist calls a "community of singularities."[42] Before treating his work's causal mode in more detail, it is worth sorting out the ways in which time and causality have

been understood in Hirschhorn's reception generally. It is also instructive to gloss parallel interests pursued by other contemporary artists—namely, questions of overproduction and the mechanisms that sponsor such processes—as specific confrontations to globalization's marketplace of temporality.[43]

For the most part, critics have seized upon the representation of the temporal in the forms of the giant mock watches that regularly turn up in Hirschhorn's art. *Rolex Etc.* (1998), for instance, sees an array of outsized watch props, done up in gold and aluminum foil and cardboard, hung on the walls of the Musée d'art moderne de la Ville de Paris. This pathetic simulacrum of luxury inspires readings both iconographic and nationalistic: the "Swissness" of the watches is escalated and the artist registers his disgust for these goods through the cheapness of their monumentalization. Such readings make a certain sense for this individual work, if not for Hirschhorn's sense of the world: they bracket one feature of this object at the expense of everything else swirling around it, assuming that the meaning of a watch was self-evident and contained, that it could carry the semantic burden of all the other elements on display.

Far removed from any too-neat homologies between the representation of watches and time, Benjamin Buchloh considers Hirschhorn's temporal problematic in terms of the cycles of commodity production (Marx would call it "circulation time") and a larger thesis on the end of modernist sculpture. He describes the artist's use of media—its connotations of "detritus and decrepitude"—through the "devalorization" of object relations under the regime of spectacle: that is, "the incessant overproduction of objects of consumption and their perpetually enforced obsolescence."[44] Hirschhorn's work is located in a genealogy of modern sculpture (the kiosks of Gustav Klutsis, the street aesthetic of Claes Oldenburg, the pavilions of Dan Graham) that narrates the relentless recuperation of its models and its progressive bankruptcy as an aesthetic category. His salvaging of the waste matter of capital suggests for Buchloh "the ever decreasing temporal cycles" of the commodity form which the artist's practice "mimetically follows."[45] Certainly the work does appropriate those forces as repetition, as the productive capacity of a world that needs always to generate more "product" so as to produce new markets: this is the "internal contradiction" that is overproduction. The profligate and even grotesque materiality of Hirschhorn's work corresponds to this new order of phenomenological violence, one resulting from the degradation of the public sphere through the excrescence of the commodity form.

Figure 3.11
Thomas Hirschhorn, *Rolex Etc.*, 1998. Museum Ludwig, Cologne, 1998.

Buchloh describes Hirschhorn's practice as trailing the fallout of overproduction, that spinning wheel turning the world of total design that would penetrate every last corner of the globe.[46] The vicious circle of overproduction has variously been explored by other artists who see the interests of production as indivisible from consumption. It is of particular interest, for example, that contemporary Chinese artists have mined the thematic of waste, overproduction, and planned obsolescence, as if in inverse relation to the rocketing ascendancy of the new socialist market.[47] (In this context, it seems oddly suggestive that some of the most avid collectors of this art are Swiss.) A Beijing-based painter and sculptor, Liu Wei, has treated issues of production and consumption in grossly corporeal terms, in sculptures of massive turds, for instance, or imaginary Western metropolises fashioned out of dog chews. Most poignant of all is *Hopeless Land* (2008), a work that literally grounds the fallout of the global marketplace as a landscape of trash. The video documents the impact on traditional agricultural practices of Beijing's accelerating urban sprawl, concomitant with an exploding middle class, and its shrinking rural areas. With images of farmers scavenging through mountains of garbage as a means to supplement their plunging incomes, Wei has given us *The Gleaners* for a post-Greenspan world, a landscape grown by excess reaping a most abject harvest.

On the other side of the consumption spectrum—equal but opposite to the problem of overproduction—lies the work *Constellation No. 3*, a startling installation by Chu Yun. Parting a curtain, one enters a pitch-black room that at first reads as tranquil and pacific, a night sky studded with colorful stars. As one's eyes adjust to the darkened space, the ground of this celestial canopy snaps into a nervous gestalt. The blinking power sources of dozens of CPUs, televisions, and stereos sketch a fitful constellation of energy marshaled, drained, and wasted, raising the question of the transmission of this energy, its ecology and apparatus. And what we recognize in this starry field is something of our own communicative habits and habitats, now staring back at us. These are objects destined for the trash heap, a story of technological obsolescence written as contemporary cosmology.

Chu Yun has made a pointed and instructive work. It is uncanny for all those winking lights, seductive in its glittering appeal and sinister in its revelation. But its impact, I would argue, might even be a little too punctual. The epiphany it offers drains off a bit too quickly, like the power sources which it literally enlightens. To the

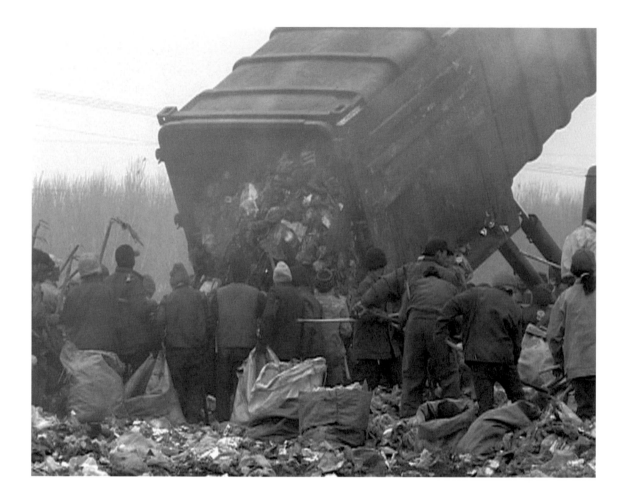

Figure 3.12
Liu Wei, *Hopeless Land,* 2008. Courtesy the artist.

Figure 3.13
Chu Yun, *Constellation No. 3*, 2009. Installation view at "Breaking Forecast: 8 Key Figures of China's New Generation Artists," Ullens Center for Contemporary Art, Beijing, 2009. Courtesy the artist and Vitamin Creative Space, Guangzhou.

extent that it reproduces the mechanisms it obliquely addresses, it cannot sustain any engagement with those mechanisms.

The work of Josephine Meckseper, on the other hand, is unstinting in its relation to such mechanisms, throwing into relief the self-generative impulses we've described for Hirschhorn's practice and exploding the relationships between ideology and the world of total design. Her art too makes use of the fetishes of mass consumption, its framing devices as well as the advertisements that are its articles of faith. And like Hirschhorn, if in a different tone (where Hirschhorn's sensibility is excessive, Meckseper's aesthetic is cutting and principled, with little trace of the artist's hand), she has appropriated the vitrine—the shop window—to put the logic of such mechanisms on display.

Meckseper's own background shadows the traumas of recent history (her grandfather was a member of the SS; her relatives' friends members of the Red Army Faction), registering the fallout of those times for the present. "I'm looking for new ways to subvert normative mass culture in order to recontextualize images and signs that have become inflated as a result of overproliferation," she observes.[48] To address processes of "overproliferation," Meckseper effectively repurposes those images as freefloating signals of a new world market. Take an untitled piece composed of a hammer and sickle set atop a mirrored cube, at once an icon rendered blunt and material and a glittering fetish. It is a political symbol of the highest order that has undergone a radical mutation, both the object of narcissistic reflection and a literal spectacle. The mirrored surface on which the silvered tools coincide—a minimalist box—is a fitting pedestal for the marriage between politics and consumerism. Meckseper states that she is uninterested in "sending direct political messages"; and paradoxically, this work confirms her statement—despite its blatant use of political iconography—through the unsavory ambivalences it lays bare. Here the former icon of the proletariat is as much status as political symbol; and the work reads as *just* short of cynical because of it (it is "just" short because it is difficult to assign cynicism to the work's author).

Sylvère Lotringer reads this tendency in Mecksepers's art as "an active awareness of the systematic cynicism that permeates contemporary society," and links this cynicism to the unrelenting logic of exchangeability. The insight resonates with Hirschhorn's causal mode: in treating the Swiss artist's relation to design, I identified the circulation of the graphic signifier as coextensive with the motor of his perpetual

Figure 3.14
Josephine Meckseper, *Untitled (Hammer and Sickle No. 2)*, 2006. Silver-painted tools, mirror on wood, 31 × 48 × 48 inches (78.7 × 121.9 × 121.9 cm). Installation view, Elizabeth Dee, New York, 2005. Courtesy the artist and Elizabeth Dee, New York. Photo: Tom Powel Imaging Inc.

revolution. A similar operation takes place in Meckseper's work, if ultimately directed to bleaker ends and in more acid terms. "Exchangeability knows no bounds," Lotringer writes, "and the best one can hope for is to know its system of pretenses and illusions. . . . Nothing is what it is because everything is in everything else. Packaging is the only fixed content. Politics, art, commerce—everything must signify in order to become exchangeable."[49]

Lotringer will see in Meckseper's work—especially her vitrines—the mechanisms of this exchangeability put on their most hallucinatory display. Various advertisements (for underwear, for fashion, for the CDU) are counterpoised with toilet brushes; with plungers; with gold bibelots and crystal trinkets; with signs hawking such things at discount prices or on clearance; with political symbols and their fashionable accoutrements, all flattened to the same level of exchange, all evacuated of individual meaning. "It is not simply the accumulation of images, but the *speed of transmission* [my emphasis] that makes individuation impossible," Lotringer writes.[50] And it is the reduction of this object world to mere signals that Meckseper effectively trails.

At once accelerating and congealing, what this round robin of shifting values suggests for Hirschhorn, on the other hand, is both grim and informative. The notion that one can identify his practice in terms of the endless logic of exchangeability (and its deeply negative valence) means, among other things, that production does not stop.

Figure 3.15
Josephine Meckseper, *Untitled Vitrine*, 2005. Aluminum, mirror, Plexiglas, lights, tape, marker on paper, C-print, rabbit fur, metal display stands, plastic mannequin, found jewelry, inkjet print, toilet plunger, toilet brush, gouache on plastic, 46 × 46 × 18.5 inches (116.8 × 116.8 × 47 cm). Installation view, Elizabeth Dee, New York, 2005. Courtesy the artist and Elizabeth Dee, New York. Photo: Tom Powel Imaging Inc.

Production with Mediation

For example, if Hirschhorn's sculptural accumulations flag what Egenhofer rightly identifies as "dead abstract labor sedimented in the means of production," one could appeal also to his work's potential for *transvaluation*, given his understanding of the graphic sign: its capacity for both accommodation and mobilization.[51] For Hirschhorn's work traffics in mediation as much as commodities, staging the relations that indivisibly bind them. Thought with Spinoza, his process is as much about the circulation and affective capacity of information—its relative speed, slowness and fallout—as about the dead weight of vanquished commodities.[52]

But to name this an operation of immanence or self-production is very far from suggesting that his work stands in an affirmative relationship to the sources he mines. A work like *Jumbo Spoons and Big Cake* (2000) is no monument to the ecstasy of communication: it displays no faith in the legibility of the sign, no commitment to the ideology of smooth and untroubled flows of contemporary sociability. Later works are even more to the point in this regard: extremely troublesome conglomerations of downloaded imagery put the victims of suicide bombers—and the bombers themselves—on the same plane as fashion models, as if to spell out the ugliest lessons of general equivalence in a wholly mediated world. "In my work," he will insist, "there is no chronology, no time span, everything has the same actuality, the same importance."[53]

This lack of hierarchy might be thought of as the leveling of difference ordered around exchangeability, enabled in no small measure by the logic of the "world of total design" and its rapacious flexibility. Hirschhorn's statement also chimes with an immanent mode of self-production: for the radical *heterogeneity* of his source material is continuous with its nonhierarchical organization and lateral extension. A photograph of his studio makes this all too clear. A surfeit of media is the literal ground of his practice, an entropic spread that suggests the oscillating debasement and reappropriation of its sources, no less the dizzying feedback loop between overproduction and obsolecence.[54]

Indeed in the work's concession to, as well as inversion of, this condition, Hirschhorn's practice dramatizes Lotringer's remark that "the multitude is a by-product of the technological mutation of the productive process."[55] It is the condition immanent to—and emerging from—the *literal* revolution of his media, web-based or otherwise. As Hirschhorn notes:

Figure 3.16
Thomas Hirschhorn, *Jumbo Spoons and Big Cake*, 2000. © Photos Jean Claude Planchet Centre Pompidou.

Figure 3.17
Hirschhorn's studio, Aubervilliers, France, winter 2006. Photo by the author.

My works are not about some given thematic and I am not distributing roles to them. The elements in my work come from sports, hobbies, arts or philosophy as others come from science, history, memory or politics. These are *constituent* [my emphasis] elements that make me work. I want to link them together, creating relationships between things that one wouldn't usually link.[56]

The cognitive jolt erupting from these connections is sometimes violent, sometimes parodic, sometimes both. It would be a fool's errand to search for a stable meaning in the relentless juxtapositions his work sets into motion. Rather, the fact of those juxtapositions themselves is critical: in what strange world, for instance, would Leonardo di Caprio stand adjacent to Che Guevera, the image of the shining celebrity echoing the heroic profile of the revolutionary, himself now a "pop-cultural" figurehead emblazoned on thousands of T-shirts? These connections, however, are no more meaningless than the system in which they circulate. Their linkages demonstrate the affective capacity of information and things, a type of Brownian movement presaged by the work's immanent logic. In a Spinozan turn of phrase, Hirschhorn speaks to the diverse "constituent" elements in his work, which converge with the processes enabling their appearance.

In fact, there is a structural complement to this notion of connectivity: the various coils and lines of aluminum foil that take their labyrinthine paths throughout many of his sculptural displays. Sometimes culminating in pendulous knobs or "tears," they have been described as "rhizomes" or "creeping vines, monstrous umbilical cords or oversized tentacles."[57] Buchloh notes that they are referred to as both "conductors" and "ramifications," as if ramifying the lines of force drawn in space among the range of Hirschhorn's cultural and political variables.[58] Accordingly, they emblematize the saturation of the world by the commodity form. But what they also theatricalize, I think, is that same world's causal machinery, which internalizes the systematic accommodation and generation of radically disparate phenomena as its first principle.[59] (Notably, one element of a work, dating from 1997, was called a "network table.")[60] It is not insignificant that this is the strategic heart of new media activism, what we not long ago called the flash mob, the smart mob, the meet-up—in other words, practices that are positioned in a parasitic relationship to the digital mechanisms of the world market.

Yet just as Hirschhorn's work is not about globalization, neither is it a buried allegory for a life in cyberspace. There is no hidden meaning to unearth but an occasion for a range of activities continuous with those processes. Consider the many daily activities that took place over the course of the Bijlmer Spinoza festival. They included rehearsals and daily performances (school children enacting scenes from famous performance art images); a play written by Hirschhorn and acted by members of the Bijlmer community; a newspaper produced each day of the festival (the artist frequently has a daily newspaper made for his various monuments, museums, and festivals); and lectures delivered by a host of philosophers, art historians, and critics, among them Marcus Steinweg and Georges Didi-Huberman. There were T-shirt-making workshops for the kids; a library to use and be consulted; an art historian (Vittoria Martini) on hand to answer questions; videos on the Bijlmer disaster; a bar to lubricate social interaction; a web connection to search elsewhere; and a website to update daily on the comings and goings at the festival. In other words, the festival was a hive of productivity and a web of encounters and transactions, some fleeting, some lingering, some whose effect could not possibly be registered, certainly not in the immediate present. It was *work*. Yet if Spinoza was the putative occasion for such actions, none of these activities were in any way reducible to his name. And if Hirschhorn has been criticized on the grounds that his art makes a fetish of the rusticated—a romance of cardboard and packing tape—such remarks little address the constituent or productive dimension of his work, its causal and active mode.

On the other hand, we should also note that such work does not hew to the conventional logic of a participatory aesthetics, what Nicolas Bourriaud called "relational" in his widely read polemic of 1998.[61] Hirschhorn will dismiss the pseudo-democratic promise made by much "interactive" art and the ideology of transparency accorded such models of communicative exchange.[62] For what site specificity might mean now under the terms of the world market runs counter to the causal mechanisms at the base of his practice. If Hirschhorn works all over the place—whether in a housing complex or a fast-food restaurant or a university lobby or museum—it is *not* because the conditions he addresses are specific or determinant to a given locale, but because they are immanent to the world he would appropriate.

Figure 3.18
Hirschhorn's studio, Aubervilliers, France, winter 2006. Photo by the author.

From Below

"Wenn schon Globalisation, dann von unten!"

On the wall of Hirschhorn's studio in Aubervilliers, a scrap of paper telegraphs a fragment on the geopolitical. Its stunted syntax reads as if its author was interrupted in mid-thought. If, to follow this brief, globalization is already here, what, then, "from under" or "from below" is yet to come? What world, in other words, is being projected "under the aspect of eternity"?

This is the paradoxical condition that Hirschhorn's work announces: a sense of the world both here and always on the way. Confronting the unblinking ugliness of our current situation, it is also the work of endless productivity, speculation out of time, itself from below.

4
On Pseudo-Collectivism; or, How to Be a Collective in the Age of the Consumer Sovereign

How do we find each other?[1] —*The Invisible Committee*, 2007

In the last chapter I addressed the logic of immanent cause in Thomas Hirschhorn's work, a forging of connections between subjects both disparate and distant, as productive as it is unsettling. When images of B-list celebrities stand shoulder to shoulder with pictures of geopolitical carnage, we are forced to regard a world in which an infinite chain of causality at once describes, licenses, and confronts what Giorgio Agamben calls "the bloody mystification of a new planetary order."[2] That immanence is central to thinking the workings of both Empire and counter-Empire means that we need to take up its consequences for one of contemporary art's most durable, if battle-worn, tropes: the collective. And if Hirschhorn's work in part flags the cruel inequities stemming from overproduction, the collective turn in recent art responds to a question of *consumption*.

As any casual art world observer might tell you, collectivism would seem inseparable from the art world's global deliberations of the past two decades. Continuous with the decentralized models of self-generation associated with the multitude, such collectives might confirm the notion put forward by the Invisible Committee, the nameless group behind the tract *The Coming Insurrection* (2007), that "*organizations are obstacles to organizing ourselves.*"[3] But we haven't come so far in this book to take the appearance of such things at face value. In fact, "face value" will prove beside the point. I call such practices "pseudo-collectivism," to unpack the issue of how to be a collective—that is, how to hold things in common—when globalization puts such rights to the commons under the gravest threat. For how is the collective to act in the wake of the "death" of socialism and the rabid privatization of resources once held as public? What might a resurgent collective activity suggest after the watershed year of 1989? When a multinational corporation based in San Francisco holds the rights to the rainwater in Bolivia; when the World Bank finances the corporatization of the same in post-apartheid South Africa; and when the "vote with your pocketbook" mantra assumes the cadence of activist creed, what forms can collectivism effectively take?[4] Within contemporary art, pseudo-collective practices offer especially acute, because paradoxically opaque, responses to an emergent individual under whose reign we are now all grossly subject. This is the epoch of the "consumer sovereign" theorized by the Austrian economist Ludwig von Mises three decades ago, now coming to full boil in the twenty-first century.

It's certainly true that much of what counts as collectivism in the art world is po-
litical in scope, if in ways hardly envisioned by its historical forebears. The collective
may have returned with its activist mandates intact (truth is, it has never really gone
away), but its appearance, let alone the diverse approaches to its organization, little
resembles the efforts of the past.[5] There is work that mimes the logic of bureaucracy
as much as the factory floor (The Center for Land Use Interpretation; the Yes Men);
of the think tank and the laboratory as much as the Comintern (as in, for example,
the biotechnical interests of Critical Art Ensemble). And there are "collectives" of a
nominally feminine guise, variously named after popular commodities, imaginary
"It girls," or even corporations (Claire Fontaine, Bernadette Corporation, Reena Spaul-
ings), with projects ranging from film to fashion to performance to installation
to publishing, whether of novels or philosophical tracts.[6] In rejecting a singular
practice, style, or approach—a resistance to anything like representational transpar-
ency—such work might address similarly anonymous tactics of contemporary activ-
ists. For example, in the film *Get Rid of Yourself* (2000) the Bernadette Corporation,
"incorporated" in 1994, charts the anonymous movements of Black-Bloc anarchists in
Genoa around the G8 summit, rioting under the requisite cover of dark hoodies and
face-masking bandannas. In this sense the organization of the group chimes with the
phenomenon they document: the "potential of community based on a radical refusal
of political identity."[7]

But if this is not quite the multitude, what, precisely, is it? In their volume of
essays *Collectivism after Modernism*, Blake Stimson and Gregory Sholette provide
abundant evidence of such practices in active dialog with and sometimes synony-
mous with social movements, conveying the formative power and utopian longings
of today's practices. From Le Groupe Amos in Kinshasa to the Bureau d'Études in
Paris, the study impresses for its vehemence, its staunch commitment to the politics
of the work surveyed, and the authors' allegiance to collectives largely bypassed by
the market-driven ethos of the art world. Bryan Holmes put such tendencies best in
naming their most recent turn an "unleashing" of "collective phantoms," capturing
something of the virtual and networked sensibilities ascendant in the era of the "flex-
ible personality."[8]

Still, as witnessed by the presence of many collectives in the white cube and in
large-scale international art exhibitions, such "alternatives" might conform to that

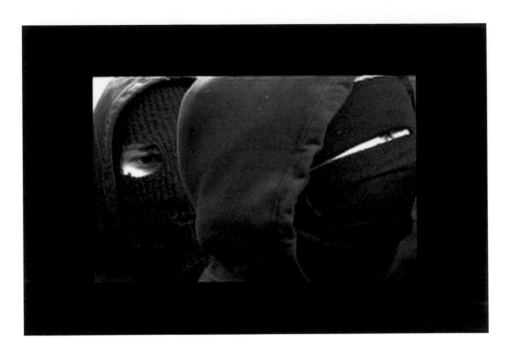

Figure 4.1
Bernadette Corporation, *Get Rid of Yourself,* video still, 2003. Courtesy the artist and Electronic Arts Intermix, New York.

very same industry's techniques, modes, and prerogatives. Stimson and Sholette excoriate a rash of "collective" art world activity premised more on sociability than socialism, partygoing than party membership. A letter to *Artforum*, reprinted in the preface to their collection, chastises this very tendency:

> For those who crave cultural distraction without the heavy intellectual price tag now comes a pack of new and *inscrutable* [my emphasis] art collectives offering colorful, guilt-free fun. Forcefield, Derraindrop, Paper Rad, Gelatin, The Royal Art Lodge, HobbyPopMuseum, their names flicker impishly across the dull screen of the contemporary art world invoking not so much the plastic arts as the loopy cheer of techno music and its nostalgia for a make-believe 1960s epitomized by LSD, free love and day-glo. . . . As Alison M Gingeras tells us in the March edition of *Artforum*, this new collectivism is not at all solemn. It is "insouciant." It eschews the "sociopolitical agenda associated with collective art making" and reflects a "juvenile disregard for historical veracity." And all that is fine because its indifference "mirrors the times."
>
> What times I ask?[9]

These words distill the radically contradictory impulses of recent collectivism, and no less of contemporary art, forewarning that these are strange days indeed.

The artists who concern me are deeply engaged with the sociopolitical agendas the history of collectivism would advance but are profoundly skeptical about its representation in the present. "Inscrutability," as well as a certain jaundiced approach to questions of "historical veracity," may be the motor of their sociopolitical engagements. What might it mean for the Atlas Group—in effect, the artist Walid Ra'ad—to present archives on the Lebanese civil war as sponsored by an "imaginary foundation"? For its part, the Delhi-based Raqs Media Collective is sanguine about the romantic images attached to collectivism, but is wholly committed to rethinking collectivism's relation to the contemporary commons. Arguably their most important contribution happens off-site to their art world persona, in the media initiative they co-founded known as Sarai.

Indeed, in the practices discussed here, an acute withdrawal of such representation is part of the collective's speculative gambit and pragmatic organization; neither

moralizing nor judgment is implied in naming such gestures "pseudo-collective."[10] On the contrary, they are a form of realpolitik, an inversion of those long-cherished values accorded the terms of representation within the public sphere.[11]

For pseudo-collectivism articulates a cogent rejoinder to the problem of the contemporary *individual* and of that individual's relation to the commons by extension: how we've been conscripted of late to perform in the public and private spheres; the possibilities and restrictions available to us.

In this regard pseudo-collectivism chimes with, but is by no means identical to, those practices of contemporary art explained through *Le partage du sensible*, the formative reading of aesthetics and politics advanced by Jacques Rancière.[12] The language of sharing flagged in the original French title underscores the prospects of what senses can be held in common at any given historical moment and their implications for politics. The "distribution of the sensible," to follow Rancière,

> establishes at one and the same time something common that is shared and exclusive parts. . . . This apportionment of parts and positions is based on a distribution of spaces, times and forms of activity that determines the very manner in which something in common lends itself to participation.[13]

Aesthetics, as he puts it, "is a delimitation of spaces and times, of the visible and invisible, of speech and noise that simultaneously determines the place and the stakes of politics as a form of experience."[14] If aesthetics, then, is that peculiar delimitation of spaces and times, of making the possible visible, history itself becomes "a form of fiction."

Questions of visibility are central to my argument, if directed to a wholly tactical response to our current situation. I begin with a theoretical brief on collectivism within the Soviet context to ground this problem today (as embodied at the World Social Forum). A more focused account follows of the return of an individual subject, having recourse to the influential readings of Giorgio Agamben and Carl Schmitt, on the one hand, and to the rise of Mises's consumer sovereign on the other. What both models suggest for collectivism now is a different kind of politics of representation in the perpetual struggle for what is held in common. It's a struggle epitomized by the "Invisible Committee," whose words haunt this chapter and whose example allegorizes the discussion of pseudo-collectivism in art. The chapter concludes following the occult movements of the Atlas Group and the Raqs Media Collective.

From the Collective and the Individual to the World Social Forum

The question of the relation between the collective and the individual finds its gene-alogy in the long tradition of the commons. The pasture shared for grazing livestock; the field accessible to all for arable farming: the thinking around such open resources is coterminous with modernity's elaboration of the public.[15] Our immediate interest is restricted to a theory of collectivism within the early Soviet Union, flashing forward to the present at the World Social Forum. Sociologist Oleg Kharkhordin's *The Collective and the Individual in Russia: A Study of Practices* is an exacting, Foucauldian analysis of Soviet collectivism premised on the self-manufacture of the individual. Kharkhordin opens by considering the fall of the Soviet Union and the dizzying speed with which Russians abandoned any and all collective practice. Studies "revealed a substantial number of people who espoused individualist ideals, a surprising finding for a country that was presumed to have been overtly collectivist for centuries."[16] That "Milton Friedman and Friedrich von Hayek seemed the most popular authors for the Russian public of the 1990s" challenged Kharkhordin to think genealogically about Russian attitudes to individualization and collectivism.[17]

Kharkhordin outlines the debates waged over the terms "collectivism" and "collective" during the critical first half of the twentieth century, from the prerevolutionary theorizing of early Bolshevism (with its deeply religious associations), to its immediate application within the postevolutionary moment, to its catastrophic abuse in Stalin's 1930s. Prior to 1917, Kharkhordin notes, collectivism stood generally for three interrelated tendencies, which would continue to resonate well after the October Revolution and find residual trace in the present:

> One, it signified a religious and philosophical notion of life after death; through joining the collective, individuals could gain a kind of immortality. Second, "collectivism" was a name for a certain political strategy that aimed at fusing the workers into a unified fighting corps by means of a revolutionary myth. Third, the word signified the future culture of the victorious proletariat after the revolution.[18]

The complex intersection of these forces dramatizes the heuristic function accorded the word "collectivism." A certain myth-making or eschatological rhetoric advances the collective's program, in tandem with later discourses surrounding the "New Man."

Kharkhordin registers the fugitive sensibilities of collectivism by extension, the sense of building toward a collective as a perpetual work in progress.[19]

Kharkhordin's brief may come as a surprise to readers of recent art criticism, for whom collectivism is generalized to mean little more than a type of groupthink, simply counting the efforts of more than one artist as a collective enterprise. In such readings, the role of the individual is not problematized beyond the subsuming of a proper name to a shared moniker or title. But what's critical in theorizing pseudo-collectivism is the stress these historical definitions place on the role of that very subject. As Kharkhordin's summary emphasizes, the will toward individual immortality, even a kind of repressed *Lebensphilosophie*, lies behind the desire to share in the group.

The cultivation of the individual, the notion of "working on oneself," as Kharkhordin describes it, will prove foundational to early Soviet theories of collectivism. In *What Is to Be Done* (1902) Lenin stresses "the need for a long methodical manufacturing of a professional revolutionary out of one's self"—a concerted *manufacturing* of the individual subject in the larger service of the collective. Not incidentally, this mode of self-manufacturing is essential to the progress of the avant-garde. "The crux of the matter," Lenin writes, "is that the avant-garde should not be afraid of working on itself, of remaking itself."[20] As amply demonstrated in the long debates surrounding artistic collectivity in the Soviet context, collectivism is no self-evident thing.[21] It's a conceit that remains all the more pressing for pseudo-collectivism, which internalizes the self-manufacturing dimension of collectivism's historical definitions but necessarily—and radically—updates it as a response to the contemporary individual.

And yet this notion might appear the exception to the rule of contemporary formations of collective practice. Consider Gene Ray's instructive essay "Another (Art) World Is Possible: Theorizing Oppositional Convergence." Discussing work that "break[s] out of the art world into other areas,"[22] Ray treats several collectives (the Baghdad Snapshot Action Crew, for example) not through the unified front staged by the Internationals but relative to the World Social Forum. Since 2001, the World Social Forum, an international summit of social movements, nongovernmental organizations, and activists, has rallied behind the slogan "another world is possible" in its efforts to combat the advances of neoliberalism.[23] Envisioned as the countermovement to the World Economic Forum, the "Forum," as its participants call it, de-

scribes itself as "a permanent world process"—a "movement of movements" against "a world dominated by capital or by any forms of imperialism."[24] Important here is that the Forum has strenuously "taken pains to de-emphasize political parties in favor of an open space to debate."[25] With close to 100,000 participants attending its meetings around the globe, including at Mumbai, Porto Alegre, Buenos Aires, Bamako, Florence, and Ramallah, the Forum insists on its polycentric status, proclaiming loudly in its charter that it is neither a group nor an organization and eschews any engagement with political parties. The notion of a "permanent world process" is central to this self-organizing mandate, in which hundreds of lectures, discussion groups, and activities serve as occasions for networking, debating, and the hiving of diverse interests.

Ray calls on the spirit and language of the Forum to explain the art of "oppositional convergence." Following Hardt and Negri on the headless structures of Empire, he suggests how the expansion of a world market and the communication technologies that facilitate it may provide the means that will lead to its undoing. The ambition, in short, is to rethink "traditional revolutionary theory" by "re-conceiving our notions of political agency" relative to these new models and processes. And the artist collective becomes the emblem of this new form of an immanent, political subject as networked and viral. "As networks of alternative subjects link up on coalitions of resistance, and as these coalitions increasingly converge globally through their articulation of demands on a planetary level," he writes, "counter-Empire emerges as a force of transformation."[26]

What intrigues about this proposal is that, on the surface at least, the self-representation of such movements little obeys such imperatives to structural transformation.[27] At the 2006 Americas iteration of the Forum in Caracas, the larger representation of collectivity adhered to a rather conventional visual logic: at the Plaza de las Tres Gracias, for instance, a socialist-realist imaginary was the order of the day, with parades of workers and activists—an 800-member Cuban delegation was especially striking—dressed in matching hats and T-shirts hoisting banners with the classic Marxist pantheon: Marx, Engels, Lenin, Che. This literally mass body incorporated the slogan "another world is possible." To be sure, if the CNNs of the world turn a televisually blind eye to the existence of the Forum, the burden of representation falls on those little represented.

Hence there is more than good reason why a strain of contemporary art documents such bodies, as in the video archive *Dissidence v. 2.0* (2010) by Minerva Cuevas, a work that maps "opposition and resistance in public spaces in Mexico City."[28] But even as Cuevas has been committed to such forms of representation—she shows us children protesting in marches, streets thronged with activists, banners and the usual accoutrements of public demonstrations—she also works in a less representational fashion, as in the slyly subversive interventions of her *Mejor Vida Corp.* Founded in 1998, the "Corporation" provides free services and products such as international student ID cards, subway tickets, and barcodes for grocery stores. These are gestures, in other words, designed to game the various systems in Mexico against which the subjects of her videos might protest, propositions that fly under the radar of the conventional sites of art exhibition.

What the description of both the World Social Forum and Cuevas's dual approach suggests is that perhaps there *is* no visual language adequate to the immanent composition associated with the "movement of movements," no iconography that can carry the weight of this representational paradox. Indeed, whatever attention was given to the spectacle of mass collectivity in Caracas, there existed at the Forum a much more subterranean presence, all the more insidious because it was ambient and dispersed. At the edges of the Forum, a pervasive media would stage its own world-making capacities, as if the mediation of collectivism was more in keeping with visions of networked social movements than with the conventional emblems of revolutionary struggle.[29] The frequent sightings of photographers taking pictures of other photographers—a media *mise-en-abyme*—theatricalized the "self-manufacture" of contemporary collectivism's subjects by putting the process itself on display.

Figure 4.2
World Social Forum, *La Plaza de las Tres Gracias*, Caracas, Venezuela. Cuban activists in a march during the launching of the World Social Forum in Caracas, January 24, 2006. Photograph by Andrew Alvarez, AFP/Getty Images, 2006.

On Pseudo-Collectivism

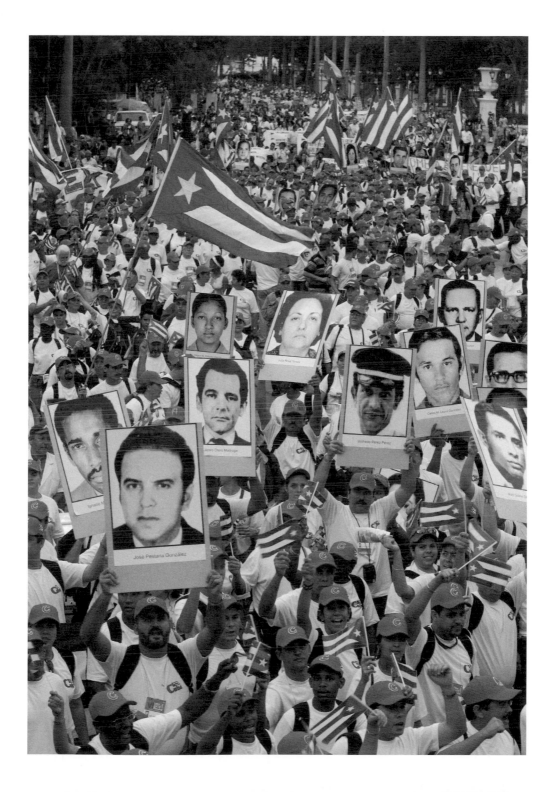

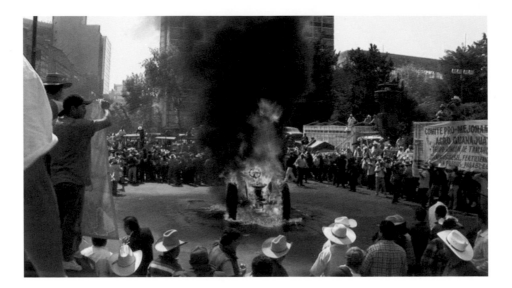

Figure 4.3
Minerva Cuevas, *Dissidence v. 2.0*, 2010. Courtesy the artist.

No account of recent collectivism in the arts can ignore the role of tactical media in the network society: we'll conclude on this note in discussing Raqs. In order to make the case for the pseudo-collective dimension of that practice, I turn first to a contemporary problem of the individual subject anticipating a "politics of representation" in its own right. The sovereign claims made by such subjects offer the gravest challenge to what collectivism means today.

The New Sovereign Politics of Representation

"I AM WHAT I AM." *This is marketing's latest offering to the world, the final stage in the development of advertising, far beyond all exhortations to be different, to be oneself and drink Pepsi. Decades of concepts in order to get where we are, to arrive at pure tautology . . . I = I.*[30]
—The Invisible Committee

The hangman, not the state, executes a criminal.[31]
—Ludwig von Mises

Given what we think we know about the status of the subject, this may seem a strange move. In the last couple of decades, academic debates on the topic have been grossly caricatured across the spectrum: the efforts to recuperate a disenfranchised subject, as proposed by identity politics and multicultural agendas, on the one hand, were seen as antithetical to the critique of the humanist subject elaborated by deconstruction, on the other. Who would have thought that the subject would return with such a vengeance—not least in regard to the collective and the individual and the pseudo-collective impulses that I am arguing for within contemporary art?

In the realm of politics and economic life, two distinct, if oddly related, conditions contribute to this state of affairs. They emblematize a turn to a different kind of subject—now incorporated as sovereign power—who throws down the gauntlet to recent forms of collectivism. One version of this subject is articulated in Giorgio Agamben's profoundly important *Homo Sacer: Sovereign Power and Bare Life*, a book

which, drawing from both Michel Foucault and Carl Schmitt, reflects on the state's capacity to administer life, to at once produce and destroy it, as the central feature of modernity's elaboration of sovereign power. The other version—proposed by Ludwig von Mises—is founded on a notion of human action organized around habits of a different kind of decision making, namely, consumption. Written from radically opposite sides of the ideological spectrum, both models propose a kind of abject existentialism, a vexed sociability continuous with neoliberal globalization.

Agamben's *Homo Sacer* takes off from Foucault's *History of Sexuality* (and, by extension, from his Collège de France lectures on governmentality), in which biopolitics signaled the ways in which the sphere of life had been integrated into the mechanisms of sovereign authority: the right of death and power over life.[32] Life, in Foucault's words, had become subordinate "to the sphere of political techniques."[33] Agamben treats the biopolitical subject at the threshold of "bare life," drawing on a tradition from Aristotle to Schmitt to Hannah Arendt. "The entry of *zoe* into the sphere of the polis," he writes—"the politicization of bare life as such—constitutes the decisive event of modernity and signals a radical transformation of the political-philosophical categories of classical thought."[34] For Agamben, the consequences of this shift are catastrophic, finding their most venal paradigm in the concentration camp. Sovereign power, by this view, enacts an unruly paradox. In its inordinate capacity to administer death, to "kill without a sacrifice," the sovereign at once stands outside the law and yet wields and determines that law, through the prerogative known as "the state of exception." "The sovereign," Agamben notes "is one who is both inside and outside of the juridical order by proclaiming the state of exception."[35]

The biopolitical subject has become an all too familiar player in a rash of recent scenarios from Abu Ghraib to Terry Schiavo to corporate patenting of DNA. Agamben's contemporary subject is informed by a haunted lineage, courtesy of the Nazi jurist Carl Schmitt, that cuts a path from the waning years of the Weimar Republic to its dark mutation in the neocon posturing inside the Beltway. Schmitt's legacy has enjoyed a curious readership of late. As was the case during his lifetime, when his writings could command an audience including Walter Benjamin and Hannah Arendt, he is read by radically disparate constituencies for the severity (and, as it turns out, prescience) of his insights. His thinking on sovereignty, as elaborated in both *The Concept of the Political* (1932) and the earlier *Political Theology* (1922), lies at the

base of Agamben's investigations; his far-reaching excoriation of liberalism and his account of the theocratic dimensions of political speech resonate a little too well with current events. Mostly, though, Schmitt is read for his (in)famous definition of the political: that autonomous sphere of life, as opposed to aesthetics or morality, organized around the dualism of "enemy and friend."

What constitutes politics for Schmitt might be described as an inverted alterity—an antagonism toward the enemy so strenuously expressed, a degree of enmity so implacable, that politics is a matter of life and death. The political enemy, Schmitt writes, is "the other, the stranger . . . something different and alien."[36] One's status as a political subject as such demands the *existential negation* [my emphasis] of the enemy." This is one species of bare life in which identity is rooted in annihilation of the other. And it leads, in the slippery-slope reasoning of contemporary politics, to our present understanding of its subjects. When politicians warn over and over that "You're either for us or against us," and when they speak repeatedly, and apocalyptically, about "the Enemy," they invoke the compulsory rhetoric of the friend/enemy dualism that Schmitt theorized nearly seventy-five years ago.[37] It is for this reason that political subjectivity no longer seems a function of agency so much as an act of conscription. We are being forced to choose sides.

That we must choose sides is a given, but just *how* we do it is not. For the one path where individuation is purportedly reclaimed and liberated assumes a very different kind of relation to self-manufacture as sovereign rule. Enter the consumer sovereign, a neoliberal notion of agency in which politics and the market are indivisible and representation is effectively equivalent to consumption. As its principal theorist Mises wrote, "The direction of all economic affairs is in the market society a task of the entrepreneurs. . . . Theirs is the control of production. . . . A superficial observer would believe they are supreme. But they are not. Neither the entrepreneurs nor the farmers nor the capitalists determine what has to be produced. The consumers do that."[38]

Just as Schmidt's enemy/friend dualism originates in the 1930s, consumer sovereignty was also born of a much earlier moment. The term was introduced in the mid-1940s by William Hutt but received its most famous elaboration at the hands of Mises, the "political economist of liberty," whose anti-Keynesian theories of business cycles would be influential for his younger Austrian colleague F. A. Hayek and have become an article of faith to libertarian thinking. Though his name is less well

known to general readers than Hayek's—or than figures such as Milton Friedman, whose Chicago School economics represents the other major variant of free-market liberalism from across the Atlantic—Mises's relevance here reduces to a story about the individual—and the collective by implication. According to an ardent supporter, Mises was "the most comprehensive and consistent critic of all forms of modern collectivism."[39]

Mises's *Human Action: A Treatise on Economics* (1949) proposed a very peculiar notion of collective belonging—a complete antithesis of collectivism. It turned on each individual's capacity for choice, the basis for practice and "human action." The book is, in Mises's neologism, a "praxeology"—a general theory of human action in which action is defined as "the manifestation of a man's will" and men carry out rational action to achieve ends through chosen means.[40] Suffice it to say that for Mises the balance between individual and collective, between part and whole, has a foregone conclusion, with the individual assuming dynamic priority in the relationship. "First," he writes,

> we must realize that all actions are performed by individuals. A collective operates always through the intermediary of one or several individuals whose actions are related to the collective as the secondary source. It is the meaning which the acting individuals and all those who are touched by their action attribute to an action, that determines its character. It is the meaning that marks one action as the action of an individual and another action as the action of the state or the municipality. The hangman, not the state, executes a criminal.[41]

The unfortunate metaphor that concludes this statement reads as a fatal verdict on collectivism. No worries, though, as the consumer sovereign has everyone's best interests at heart. "Everybody in acting serves his fellow citizens," Mises writes. "Everybody, on the other hand, is served by his fellow citizens. Everybody is both a means and an end in himself and a means to other people in their endeavors to attain their own ends."[42]

Some fifty years after Mises's pronouncements, the consumer sovereign has seemingly become the individual's last refuge and most pernicious persona, the impotent arbiter of a world in which action is equivalent to choice, freedom of choice

means lording it over the free market, and the free market in turn confirms the consumer sovereign's dream of "human action." This cyclical logic means that the individual subject is actualized by the market choices he or she makes. And where globalization is concerned, the post-Fordist world view—a just-in-time approach to being in the world—generously accommodates this narcissistic logic. The ethos of flexibility—mass customization and the proliferation of niche markets—plays into a fantasy of individuation and agency as "designed" under the consumer's reign.

But this notion of self-actualization by design is both a grotesque tautology and a collectively shared fantasy. It is called out by the Invisible Committee when, in the pages of *The Coming Insurrection*, they cite the slogan of a well-known Reebok advertisement: "'I AM WHAT I AM' . . . I = I." To take on this new form of sovereign rule requires a different, far stealthier approach to collective representation. Invisibility will counter that personal "I," whose seeming self-evidence is little more than a market effect.

Invisibility, Anonymity

In 2007, the Invisible Committee published *L'Insurrection qui vient*, a book whose ultimate words "All power to the communes" sound a faint echo of a distant era but are no less impassioned because of this *seeming* retreat into the past. Its pages channel the truculence of Guy Debord; its tone ranges from the caustic to the romantic but remains mostly unleavened by a ferocious gallows humor. The anonymously penned tract was the central piece of "evidence" in the 2008 arrests of the so called Tarnac 9—four men and five women, between the ages of 22 and 34, all highly educated students who maintained "good relationships with their families."[43] The nine were living in the impoverished rural village of Tarnac, population 350, as a rejection of the consumerist and work-driven ethos of the city. Together they raised ducks, chickens, and sheep, grew vegetables, provided food for the elderly, and ran an informal library, cine-club, bar, and restaurant, among other activities. They avoided salaried work and banned cell phones. They were described by their neighbors as helpful, open, and kind.

They also traveled extensively on behalf of their commitments: to "visit political squats; to participate in the counterdemonstrations for the G8 or other European

summits," and to protest anti-immigration policies as well as "an army recruitment centre in New York," at which point they attracted the attention of the FBI.[44] In both their domestic habits and worldly proclivities, in other words, they formed attachments to the kind of headless, self-organizing movements sometimes associated with the movement of movements immanent to the World Social Forum. Following six incidents of sabotage against the French high-speed train service in November 2008—and after months of surveillance by the French police—the nine were seized in predawn raids, replete with a helicopter and balaclava-hooded paramilitary.[45] This was just the beginning of the nightmare: 34-year-old Julien Coupet, the alleged ringleader, sat in prison, uncharged with any crime, for over half a year. The French minister of the interior stated that the nine belonged to the "ultraleft, anarcho-autonomist movements" and that their book was a shining example of a newly ascendant genre of literature, the "pre-terrorist." Ominous names like "Red Brigade" and "Baader-Meinhof" were increasingly floated in the press. No other than Glenn Beck condescended to warn of the dangers of the publication.

The Coming Insurrection has been linked to the Tarnac 9 through Coupat's contributions to the short-lived journal *Tiqqun*. Rachel Kushner observes that these writings "combined resonances of . . . Agamben, Foucault . . . and Schmitt" and, like the book, telegraphed Debord's implacability.[46] Organized around "seven circles of analysis," *The Coming Insurrection* argues that government's role has fundamentally become the management of crises, pointing to uprisings and occupations in Greece, Tarterêts, and Oaxaca as incontrovertible evidence of global insurrection. Empire, according to the Invisible Committee, wields "the mechanisms of power that preventively and surgically stifle any revolutionary potential in a situation."[47] In Empire's wake, the book calls for "a new idea of communism" free from the organizational attachments of the old. Not the communism of the internationals, this, but an occasion for collective "complicities."[48]

For our purposes, the book is as much an allegory as a polemic, for "it is signed in the name of an imaginary collective."[49] Rejecting leftist modes of organization from the past, it stakes a decisive claim about political representation in the present. Its "contributors are not its authors," the Invisible Committee writes, "they've made themselves scribes of the situation."[50] It's a position that establishes the terms for the critique launched in the first circle of the book, on the emergence of a new kind of individual subject—a first-person "I" as a phantasmatic subject position spawned from

On Pseudo-Collectivism

the incestuous encounter between mass production and mass customization. That subject takes on a hyperbolic relation to self-manufacture all too reminiscent of the consumer sovereign and its relentlessly flexible persona:

> I AM WHAT I AM. Never has domination found such an innocent-sounding slogan. The maintenance of the self in a permanent state of deterioration, in a chronic state of near collapse, is the best-kept secret of the present order of things. The weak, depressed, self-critical, virtual self is essentially that endlessly adaptable subject required by the ceaseless innovation of production, the accelerated obsolescence of technologies, the constant overturning of social norms, and generalized flexibility. It is at the same time the most voracious consumer and, paradoxically, the most productive self, the one that will most eagerly and energetically throw itself into the slightest project, only to return later to its original larval state.[51]

This, then, is the backdrop against which the Invisible Committee argue that "the sphere of political representation has come to a close."[52] The particular remedy to this situation comes in the paradoxical "form" of something purposefully obscure, secreted, and subterranean. "Flee visibility. Turn anonymity into an offensive position," they write.

> In a demonstration, a union member tears the mask off of an anonymous person who has just broken a window. "Take responsibility for what you're doing instead of hiding yourself." But to be visible is to be exposed, that is to say above all, vulnerable. When leftists everywhere continually make their cause more "visible"—whether that of the homeless, or women, or of undocumented immigrants—in hopes that it will get dealt with, they're doing exactly the contrary of what must be done. Not making ourselves visible but instead turning the anonymity to which we've been relegated to our advantage, and through conspiracy, nocturnal or faceless actions, creating an invulnerable position of attack.[53]

When the only recourse to individual subjectivity in the present is consumer sovereignty, when the notion of "voting with your pocketbook" all but concedes the failures of participatory democracy, the mass anonymity to "which we've been relegated" is

itself transvalued as a choosing of sides, a way of being in the world.[54] "To be socially nothing is not a humiliating condition," the Invisible Committee write, "the source of some tragic lack of recognition—from whom do we seek recognition?—but is on the contrary the condition for maximum freedom of action."[55]

Imaginary Foundation: The Atlas Group

Visibility and invisibility will take on a radically new valence for Empire's conflicted politics of representation; pseudo-collectivism furnishes an appropriately occult response to this dilemma. As if trailing the fitful itineraries of the free market by proxy, these pseudo-collective efforts at once flag our conscription as political subjects and/ or give warning to the consumer sovereign. The more the commons is aggressively despoiled by the ethos of consumer choice, the more pressing the stakes in the collective's recent fortunes. Hence a new spin on the age-old drama between the collective and the individual. In this latest version, the consumer sovereign lords it over the commons by fiat. The collective, in an ironic twist, refuses to share in the process.

Shadow "organizations" such as the Atlas Group might appear to take on the role of the collaborative efforts of the past in their address to contemporary political circumstance; the phenomenon has been written about most compellingly in such terms by both Vered Maimon and Carrie Lambert-Beatty, among others. While renouncing the terms of singular authorial subjectivity, as all collectives do, they also refuse the terms of contemporary political representation founded on the monolithic (because unitary) identities of its subjects. The Atlas Group is a research-based institution or "imaginary foundation" (producing installations, performances, video, media) devoted to collecting and documenting events relating to Lebanon's civil war from 1975 to 1991. Of course, no confidence is betrayed in saying that this "group" is the work of a single artist—Walid Ra'ad—with occasional interventions from colleagues and peers, some of them "real" (like the Arab Image Foundation) and some also imagined. In fact, the Atlas Group was the 15-year project of Ra'ad, a professor at Cooper Union who divides his time between Beirut and New York. Even as the identity of the group remains the art world's worst-kept secret—identity, paradoxically, is both central to the work and utterly beside the point—Ra'ad will consistently confuse the first-

person singular with the collective in discussing this "imaginary foundation" and routinely scramble the chronologies attached to the members of the group itself.[56]

Perhaps the best-known series of "works" by the Atlas Group is the archive of Dr. Fahdi Fakhouri, the preeminent historian of the Lebanese civil war until his death in 1993. That Fakhouri is as much an invented persona as the Atlas Group underscores the deeply nested character of its pseudo-collective interests. Fakhouri "bequeathed 226 notebooks and two short films to the foundation."[57] In *Already Been in a Lake of Fire: Notebook Volume 38*, he surveys the hundreds of car bombs detonated in Lebanon between 1975 and 1991. As the handwritten Arabic text of the appendix notes, it "contains 145 cutout photographs of cars. They correspond to the exact make, model and color of every car that was used as a car bomb between 1975 and 1990."[58] The images as well as the accompanying text are indeed disquieting, though not in the way anticipated by the description. Neither devastated buildings nor ruined flesh are to be seen, but cut-out pictures of each vehicle accompanied by information scrawled in a casual hand. In this catalog of dead and deadly cars, a gray BMW floats unmoored from its white ground; a Nissan truck recedes into an imagined distance; a jumbled collection of Peugeots are fanned out at impossible angles. It is a rather modest, cut-and-paste aesthetic, no more sophisticated than a scrapbook, with all its suggestions of the domestic and the personal intact. And this, of course, is to beg the question of its author's identity: is this *really* the work of "the preeminent historian of the civil war"? Is history such a shambling and home-grown affair, its instruments little more than glue stick and pasted paper? However humble as a visual performance, additional information belies the tone of the notebooks. That pretty silver Volvo, we are informed, killed 56 people in Beirut, injured 120 others, and burned some 11 buildings in the process.

This peculiar aspect of the Lebanese civil war is explored in additional investigations by the Atlas Group. *My Neck Is Thinner Than a Hair: A History of the Car Bomb in the 1975–1991 Lebanese Wars*, which is explicit in naming its collaboration with Ra'ad, also draws on the history of the Lebanese car bomb during the same period. In this instance, the work trades the meager accessories of cut-outs and handwriting for something approaching journalistic photography. Black-and-white pictures taken from Lebanese daily newspapers document the shredded engines left in the wake of these explosions. Compared to *Already Been in a Lake of Fire: Notebook Volume 38*, this

Plate 57

Volvo
B20 or B30
Blue
June 19, 1985
21:09
Corniche of the sea, Tripoli
79 killed
150 injured
150 kg. of TNT
Hexogen

Plate 58

Mercedes
200
Beige
August 14, 1985
10:30
Beirut, Mar Takla
13 killed
109 injured
150 kg. of TNT

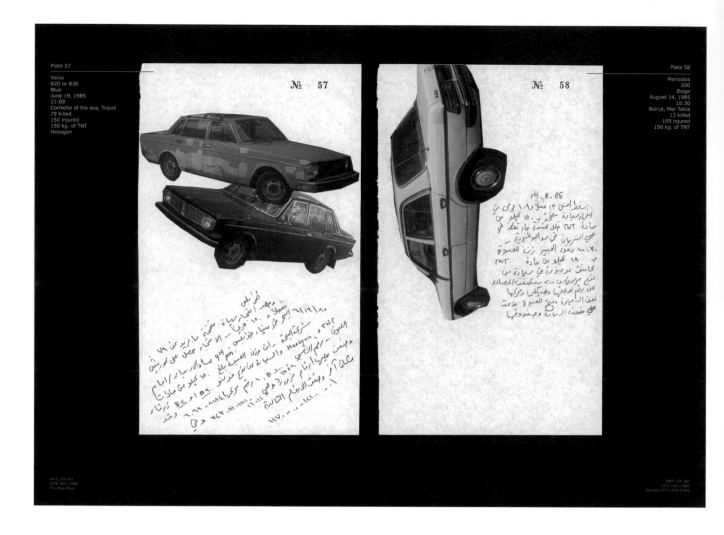

№ 57

№ 58

Figure 4.4
Walid Ra'ad/Atlas Group, *Already Been in a Lake of Fire: Notebook Volume 38* (plates 57–58), 2002. Archival inkjet print, 44 × 78¼ in. © Walid Ra'ad. Courtesy Paula Cooper Gallery, New York.

Figure 4.5
Walid Ra'ad/Atlas Group, *Already Been in a Lake of Fire: Notebook Volume 38* (plates 63–64), 2002. Archival inkjet print, 44 × 78¼ in. © Walid Ra'ad. Courtesy Paula Cooper Gallery, New York.

archive conforms to the design protocols of the official record. And in this regard, it also more closely approximates that strain of conceptual art described as an "aesthetics of administration."[59] A bureaucratic logic is at work in the orderly, near-clinical registration of insurgent violence.

What would it mean for an "imaginary foundation"—a pseudo-collective, in our terms—to address a shared topic of such gravity through such radically disparate visual means? The one hand-torn and scrappy, the other hewing to a more institutional aesthetic? A potential response to this question might be detected in another archive in the group's holdings, a work addressing a far less consequential phenomenon than the murderous capacity of exploding cars. In Fakhouri's *Notebook Volume 72*, newspaper clippings document horse races bet upon by "the leading historians of the Lebanese War."[60] As with the works just discussed, it functions somewhere between archive and scrapbook and confuses the affective implications assigned to both types of documentation. Its quasi-exhaustive quality straddles the line between encyclopedic and obsessive. Blurred images from newspapers contribute to Fakhouri's oblique archival sensibility, while scribbled marginalia suggest a working document.

The text accompanying this notebook grants peculiar insight into the pseudo-collective interests of the group. As the foreword to *Notebook Volume 72* declares, "It is a little known fact that the major historians of the Lebanese wars were avid gamblers. It is said that they met every Sunday at the race track—Marxists and Islamists bet on races one through seven; Maronite nationalists and socialists on races eight through fifteen." It's an apparently random but ultimately telling formulation; for that randomness signals the decomposing of collective identities in a historically fraught region, too often reduced in the media to a monolithic and undifferentiated block. But to group Marxists, Islamists, and Maronites together in this apparently random social situation is to name ideology, religion, and nation as the conflicted terms through which collective identifications are typically assigned.

What also draws these groups together is a peculiar logic of speculation. Here the identities of the gambler and the historian converge, where banking on the prospects of the future is relative to the outcomes of the past. For the Atlas Group, the historian and the gambler share a closer affinity than expected. It's as if the distance between the former's reputation as objective, official, and academic were continuous with the risk-taking ventures of the later. That proximal relationship suggests a submerged

Figure 4.6
Walid Ra'ad/Atlas Group, *My Neck Is Thinner Than a Hair*, 2003. Archival inkjet print, 9¼ × 17½ in. © Walid Ra'ad. Courtesy Paula Cooper Gallery, New York.

Date:
18 April 1989

*Distance Between Horse
and Finish Line:*

- 67

Winning Historian / Time:
KS - 261

Race Distance:
1400 m.

Winning Time:
1:40

Average Speed:
50.3 km/hr.

Historians' Initials and Bets:

1. KS -261
2. MM -117
3. FF -006
4. PH +112
5. HG +521
6. RO +611
7. AB -211
8. SK -212

Description of the Winning Historian:

He was imbued with a patience and
otherworldliness ill-suited for politics

and contingent relation to identity. A scribbled description on a sheet of paper dated July 5, 1978, conveys this fugitive sensibility: "A potent shadow and a legend that has grown into an officially sanctioned cult." Perhaps Dr. Fakhouri is referring to a horse, but the language is too ambiguous: he could just as well have been discussing the work of the historians and gamblers.

The archive itself is more "potent shadow" than historical representation, and reproduces the occult dynamic of the group itself. We need to stress that the Atlas Group is called a "project" or a work by Ra'ad, and indeed Ra'ad no longer occupies the same relationship to the project. Perhaps the most pervasive reading of the Atlas Group speaks to the notion that fact and fiction, memory and projection do not just comingle but are indivisible in the productions of history, an idea consistent with Rancière's reading of history as fiction. But this condition is just as true for the organizations that make such historical productions possible—or, in the case of the Atlas Group, those groups rendered invisible through the dictates of Euro-American media and the powers of conscription that would position us as enemy or friend. If car bombs, terrorism, and Islamic fundamentalism have come to represent the collective identity of this part of the world—the reduction of Middle Eastern identity to its role in Samuel P. Huntington's "clash of civilizations"—the Atlas Group wreaks havoc with such a profile, trading on the multivalent, at times wholly contradictory logic of this identity and its constitution as its own kind of world process. To put it in the bluntest terms: there is no singular nor stable subject with which to identify, neither enemy nor friend to conscript.

Figure 4.7
Walid Ra'ad/Atlas Group, *Notebook Volume 72: Missing Lebanese Wars* (plate 133), 2006. Archival inkjet print, 20 × 16 in. © Walid Ra'ad. Courtesy Paula Cooper Gallery, New York.

Latent: The Raqs Media Collective

The diversity of the commons challenges the singularity of property. There is only one way of possessing something but there can be countless ways to share it.[61]
—Raqs Media Collective, "Fragments of a Communist Latento"

A different order of pseudo-collectivism is advanced by the Raqs Media Collective, a group of theorists, media practitioners, and artists founded in Delhi in 1991. Formed by Monica Narula, Jeebesh Bagchi, and Shuddhabrata Sengupta, then master's students in the Department of Communications at Jamia Millia Islamia, the name "Raqs" is, among other things, an abbreviation for "rarely asked questions," a pithy reversal of the "frequently asked questions" standard to countless websites. For Raqs, such questions appeal to just *what* is being shared and how—the "diversity of the commons" and the "countless ways to share it," as they write in their image-text essay "Fragments of a Communist Latento" (2006), the name of which announces a decisive turn away from the manifest. Some forty years ago, Garrett Hardin published "The Tragedy of the Commons," a neo-Malthusian brief on the impending catastrophe of population explosion and the scandalous overuse of a shared resource: famously he deployed the iconic image of a field shared by herdsmen grazing their flocks to argue for the necessity of controlling the commons. Raqs demonstrates just how far we have traveled from this model, working both within and in excess of its territorial requirements and the proprietary measures restricting access to it. In installations sourcing a wealth of old and new media, the group takes up, among a host of issues, the public domain of the digital commons; the nonsynchronous experience of modernity (the installation *Time Book* mimics the factory logs clocking worker productivity by the hour, minute, and dollar); communications under the pressures of globalization; and the politics of mobility and dislocation entrained in these linked phenomena. This last condition is perhaps best allegorized in a photograph from their first show in New Delhi, held at Gallery Nature Morte, called *There Has Been a Change in Plan* (2006). In an image of a plane taken head-on, its nose removed in a gesture of aeronautical decapitation, the aircraft has been effectively immobilized and marooned on a wooden platform "like a widow on a funeral pyre."

Critically, Raqs's responses to these issues are as open-ended as their visual rhetoric is gnomic, confirming Lawrence Lessig's suggestion in *The Future of Ideas* that "not knowing how a resource will be used is a *good* thing."[62] A mainstay of the biennial circuit for over a decade, Raqs appeared in Documenta 11 in 2001 and the Venice Biennale in 2003 and 2005, and served as co-curators to the European biennial, Manifesta, in 2008. Well-traveled as they are within such circles, their art world identification masks the more amphibious spaces the group occupies relative to Sarai, the new media initiative they co-founded in 1998 with scholars Ravi Vasudevan and Ravi Sundaram. To blur the lines between these spheres of activity is in keeping with the nominal associations of the group. Besides meaning "rarely asked questions," *raqs* is also a word in Persian, Arabic, and Urdu that translates as "dance" but more specifically "the state that 'whirling dervishes' enter when they whirl." Given the overlapping and nested spaces the group inhabits—the sprawl of Delhi, the virtual sphere of the digital commons, and the rarefied climes of the global art world—their name mimes the recursive whorls of media that are both their platform as artists and their object of inquiry.

Raqs will tell you that the art world's peculiar fetish for collectivism hews to a misty-eyed vision of its storied past, where images of pavements tossed and stormed barricades fail to capture what is at once more mundane and more insidious about its contemporary forms and the reimagining of the commons by extension. No doubt media-driven collectivity is as banal as wikis or the Facebook multitudes, to say little of the dark underbelly of decentralized networking in the age of Al Qaeda. The ubiquitous practice of file sharing, on the other hand, may be as activist in spirit as redistributing GNU source code or as actionable as peer-to-peer networking on Napster. These examples raise a host of politico-ethical questions on access and apportionment, authorship, control, and creativity, and scratch the surface of the gargantuan legal implications underwriting this terrain. Testing the limits of copyright, trademark and patent law, initiatives such as the Creative Commons Foundation and CopyLeft have addressed the increasingly censorious dimensions stemming from the privatization of code and its ramifications for monopolizing and controlling information, both platform and content alike.

If only obliquely, Raqs takes a two-pronged approach to this broad range of issues. First, a quick survey of their work suggests a withdrawal of the traditional

Figure 4.8
Raqs Media Collective, *There Has Been a Change of Plan*, 2006. Courtesy the artists.

commons as channeled through an iconography of shadows and blurs, things lost and found, blocked signals, secret agents, and inaccessible spaces. In an age in which the consumer sovereign arbitrates over what Raqs calls "life-style consensus," a host of phantoms populate their art, as if scavenging what remains of the commons' plunder. There's the pile of garish trainers in *Lost New Shoes*, global commodities whose owners have gone missing, a paradoxically tidy summation of the geopolitical anomie of forced migration and collective dispossession from the land, the equal but opposite to work we've seen in an earlier chapter, Gursky's ubiquitous Nikes. In the video and sound installation *A/S/L (Age, Sex, Location)* (2003), female workers in Indian call centers serve as remote agents of distant communications, ventriloquizing and attempting to inhabit the cadence of spoken English. And in *The Imposter in the Waiting Room* (2004), an installation composed of light boxes, projections, letters, and sound, the image of a waiting room, occupied by a figure in a bowler hat with his back turned toward the audience, suggests a latent encounter with modernity, legions waiting to get their foot in the door.

All of these works speak to a restive kind of presence, neither wholly there nor completely absent but trafficking in some in-between and uncharted space. It's an aesthetic that contravenes the logic of transparency, immediacy, and accessibility conventional to the received wisdom on the commons; and likewise troubles the historical claims to collective visibility virtually grounded in such resources. But there also exists the further implication that such shado might provide cover under which to work, not to mention survive. If Raqs's presentation is at odds with the occasionally militant persona projected by other contemporary collectives, it hardly romanticizes the conditions giving rise to their own subjects' liminal status.

Works of this sort, rather, anticipate a second and linked aspect of their practice. The project Sarai, for one, reveals an approach to media in which latency trumps the manifest and the declarative, and where the commons is as dispersed as it is widely shared. You could say that Raqs is the art world agent of its members' media-based inquiries. It is alongside, through, and within Sarai that they remake the commons in the long shadows cast by its media elites.

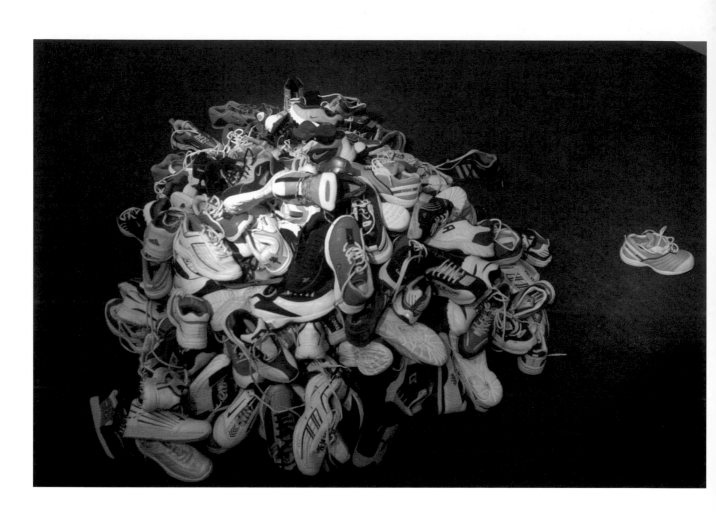

Figure 4.9
Raqs Media Collective, *Lost New Shoes*, 2005. Courtesy the artists.

Sarai

Housed in the basement of the Centre for the Study of Developing Societies (CSDS), an independent research institution located in a leafy neighborhood in North Delhi, Sarai is a nonprofit organization described as a "space for research, practice and conversation about the contemporary media and urban constellations," codirected by two former fellows of the CSDS, Sundaram and Vasudevan, scholars of cinema, media, and urbanism. Raqs and Sarai are both structurally and philosophically inextricable: Raqs refers to questions rarely addressed, Sarai provides the spaces for collective reflection across a range of both actual and virtual sites. These "sites" include the laboratory at the CSDS hosting students and visiting fellows from South Asia and abroad; the thematic readers published annually including writings of both well-known and emerging thinkers; collaborations with other media-based initiatives, such as the programs of the Waag Society in Amsterdam; and—within the space of the commons—the user-generated content resulting from access to, and development of, free software.

Though Raqs coalesced well in advance of Sarai, describing the lead-up to the latter amounts to understanding what is "collective" about the former. The term *sarai* refers to the roadhouse rest stops built during the Mughal period for caravans and travelers, a fitting moniker for a program studying the urban ecology of Delhi, the networked architecture that effectively brokers connections between disparate communities in the city and abroad, and the itinerant sensibility of digital media, its nodes and links and hypertextual excursions. As students of documentary film and communications in the 1990s, Raqs describe a pivotal moment when a "reconfiguration of media spaces" occurred throughout the city. 1998 witnessed spontaneous street protests in Delhi in response to the nuclear tests of both India and Pakistan, but other metropolitan shifts—of a decidedly subterranean nature—were already afoot. "Public phone booths were transforming themselves into street corner cybercafés, independent filmmakers were beginning to organize themselves in forums, and a new open source and free software community made its mark in the city's Electronic Bulletin Boards," Sarai observe in an interview with Mike Caloud.[63]

For Raqs and Sarai both, chaos was the wellspring of creative ferment. Something of a slapdash and improvisational sensibility animates Sarai's description of

this moment, a function of what they call Delhi's "recycled economy"—the repurposing of media that keeps the old in circulation with the new and underscores the ways in which deprivation breeds creativity, often through acts of piracy. In other words, it's a history that flags the brute inequities surrounding access to media, as with any other material resource, as they are experienced on the ground in South Asia. No Napster narrative this: Sarai's is not the oft-told tale of a 13-year-old in the United States downloading Metallica on the sly. Perhaps the rubric of a "digital divide" *seems* a foregone conclusion within Euro-American conversations about digital culture, but the question of the haves and have-nots of this resource can barely touch upon conditions in India, however powerful the images of Bangalore as the subcontinent's answer to Silicon Valley.

Sarai's history also confirms a wider shift in the rhetoric of the commons as mediated through cyberspace. In "The Tragedy of the Commons" Hardin argued that what was once pastoral would turn tragic not only because of the ensuing scarcity of resources but because of the abuse of freedoms that led to it. It is, paradoxically, freedom that brought ruin to the commons, and Hardin's controversial response to this crisis involved such unsavory recommendations as population control. For some of his contemporary readers, however, "freedom" is the prerogative to maximize one's gains relative to a shared resource; and control of that resource—most recently, through aggressive claims to its privatization—is justified as the only way to stem the exploitation of the commons. The consumer sovereign, after all, is imagined to have everyone's back.

Freedom, however, takes on completely different meanings when digital media, an infinitely renewable good, are the resource in question; for information, as it was articulated by the gurus of the emerging digital age, not only "wants to be free" but was thought relative to the utopian flights of a "post-scarcity" age.[64] As Richard Stallman, the founder of the Free Software Foundation, puts it, free means "free not in the sense of free beer" but "free in the sense of free speech."[65] In the age of the consumer sovereign, when the public good is demonized as little more than a welfare state, one is tempted to update this formulation: "free" means free not in the sense of a free market, but free in the sense of a free culture.

Lessig, whose groundbreaking work with the Creative Commons Foundation provides the legal justification for the free culture movement, sees the twinned futures of

innovation and the Internet as resting precisely on access to code. Whether governments or markets take hold of this resource may be beside the point. The question is whether control, as articulated through current forms of copyright law, is in any way relevant to media whose recursive capabilities necessarily exceed such proprietary restrictions, and whose cultures of collaboration and sharing are historically and structurally foundational to the media's technical development in the first place. In *The Future of Ideas*, Lessig details how the evolution of Unix-type operating systems, such as the gold standard of the genre in Linux, facilitated some of the most important innovations in the history of the Internet, developments that happened not because such source code was controlled but because it was free. Regulatory influence over the Internet, on the other hand, can only stand in the way of creativity, whether driving technical improvements and the redistribution of new software or the making of new cultural forms. "It is an iron law of modern democracy," Lessig writes, "that when you create a regulator, you create a target for influence, and when you create a target for influence, those in the best position to influence will train their efforts upon that target."[66]

As if channeling this particular logic, various programs at Sarai use Linux in the creation of a digital commons, work that explores and archives conditions close to home while simultaneously forging connections with communities elsewhere. The collaborative project Cybermohalla (*mohalla* translates as "neighborhood") represents one of the group's most notable efforts to explore the secreted corners and street-level semiotics of Delhi, its own kind of "media city," to borrow one of Sarai's preferred expressions. Partnering with the Ankur Society for Alternatives in Education, a Delhi-based nongovernmental organization, Sarai set up four media labs in slum neighborhoods in which the Ankur Society had established contacts, providing access to such technology while supporting collaborative research and explorations into the city itself.

On the other side of the spectrum, the platform known as Opus (Open Platform for Unlimited Signification), conceived of by Raqs and implemented in collaboration with a number of Sarai residents, facilitates creativity off site in a more explicit thematization of the digital commons. "Opus seeks to build a creative commons with a community of media practitioners, artists, authors and the public from all over the world," the copy on its website reads. "Here people can present their own work and

make it open for transformation, besides intervening and transforming the work of others by bringing in new materials, practices and insights."[67] Opus, in short, makes the work of art itself a kind of commons—a world process—with "the source [code], ... in this case the video, image, sound or text, ... free to use, to edit and to redistribute."

One is struck by the tenor of this language, at once expansive and utopian, in light of Opus's debut: the program launched at Documenta 11 in 2001, arguably among the most prestigious of international art exhibitions. It was around this time as well that the rhetoric of globalization had begun to crystallize in curatorial circles, with Raqs increasingly assuming de facto status as ambassadors of "contemporary Indian art." That identification misses the point, in a way, not least because of the laughable tokenizing of these artists in nationalistic terms. We could put it like this: In spite of the usual buzz around "new genres" and the provisional real estate accorded new-media work in museums and galleries, Opus is not the kind of art that turns up in the market-driven spheres of the conventional art world. With Opus, you could argue, there is really not much to see. As an open-ended platform, theoretically authored by legions of online users, you could say that it's not really "a work" at all, at least not by the usual proprietary standards assumed in both collecting and exhibiting works of art. Visibility will lie elsewhere—or nowhere. And so the peculiar and productive friction between Opus, an open source for the anonymous commons, and Documenta, a historically exclusive collection of authors and insiders, is at the crux of the pseudo-collective tendencies underwriting Raqs's project. To be a collective in the age of the consumer sovereign, after all, means gaming the spaces left in the commons' wake.

Clock

At the Centre for the Study of Developing Societies, a clock hangs on the wall of the library with a curious face, its numbers replaced by a list of emotions oscillating between the disquieting, the banal, and the revelatory: "Anxiety, duty, guilt, indifference, awe, fatigue, nostalgia, ecstasy, fear, panic, remorse, epiphany." The clock, an object furnished by the Raqs Media Collective, portends an uncertain future as it presides over the reading room. Established in 1963, the Centre's reputation stems

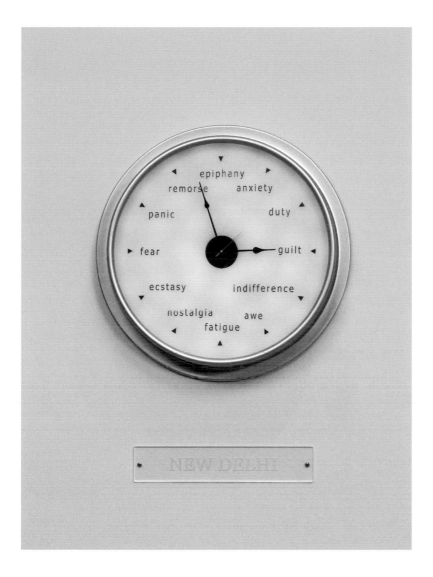

Figure 4.10
Raqs Media Collective, *A Day in the Life of . . .* , 2009. Courtesy the artists.

from its collaborative and interdisciplinary research initiatives—many on progressive social movements. Studies there have sought to question "any one conception of modernity and received models of development and progress" while addressing the "creative use of local traditions in the making of multiple and alternative modernities."

To place this clock at the intellectual heart of such an institution is to announce both the timeliness and the fragility of such endeavors, confirming the fretful pace of a moment for which no singular identity exists. It counts down the affective stakes around the creative uses of such knowledge, apportioned among a community of like-minded but separate users. For this reason, it is not surprising that the clock makes an equally charged appearance on the homepage of Raqs's website, as it does in more than a few of their works. Freed from the bricks-and-mortar actuality of a research institute and the territorializing demands of gravity by extension, the timepiece greets an audience well beyond the Delhi intelligentsia as it appeals to the similarly unknown prospects of knowledge shared across the digital commons.

Conclusion:

Numbers

"Forgetting the art world? Well, it's about bloody time." Such was the response of a well-known artist to the title of this book, far more colorfully expressed than the polite speech of academia. His was a declaration of impatience with that world: its cultures of overweening privilege and its seeming irrelevance to the brute realities of current geopolitics. The charges aren't easy to wish away. As I write these words in a time of global "austerity" measures, the art world's penchant for the frivolous and its coziness with an ascendant oligarchy can only confound—or even offend.

For these reasons, I didn't quite have the heart to tell him that "forgetting the art world" wasn't quite the same thing as ignoring the "official" art world, turning a blind eye to its rituals and intrigues. While I admire this artist unreservedly for his work's unflinching confrontation with such realities, my argument has been that we shouldn't turn away, or better put, *can't*. For better or for worse, we're in it, here and now, the reason, undoubtedly, for our collective exhaustion with it. On the other hand, the artist's complaint inadvertently echoed, some three decades after the fact, a statement treated at length in the introduction of this book: Arthur Danto's claim that "the art world stands to the real world in something like the relationship in which the City of God stands to the earthly city." But my thesis is that the distance between such worlds has closed under globalization; and that it is the *work* of art that has progressively mediated these two realms, formerly theorized as separate and distinct. To repeat: in its "mattering and materialization" the work of art is both object of, and agent for, globalization. It is continuous with, and immanent to, globalization's processes and techniques. It produces and reproduces those processes and techniques. To "forget the art world" is not to leave it behind as though stepping outside it, but to acknowledge both its ubiquity and the continuity of its techniques with a world that we once thought it surveyed, as if existing "down below."

Concluding, I briefly address a strain of contemporary practice that does play fast and loose with the art world's institutional conventions, and no less with those questions of representation raised at the beginning of this book. I do so to make a larger point about the various border crossings that mutually constitute the art world and its globalized vicissitudes. Referred to in chapter 4, such works are encounters in which document and fiction collide; where activism begins and "art" ends; and where the hard edges of the white cube all but dissolve, its coordinates now generalized to the street, the land, the sea, and the ether, the commons and the public sphere. The most powerful readings of these tendencies are by Shannon Jackson and

Carrie Lambert-Beatty, Jackson for what she calls "social works" and Lambert-Beatty in her discussion of the "parafictional."[1] It's no accident that both are scholars of performance art. Whether the ideological high theater of the Yes Men or the notion of "staged management" in the work of William Pope.L, the performative character of such work amounts to a politics in its own right, answering to social movements and matters of global justice, confusing the protocols that are imagined to shelter the art world from the "real" world, and confusing further the lines once drawn between fact and fiction. Bromides about acting in the gap between art and life are subject to urgent revision under globalization's various pressures. That gap, as these practices demonstrate, may already have been eclipsed.

But we need to keep in mind that these tendencies work from other directions as well, which is only consistent with the border crossings on the side of art. Pop culture of the last decade is rife with such examples, media-savvy spectacles in which performance effectively trumps reality, which has in turn become synonymous with contemporary media. Sacha Baron Cohen's popular *Borat* (2006) is a fair illustration, to take a mundane example. An actor goes on the road in character, and in interacting with a spectrum of "real" or everyday people produces something between ethnographic send-up, road movie, mockumentary, and *cinéma vérité*. Other instances abound. If the notion of "reality TV" once sounded a faintly oxymoronic note, the phrase now reads as tautological. Or if the digital worlds created in Second Life first appeared as a harmless online diversion—a cyberspace playground for newly hatched avatars— those linden dollars expose the mechanics of common currency as a fundamentally virtual conceit. In its capacity for buying goods and services within cyberspace, digital money only dramatizes what hard cash and cold credit do in the analog world.

These examples from the pop-cultural domain confirm a point made repeatedly relative to art and globalization. Contemporary global media are integral to narrowing the gap between the art world and other worlds, between representation and presentation. Nothing might sound more obvious at this stage, but a final warning bell of sorts must be struck: such encroachments can be as colonizing and pernicious as they are emancipatory. For that narrowing of gaps would seem in line with yet another kind of closing, discussed in chapter 2: the notion of the "eclipse of distance" that served as both symptom and ideological alibi of Daniel Bell's postindustrial society.

In countering the largely celebratory subtext of Bell's idea, I finish with two examples which, virtual as they may be, are abjectly material in their implications. They are

identified by numbers rather than proper names, which captures the peculiar mutability of cultural forms I'm describing. If these numbers suggest something abstract and rational—appealing to a sense of clarity and objectivity by extension—their significance on the ground is anything but.

419

Hello,

I am MR.HAENSSGEN HORST DIETER and the Deputy Managing Director of a reputable Bank. I was the accounting officer of a reputable client of ours who shares your surname and is a national of yours who resided in our locality; He was a construction contractor here. On the 16th of March 2006, my client, his wife and their only son were involved in a car accident. All occupants of the vehicle unfortunately lost their lives. Since then I have made several inquiries to your embassy to locate any of my clients extended relatives this has also proved unsuccessful.

After these several unsuccessful attempts, I decided to track his last name over the Internet, to locate any member of his family hence I contacted you. I have contacted you to assist in repatriating the assets and huge Capital of funds left behind by my client before they get confiscated or declared unserviceable by the shareholders of this bank, Please if interested respond to my email address. So that I would give you more details
Regards,

MR.HAENSSGEN HORST DIETER

Anyone who has ever bothered with email has surely made the acquaintance of "someone" like Mr. Haenssgen Horst Dieter, if not his countless improbably named colleagues writing from similarly far-flung destinations. Whatever the name of the author, and wherever the alleged location from which the messages issue, these letters hew to a set of narrative tropes with impressive fidelity. A reputable figure, an

official representative of a recently deceased individual or family, has been searching for the rightful heir to a small fortune, and reaches out across the ether to make contact. Praise is given to god in locating that individual (the recipient, of course, being you), who stands to reap untold gains through continued interaction with the writer. But only, if only, one were ultimately trusting enough to part with sensitive numbers. The numbers of your bank account or credit card, for instance, or maybe even your Social Security . . .

So pervasive are these online confidence tricks, outlandish exercises in phishing, that a genre of websites has cropped up devoted to collecting such missives and exposing their fraudulence through a kind of reverse gaming called "scam baiting."[2] The game is easy to play and has itself been described as a type of performance or theater. Upon retrieving such a message from your inbox, you assume the role of naïf, taking the proverbial bait. You answer the query of Mr. Haenssgen Horst Dieter with a generic response; you continue the online exchange to the point where Mr. Dieter begins to demand specifics about your personal information. The goal is to see how much more elaborate, baroque, and even imaginative the dodge can become, and the lengths to which the perpetrators might go in the interest of stealing your money. Basically, you're testing the creativity, flexibility, and artfulness of the charade, given the well-established patterns of the inaugural communication.

In Internet lore, these letters have become identified with the number 419, after the corresponding article of the Nigerian Criminal Code.[3] While many of these advance-fee frauds do originate in Nigeria, where an entire criminal element has sprung up around them since the late 1990s, the itinerant character of the medium dictates that such letters are hardly exclusive to that place, arriving as well from Russia, South Africa, Ukraine, Spain, the Netherlands, and the United States, among other countries. Nonetheless the term "419 fraud" remains instructive for what it communicates about the kind of border crossing much contemporary art performs, if from a different corner of the ethical spectrum. "419" identifies the location of these messages as geographically situated, bringing the ether down to earth, as it were, and more crucially marks the passage of such virtualities into the realm of the juridical and the economic, law and commodity both. As one scholar put it, the rise and accessibility of email made such letters "one of Nigeria's most important export industries."[4] To call such

communications an "industry" and an "export" is to acknowledge their irredeemably materialist consequences—and from a country pegged as one of the "Next 11" (N-11) economies by no less than Goldman Sachs.

If the success of these gambits seems increasingly implausible given their notoriety, the sheer volume of such letters flooding inboxes everywhere suggests that money can still be made from the swindle. All it takes is one gullible singularity among the multitudes to pay handsome dividends: the potential is very real indeed, with some $200 million allegedly pilfered from Americans at one time. In this regard the 419 genre sheds light on other instances of contemporary media, seemingly inconsequential messages which assume a decisive phenomenal weight and gravity. Taking the form of SMS text messages or blogs, they might be followed by thousands or fall on resolutely deaf ears. They might call forth the riotous passions of a flash mob or narrate the shopping habits of an Ashton Kutcher. Or maybe the gesture will meet up with a firewall that will prove the farthest thing from virtual, a trenchant reminder of the recalcitrance of media and the desperate stakes around which much of it ultimately turns.

140

Indeed, the second significant number in this vein is 140. As any fourteen-year-old will tell you, this is the maximum number of characters in a tweet, one of those SMS posts that often read like mangled haikus. With the untold number of messages that go out each day, whether from wannabes or upstart businesses, there's little way to quantify the ratio between fluff and genuine information. But where art is concerned, the use of the medium has lately become an issue of the cinderblock world and the flesh-and-blood subjects who would inhabit it.

Take the example of China's most famous contemporary artist, Ai Weiwei, a global artist par excellence: signatory of China's rise in the international art market, contributor to the design of Beijing's Olympic Stadium, and one-time resident of New York's Lower East Side. Perhaps it is his work in media that most strongly endorses his global cachet. His commitment to the blogosphere and to Twitter—and his unvarnished criticism of the Chinese government—are arguably equal to his work as

a sculptor.[5] His faithfulness to the medium and its activist potential is registered by the history, consistency, and frequency of his messages, roughly from 2006 forward (2,700 posts on Sina Blog). Such tweets and blog postings range in tenor from the harshly satiric to the philosophical to the scathing. The devastating 2008 earthquake in Sichuan province, killing nearly 70,000 people including an estimated 6,000 school children, prompted an angry and mournful attack on the corruption of local officials who may have been paid off to circumvent critical building codes.[6]

For all the vehemence of Ai Weiwei's blog entries, it is the economy of the Twitter dispatch—those "mere" 140 characters—that most poignantly crystallizes the urgency of his endeavor. And so I end with two of these messages, no more than 280 Chinese characters in total. As translated by a dedicated online community of followers from around the world, they telegraph both the promise and the liabilities of such crossings, the movement between the ethereal imagination and its concrete actuality as an art world. They signal more broadly the risks, the potentialities, and the mortal prospects of a globalized art world uncontained by, or perhaps liberated from, its historically policed borders.

Friday, March 25, 2011

According to analysis, the continuing large-scale attacks to Google and Facebook for the past hours are suspected to be from extremely skilled hackers "with a background and at state level" from somewhere in Beijing or Harbin. At the same time, the Iranian government has imposed stricter censorship.

据分析,过去几十小时对谷歌和脸?的持续强大攻击疑似来自北京及哈尔?某处的"有背景的,国家级"极为成熟的黑客技术手段支持。 同时,伊朗政府的屏蔽手段也升级[7]

Sunday, April 3, 2011

One hour ago a bunch of police came to Ai Weiwei Studios at Caochangdi FAKE 258 with a search warrant and 8 staff members were taken away to Bejiing Chaoyang District Nangao police station for questioning: Xu Ye, Qian Feifei, Dongjie, Xiaowei, Xiaoxie, Xing Rui, Jiang Li, Xiaopang Zhizi. Lu Qing [Ai Weiwei's wife]

is with the police at home. There are now police at both the front and the back doors of the studio and no one is allowed to enter or leave. Ai Weiwei has been detained at Beijing Capital Airport for 3 hours and [we] have been unable to contact him. (This is an assistant tweeting).

一小时前来了一批警察出示搜查令,来到艾未未工作室草场地发棵258号,带走了8个工作人员至北京朝阳区南皋派出所问?:徐烨,钱飞飞,董姐,小伟,小谢,邢锐,蒋立,小胖侄子。路青一人与警方在家,现在工作室前后门均有警察,无法进出。艾未未在北京机场已被扣押3小时,无法联系。(未未助手

Please note this is a rough translation only—corrections needed.[8]

Notes

Acknowledgments

1. Pamela M. Lee, "Introduction," in *Site/Seeing: Travel and Tourism in Contemporary Art,* organized by Jonathan Caseley, Karin Higa, and Pamela M. Lee (exhibition booklet), (New York: Whitney Independent Study Program, 1991), 1.

Introduction: Forgetting the Art World

1. Let me be clear that I am not claiming there is no "outside" of the art world, even if (as one of the dominant arguments on globalization will hold) there may be no "outside" to Empire. The distinction to be made is whether or not one who formerly identified with the historical notion of an art world (as defined by the philosopher Arthur Danto) can now purport to move outside its progressively expansive reach. To suggest that there is no "outside" as such, however, is to buy into the notion that all forms of culture and social experience have been homogenized or rendered universal through the processes of globalization.

2. For example, Richard Florida, *The Rise of the Creative Class* (New York: Basic Books, 2002). Likewise, see the document by UNESCO, "Culture, Creativity and Markets," cited in George Yúdice, *The Expediency of Culture: Uses of Culture in a Global Age* (Durham: Duke University Press, 2003), 28.

3. Walter Benjamin, "The Work of Art in the Age of Mechanical Reproduction," in *Illuminations*, trans. Harry Zohn (New York: Schocken Books, 1986), and Theodor W. Adorno and Max Horkheimer, "The Culture Industry; or, Enlightenment as Mass Deception," in *Dialectic of Enlightenment* (Stanford: Stanford University Press, 2002). In the postwar moment, Guy Debord's theory of the spectacle has proven the most influential reading of a world in which all social relations are mediated by capital as hardened into an image. Guy Debord, *Society of the Spectacle* (New York: Zone Books, 1995). For a more recent critical account of the rise of architecture and design within culture, see Hal Foster, *Design and Crime* (London: Verso, 2002).

4. Yúdice, *The Expediency of Culture*, 13. Yúdice is clear that his argument does not reprise the well-known theses of the Frankfurt School regarding the commodification of culture but instead takes on the "expanded role of culture" as a "crucial sphere of investment"—one critical to the larger working of global capital.

5. Though the word "globalization" is of recent etymological vintage, the concept finds a decisive genealogy in social theory since at least the nineteenth century, with the *Communist Manifesto* foremost among those writings diagnosing what many consider globalization's most salient features. As Marx and Engels famously write,

> Modern Industry has established the world market. . . . All fixed, fast frozen relations . . . are swept away; all new-formed ones become antiquated before they can ossify. All that is solid melts into air. . . . The need of a constantly expanding market for its products chases the bourgeoisie over the whole surface of the globe. . . . All old-established national industries have been destroyed or are daily being destroyed.

Karl Marx and Friedrich Engels, "Manifesto of the Communist Party," in *The Marx-Engels Reader*, ed. Robert C. Tucker (New York: Norton, 1978), 475–476. Globalization's more recent economic inflection is linked to the Harvard economist Theodore Levitt in his 1983 article "The Globalization of Markets," *Harvard Business Review*, May-June 1983, 1–12. According to Levitt's obituary, however, the word itself appears to have entered the lexicon around 1944. Barnaby J. Fedder, "Theodore Levitt, 81; Coined the Term 'Globalization,'" *New York Times*, July 6, 2006.

6. To define globalization is to wrestle with its periodization. Immanuel Wallerstein's World-Systems analysis famously historicizes its univocal nature relative to the capitalist world economy (e.g., through the categories of core, periphery, and semiperiphery) as a singular system in place since the sixteenth century in which "the whole planet operates

within this regulatory mechanism of a binding and constant division of labor" (Ulrich Beck, *What Is Globalization?* [Cambridge, U.K.: Polity Press, 2000], 32). Wallerstein's association with sociologists such as Giovanni Arrighi is indebted to the model of history as *longue durée* elaborated by Fernand Braudel and the Annales School; a reliance upon the long-wave theory proposed by the Soviet historian N. D. Kondratiev has been critical to such reflections. On these methodologies see Terence K. Hopkins and Immanuel Wallerstein, "The World-System: Is There a Crisis?," in their *The Age of Transition: Trajectory of the World-System 1945–2025* (London: Zed Books, 1996), 1–10.

By contrast, a reading such as Michael Denning's *Culture in the Age of Three Worlds* (London: Verso, 2004) identifies globalization relative to the "Age of Three Worlds," that is, from 1945 to 1989. While my study acknowledges the centrality of early modern accounts of globalization, its particular engagement with post-Fordist production marks the beginning of the 1970s (the delinking of the gold standard and the end of Bretton Woords, the global oil crises, etc.) as especially salient to neoliberal globalization.

7. Arjun Appadurai, *Modernity at Large: Cultural Dimensions of Globalization* (Minneapolis: University of Minnesota Press, 1996), 32. This is indeed how the sociologist Ulrich Beck characterizes the globalization debate in his helpful analysis (*What Is Globalization?*, 32).

8. A representative and diverse group of texts speaking to such themes might include Jacques Derrida, *Spectres of Marx* (New York: Routledge, 1994); Serge Latouche, *The Westernization of the World: The Significance, Scope and Limits of the Drive toward Global Uniformity* (Cambridge, U.K.: Polity Press, 1996); and the postcolonial criticism associated with Homi Bhabha such as his *The Location of Culture* (London: Routledge, 1994).

9. Hal Foster, "Against Pluralism," in *Recodings* (Seattle: Bay Press, 1985), 15.

10. Which is, perhaps, to beg the question of whether the art world as it is generically understood *is* a Eurocentric institution. I am aware that this formulation suggests there were no "art worlds" outside the usual centers of art commerce—New York, Paris, and London, for starters. This is certainly not my claim, as the history of art too readily shows. On the other hand, the notion of an art world to be discussed has indeed been *treated* as a distinctly Eurocentric institution. For a critique of this phenomenon, see Alfred Gell's reading of the controversial 1988 exhibition at the Museum for African Art, New York, "Art/Artifact," for which Danto contributed a catalog essay. Alfred Gell, "Vogel's Net: Traps as Artworks and Artworks as Traps," in Howard Morphy and Morgan Perkins, eds., *The Anthropology of Art: A Reader* (Malden, Mass.: Blackwell, 2006), 219–237.

11. On a related issue—the crisis of recent art refusing to acknowledge its apparent groundlessness—see the discussion between Paul Virilio and Sylvère Lotringer in *The Accident of Art* (New York: Semiotexte, Foreign Agents, 2005).

12. In a conversation with Stuart Hall, Michael Hardt makes a pointed comparison between political representation (the fate of democracy under globalization) and its correlate aesthetic representation. See Stuart Hall and Michael Hardt in "Changing States: In the Shadow of Empire," in Gilane Tawadros, ed., *Changing States: Contemporary Art and Ideas in an Era of Globalization* (London: Institute of International Visual Arts, 2004), 132–138.

13. Tim Griffin, "Global Tendencies: Globalism and the Large-Scale Exhibition," *Artforum International* 42, no. 13 (November 2003): 152–163; James Meyer, "Roundtable on Globalism," in the same issue of *Artforum International*; and the much earlier "The Global Issue: A Symposium," *Art in America* 7, no. 7 (July 1989). There is also a literature that focuses on the role of the land in these narratives, whether in terms of site-specific art or of issues of diaspora. See, e.g., Irit Rogoff, *Terra Infirma: Geography's Visual Culture* (London: Routledge, 2000); Miwon Kwon, *One Place after Another: Site-Specific Art and Locational Identity* (Cambridge, Mass.: MIT Press, 2002).

14. See Irit Rogoff, "Geo-Cultures: Circuits of Arts and Globalizations," in Jorinde Seijdel, ed., *Open: The Art Biennial as a Global Phenomena* (Rotterdam: NAi Publishers, 2009), 106–116.

15. Consider the Chinese art market as paradigmatic of this phenomenon. The literature on the topic is enormous, from its meteoric ascendance circa 2005 to its precipitous downturn with the global recession in 2009. A sample of articles that collectively chart its rise and fall include David Barboza, "Chinese Art Market Booms, Prompting Fears of a Bubble," *New York Times*, January 4, 2007, http://www.nytimes.com/2007/01/04/world/asia/04ihtchina.4097207 .html?pagewanted=1. Charles Saatchi's purchase of a painting by Zhang Xiaogang for $US1.5 million signaled the radical upswing of the global market for Chinese art, followed by a Swiss collector who bought a painting by Zhang for over $US2 million.

By the same token, the success of this market is also related to the efforts of two curators, of different kinds, whose influence in the Euro-American reception of recent Chinese art has been considerable: Hou Hanrou (formerly of Paris and currently of San Francisco) and the art historian Wu Hung, professor at the University of Chicago. On Hou's many curatorial and critical endeavors—a great many of which appeal to issues of China's place in a global art world—see his collected writings *On the Mid-Ground*, ed. Yu Hsiao-Wei (Hong Kong: Time Zone 8, 2002). The esteemed art historian Wu Hung has organized a number of high-profile exhibitions, including most recently "Transience: Chinese Experimental Art at the End of the Twentieth Century," in 2005.

16. A very brief sampling of these curators' exhibitions and publications includes: Okwui Enwezor, ed., *Documenta 11, Platform 1: Democracy Unrealized* (Ostfildern-Ruit: Hatje Cantz, 2002); Francesco Bonami, ed., *Dreams and Conflicts: The Dictatorship of the Viewer: La Biennale di Venezia: 50th International Art Exhibition* (New York: Rizzoli, 2003); Catherine David and François Chevrier, eds., *Politics, Poetics: Documenta X* (Ostfildern-Ruit: Hatje Cantz, 1997); and "Cities on the Move" (a multipart international exhibition organized by Hans-Ulrich Obrist and Hou Hanrou).

17. See the special cahier on the "Art Biennial as a Global Phenomenon" in Seijdel, *Open*.

18. Charlotte Bydler, *The Global Artworld, Inc.: On the Globalization of Contemporary Art* (Uppsala, Sweden: Uppsala University, 2004). Bydler's doctoral thesis, published as a book, remains a highly instructive text on globalization and contemporary art for its detailed analyses of select international exhibitions, including those in Istanbul, Havana, Kwangju, and the roaming European biennial, Manifesta.

19. See Documenta, *50 Years of Documenta, 1995–2005* (Göttingen: Steidl/Documenta, 2005).

20. Thomas McEvilley, "Arrivederci Venice: The Third World Biennials," *Artforum International* 32, no. 9 (November 1993): 114.

21. Two examples confirm his point. The case of Dak'Art, evolving from its earlier incarnation as the Dakar Biennial in 1992, represented a new focus on the contemporary arts of a decolonized Africa, Léopold Senghor's *Négritude* realized in art world terms over three decades after the founding of Senegal. For its part, the Gwangju Biennial was established in response to the May 18, 1980, uprising against the military junta of Chun Doo-hwan, which led to the massacre of countless citizens. To follow Lee Yongwoo, the Biennial's first curator, the exhibition "has a quite different purpose compared to other biennales of the West"; it is "about probing Korea's modern history and treating its wounds." Cited in Bydler, *The Global Artworld, Inc.*, 13.

22. Karen Fiss's current research on visual arts, design, and nation branding in South Africa and other countries is instructive here. She has delivered papers on the topic at the African Studies Association meeting in San Francisco, November 2010 ("Mbeki's Pan-Africanism: Tradition, Heritage, and National Identity at Pretoria's Freedom Park") and at the Reina Sofía, Madrid, in March 2011. Her manuscript in progress is tentatively titled "From Nation Building to Nation Branding."

23. UNESCO report cited in Yúdice, *The Expediency of Culture*, 28.

24. On the Singapore Biennial, see my review "2006 Singapore Biennial," in *Artforum International* 45, no. 3 (November 2006): 289–291.

25. Bydler, *The Global Artworld, Inc.*, 64.

26. See the diverse and often deeply illuminating literature on art and the airport or the visual culture of the airport: for example, Martha Rosler, *In the Place of the Public: Observations of a Frequent Flyer* (Stuttgart: Hatje Cantz Verlag, 1999); Johan Grimonprez, *In Flight* (exhibition publication to accompany "Dial 'H-I-S-T-O-R-Y,'" 1998); David Pascoe, *Airspaces* (London: Reaktion Books, 2001).

27. Kwon, *One Place after Another*, 156.

28. The rhetoric of "tension and contradiction" is manifest in Francesco Bonami's jointly organized version of the 50th Venice Biennale, "Dreams and Conflicts: The Dictatorship of the Viewer."

29. In calling on the notion of "agency" and the art world I point to Alfred Gell's anthropological theories surrounding "art and agency" and its influence on the study of world art history. For an instructive review and reflection, see Whitney Davis, "Abducting the Agency of Art," in *Art's Agency and Art History* (Malden, Mass.: Blackwell, 2007), 199–220.

30. Arthur Danto, "The Artworld," *Journal of Philosophy* 61, no. 19 (October 15, 1964): 571.

31. Arthur Danto, "Artworks and Real Things," *Theoria* 39, nos. 1–3 (April 1973): 11–12.

32. George Dickie, *Art and the Aesthetic: An Institutional Analysis* (Ithaca: Cornell University Press, 1974).

33. Among his many influential works exploring the notion of cultural capital, see Pierre Bourdieu, *Distinction* (Cambridge, Mass.: Harvard University Press, 1984).

34. Gell, "Vogel's Net."

35. Lawrence Alloway, "Network: The Art World Described as a System," *Artforum* 10, no. 9 (September 1972): 29.

36. Ibid.

37. Ibid.

38. Baldessari quoted in Manav Tanneeru, "Globalization, Technology Changing the Art World," *cnn.com*, November 26, 2006, http://articles.cnn.com/2006-11-26/entertainment/art.globalization_1_high-art-curators-and-museum-directors-art-boom?_s=PM:SHOWBIZ

39. Yúdice, *The Expediency of Culture*, 12, 17.

40. Ibid., 19.

41. Michael Hardt and Antonio Negri, *Empire* (Cambridge, Mass.: Harvard University Press, 2001), 411.

42. The influential Swedish curator Daniel Birnbaum, for example, made this rubric the point of departure for the Venice Biennial, "Making Worlds." Daniel Birnbaum, ed., *Making Worlds: 53rd International Art Exhibition: La Biennale di Venezia* (Milan: Marsilio, 2009). In another register, a wide-ranging effort is afoot to theorize the notion of "world art" from the belated perspective of globalization; programs such as the "world art studies" curriculum at the University of East Anglia dramatize the institutional momentum behind such initiatives, while monumental studies (among which the work of David Summers is exemplary) reimagine the very shapes by which art history might be researched and written. For his discussion of David Summers and the question of world art history more broadly, see James Elkins, ed., *Is Art History Global?* (London: Routledge, 2006). Finally, for a philosophical consideration of "world" and the

image indebted both to Heidegger and to psychoanalysis, see Kaja Silverman, *World Spectators* (Stanford: Stanford University Press, 2000).

43. See note 9 to "Study for an End of the World," the second chapter in my *Chronophobia: On Time in the Art of the 1960s* (Cambridge, Mass.: MIT Press, 2004), 327.

44. Ibid.

45. Given the philosopher's ignominious association with National Socialism, it may seem especially questionable—even inappropriate—to make reference to Heidegger in the context of globalization. Still, his later essay, "The Thing" famously opens with a description that foreshadows the most pervasive global thematic:

> "All distances in time and space are shrinking. . . . Man now reaches overnight, by plane, places which formerly took weeks and months of travel. He now receives instant information, by radio, of events which he formerly learned about only years later, if at all.

Martin Heidegger, "The Thing," in *Poetry, Language, Thought* (New York: Harper, 2001), 163. I would argue that Heidegger's thought has significantly permeated the literature on globalization, and cognate debates within the humanities on power and postcolonialism. Among others, see Dipesh Chakrabarty in his important text *Provincializing Europe: Postcolonial Thought and Historical Difference* (Princeton: Princeton University Press, 2000).

46. Fredric Jameson, "Preface," in Jameson and Masao Miyashi, eds., *The Cultures of Globalization* (Durham: Duke University Press, 1999), xi.

47. See Jameson on the eclipse of critical distance as a signal feature of postmodernism, in *Postmodernism: The Cultural Logic of Late Capitalism* (Durham: Duke University Press, 1991), 181; also see his discussion of immanence and nominalism in Adorno in the same, 192.

48. On this point I depart from the observation made by the collective Superflex that "since the early 1970s it has been impossible to describe the category of art in formal terms." Though I gather the group is referring to the sclerotic or clichéd notion of formalism associated with Clement Greenberg, I would insist that globalization (and global spectacle) demands we be that much more attentive to the formative dimensions of works of art and visual culture. See Superflex's terrific book *Self-Organisation/Counter-economic Strategies* (New York: Sternberg Press, 2006), 322.

49. Hamza Walker, "The Grand Scheme of Things," Renaissance Society at the University of Chicago, 2007, http://www.renaissancesociety.org/site/ Exhibitions/Essay.Steve-McQueen-Gravesend.591.html

50. Joseph Conrad, *Heart of Darkness and the Secret Sharer* (New York: Classic Books America, 2009), 3.

51. The title of T. J. Demos's essay on McQueen and other artists, "Moving Images of Globalization," beautifully captures the sense of the film's motility and locates this tendency relative to its ambiguity, particularly where the representation of the workers is concerned. As he writes, "*Gravesend*'s filmic construction blurs the referential and the allegorical, the documentary and the fictional, in order to convey savagery through phenomenological estrangement." Demos treats the ambiguity of *Gravesend* through recourse to both Giorgio Agamben and Jacques Rancière, the later of whose *Politics of Aesthetics* has become critical in discussions of recent art. Demos, "Moving Images of Globalization," *Grey Room* 37 (Fall 2009): 6–29.

52. Alan G. Artner, "'Gravesend' Fails to Stand on Its Own: Film Is Ambitious, but It Needs Text to Be Understood," *Chicago Tribune*, September 27, 2007, http://articles.chicagotribune.com/2007-09-27/features/0709250502_1_renaissance-society-film-gravesend (accessed March 9, 2010).

53. Doreen Massey, *For Space* (London: Sage, 2005), 81.

54. Steve McQueen, phone conversation with the author, March 9 and 10, 2010.

55. The first time I saw *Unexploded* I was reminded of Gordon Matta-Clark's work, whose own manipulation of holes and architecture was a cogent spatial and political comment on the destruction of place and historical memory in the 1970s. In discussion, McQueen confirmed the observation, suggesting that the parallel struck him in the process of editing the footage. Yet it is perhaps less Matta-Clark's work and more its peculiar afterlife in recent military affairs that is to the point of McQueen's film. Consider the disturbing update of such politics as described by Eyal Weizman in his account of Israel's Operational Theory Research Institute (OTRI) in "Urban Warfare," in *The Hollow Land: Israel's Architecture of Occupation* (London: Verso, 2007), 209.

56. On Coltan, see Amnesty International (AI), "Democratic Republic of Congo: Rwandese-Controlled East: Devastating Human Toll," *Amnesty International Online*, 19 June 2001; and Blaine Harden, "The Dirt in the New Machine," *New York Times,* August 12, 2001, section 6, 35.

57. Thomas Friedman, *The World Is Flat: A Brief History of the Twenty-First Century* (New York: Farrar, Strauss and Giroux, 2006), 340.

58. More to the point, though, is that it is not a radio but rather a mobile phone that is the instrument mediating this babble of voices. McQueen reports that it was the British media controversy known as the "Squidgy Tapes"—the recording of cell phone conversations exposing the affairs of Princess Diana that was the inspiration for this soundtrack.

59. Harden, "The Dirt in the New Machine," 35.

1 The World Is Flat/The End of the World: Takashi Murakami and the Aesthetics of Post-Fordism

A version of this chapter was published as "Economies of Scale: Takashi Murakami's Technics," *Artforum International* 46, no. 2 (October 2007): 336–343. Research considers Murakami's studio practice in Asaka, that is, prior to the move of his "factory" to Tokyo. Throughout I deploy the Western convention of placing the given name of the artist ("Takashi") before the surname ("Murakami").

1. Haruki Murakami, *Hard-Boiled Wonderland and the End of the World*, trans. Alfred Birnbaum (New York: Vintage International, 1993), 305–306.

2. Murakami himself is the first to draw upon these sources; but for two of the numerous accounts describing these connections, see the essays collected in Margit Brehm, ed., *The Japanese Experience: Inevitable*, exh. cat. (Ostfildern-Ruit, Germany: Ursula Blickle Foundation and Hatje Cantz Verlag, 2002); and Jeff Fleming, Susan Lubowsky Talbott, and Takashi Murakami, *My Reality: Contemporary Art and the Culture of Japanese Animation* (Des Moines: Des Moines Art Center; New York: Independent Curators, NY, 2001). Although this essay attends mostly to Murakami's early "superflat" moment, also see the essays in Paul Schimmel, ed., *Murakami* (New York: Rizzoli; Los Angeles: Museum of Contemporary Art, 1997).

The abundant literature on manga and anime includes Frederik L. Schodt, *Dreamland Japan: Writings on Modern Manga* (Berkeley: Stone Bridge Press, 1998). *Otaku* represents the potentially dark side of the equation: In the late 1980s, *otaku* began to take on sinister connotations when it was discovered that one Tsutomu Miyazaki had kidnapped and murdered four young girls. According to Schodt, Miyazaki left the remains of one his victims with her family, using as his pseudonym the name of one of his favorite anime characters. Miyazaki was apprehended and discovered to be an obsessive anime and manga fan, which spawned endless debate on the antisocial, indeed dangerous

tendencies associated with reading and collecting manga, especially its pornographic variants. *Otaku* at this point become synonymous with mania and antisocial forms of behavior. See Sharon Kinsella, "Amateur Manga Subculture and the Otaku Panic," in *Adult Manga: Culture and Power in Contemporary Japanese Society* (Honolulu: University of Hawai'i Press, 2000), 102–139. For a reading that expressly links Superflat to the timing of anime (with recourse to the theories of Jean-Louis Baudry and Paul Virilio), see Thomas LaMarre, *The Anime Machine* (Minneapolis: University of Minnesota Press, 2009); also see LaMarre on *otaku* and Murakami in "Otaku Movement," in Tomiko Yoda and Harry Harootunian, eds., *Japan after Japan: Social and Cultural Life from the Recessionary 1990s to the Present* (Durham: Duke University Press, 2006).

3. Nihonga, which translates to "Japanese painting," is the term loosely associated with all Japanese art making of the Meiji era (1868–1912) based on the formats and materials of traditional Japanese art. On Nihonga, see Ellen Conant, *Nihonga: Transcending the Past Japanese Style Painting 1868–1968* (St. Louis: Saint Louis Art Museum, 1995). Also useful are books on the two figures most closely identified with its institutionalization in the art academies, namely, Ernest Fenollosa and Okakura Tenshin; but as Conant points out, the relationship between the two and Nihonga is necessarily more complex than those conventional narratives which hold that Fenollosa effectively "invented" the genre, a conceit with colonializing implications. See Victoria Weston, *Japanese Painting and National Identity: Okakura Tenshin and His Circle* (Ann Arbor: Center for Japanese Studies, University of Michigan, 2004). Shigemi Inaga's deeply illuminating scholarship on aesthetics, Japanese modernity, and cultural exchange with the West is also of great relevance here, as in Inaga, "Philosophia, Ethica and Aesthetics in the Far-Eastern Cultural Sphere: Receptions of the Western Ideas and Reactions to Western Cultural Hegemony," unpublished paper delivered at conference "Cultures of Knowledge," 2005, Pondicherry; final version, February 2007.

4. Takashi Murakami, "A Theory of Super Flat Japanese Art," in *Superflat* (Tokyo: Madra Publishing, 2000), 17.

5. For an excellent treatment of this problem as it relates to the work of, among others, Kara Walker, see David Joselit, "On Flatness," in Zoya Kocur and Simon Leung, eds., *Theory in Contemporary Art since 1985* (London: Wiley-Blackwell, 2004), 209–308.

6. See Leo Steinberg's classic reading of "the flatbed picture plane," in Steinberg, *Other Criteria: Confrontations with Twentieth-Century Art* (London: Oxford University Press, 1972), 88.

7. Doreen Massey, *For Space* (London: Sage Publishing, 2005).

8. Stuart Hall, "Brave New World," *Marxism Today,* special issue: "New Times" (October 1988): 24–29.

9. The economic stagnation of countless markets in the 1970s prompted social scientists to reflect on what was called "the crisis in Fordism" and the dominance of the United States in international economics. As one put it, it "reflects a certain preoccupation with the changing fortunes of American capitalism and the decline of US hegemony in the global market . . . signaling the end of the global diffusion of . . . the 'American Way of Life.'" See Mark Elam, "Puzzling Out the Post-Fordist Debate: Technology, Markets and Institutions," in Ash Amin, ed., *Post-Fordism: A Reader* (Oxford: Blackwell Press, 1994), 43.

10. In the section of the *Prison Notebooks* dating from 1934 entitled "Rationalization on the Demographic Composition of Europe," Gramsci writes of the catastrophic effects of Fordism's importation into Italy after World War I:

> In Europe the various attempts which have been made to introduce certain aspects of Americanism and Fordism have been due to the old plutocratic stratum which would like to reconcile what, until proved to the contrary, appear to be irreconcilables: on the one hand the old, anachronistic, demographic social structure of Europe, and on the other hand an ultra-modern form of production and of working methods—such as is offered by

the most advanced American variety, the industry of Henry Ford. For this reason, the introduction of Fordism encounters so much "intellectual" and "moral" resistance, and takes place in particularly brutal and insidious forms, and by means of the most extreme coercion. Europe wants to have its cake and eat it, to have all the benefits which Fordism brings to its competitive power while retaining its army of parasites who, by consuming vast sums of surplus value, aggravate initial costs and reduce competitive power on the international market.

Selections from the Prison Notebooks of Antonio Gramsci, ed. Quentin Hoare and Geoffrey Nowell Smith (London: Lawrence and Wishart, 1971), 51.

11. If Gramsci's reading was intended to counter the hegemony of American-style industry in the historical context of Italy between the wars, Fordism has more generically been equated with standardization: the vertical integration of all steps in the productive process and the accumulation of capital demanded in the shift from craft to mass production. On the architecture and design of Fordism, which literally facilitates these models of production, see Federico Bucci, *Albert Kahn: Architect of Ford* (Princeton: Princteon Architectural Press, 2002).

12. Social scientists trace three main positions with regard to the post-Fordist debate, which can briefly be summarized as (1) the regulation approach, (2) the flexible specialization approach, and (3) the neo-Schumpeterian approach. The regulation approach draws on the twinned concepts of "regime of accumulation" (a stable mode of macroeconomic growth) and "mode of regulation" (a mode of social and economic regulation) in an effort to historicize capitalist development. This approach is most often associated with authors such as Aglietta, Coriat, and Lipietz.

 The "flexible specialization approach" advanced by the American sociologists Charles Sabel, Michael Piore, and Jonathan Zeitlen, among others, focuses on the notion of "Industrial Divides"—or what have been called "arenas of production." In contrast to mass production technologies, "flexible specialization"—a form of "craft production"—has been argued to supersede the Fordist model with the stagnation of markets in the 1970s.

 The third model renovates Nikolai Kondratiev's influential model of 50-year "waves" and Joseph Schumpeter's theory of business cycles. It argues for the crisis of Fordism in terms of the passage of Kondratiev's "fourth long wave," in part instantiated by the rise of new electronic technologies. Accusations of technological determinism have plagued the reception of this particular school of thought. See Michael J. Piore and Charles F. Sabel, *The Second Industrial Divide: Possibilities for Prosperity* (New York: Basic Books, 1984).

 For two very useful introductions to these positions see Ash Amin, "Post-Fordism: Models, Fantasies and Phantoms of Transition," in Amin, *Post-Fordism: A Reader*, 1–41; and Elam, "Puzzling Out the Post-Fordist Debate."

13. David Harvey, "From Fordism to Flexible Accumulation," in *The Condition of Postmodernity* (Oxford: Blackwell Press, 1990), 141–172.

14. The notion of flexibility is almost as controversial as the debate on post-Fordism itself. It is conceived largely through modes of production—the notion of industrial divides associated primarily with the work of Charles F. Sabel and Michael J. Piore; its rhetoric has also been theorized extensively by critical urban geographers or economic geographers such as David Harvey, who attend to the ways in which new managerial strategies produce new conceptions of space relative to labor. On the debates around flexibility, see James Curry, "The Flexibility Fetish: A Review Essay on Flexible Specialization," *Capital and Class* 50 (Summer 1993): 99–126; Meric S. Gertler, "The Limits of Flexibility: Comments on the Post-Fordist Vision of Production and Its Geography," *Transactions of the Institute of British Geographers*, n.s. 13, no. 4 (1988): 419–432. Also see Harvey, "Theorizing the Transition," in *The Condition of Postmodernity*, 173–189.

15. The Toyota production system—the "just in time" or *kanban* system—was first conceived and implemented after the end of the Second World War by the engineer Taiichi Ohno. On the philosophy and mechanics of this system, see Taiichi Ohno, *Toyota Production System: Beyond Large-Scale Production* (Portland, OR: Productivity Press, 1978); Shigeo Shingo, *Study of Toyota Production System: From Industrial Engineering Viewpoint* (Tokyo: Japan Management

Association, 1981); and Yasuhiro Monden, ed., *Applying Just in Time: The American/Japanese Experience* (Norcross, GA: Industrial Engineering and Management Press, 1986). On the emergence of Toyotaism relative to Ford, see Haruhito Shiomi and Kazuo Wada, *Fordism Transformed: The Development of Production Methods in the Automobile Industry* (Oxford: Oxford University Press, 1996); and Steven Tolliday and Jonathan Zeitlin, eds., *The Automobile Industry and Its Workers: Between Fordism and Flexibility* (Hampshire: Palgrave Macmillan, 1987). Popular accounts include Jeffrey K. Liker, *The Toyota Way: The Company That Invented Lean Production* (New York: McGraw Hill, 2004); and James P. Womack, Daniel T. Jones, and Daniel Roos, *The Machine That Changed the World: The Story of Lean Production* (New York: Harper Perennial, 1990).

In discussing Murakami's work with reference to something called "the Toyota management system," it can hardly be overemphasized that I am concerned neither with cars as such nor with restricting this tale to contemporary Japan (in fact, one would want to be cautious of the essentializing undertones that come with the territory). The very logic of post-Fordism militates against nationalized markets. Systems of "lean production," though credited for Japan's postwar economic miracle, have proven an itinerant success story in the interrelated domains of multinational manufacturing, marketing, and information processing: indeed, the demands of flexible labor require extramural populations. The extent of this interconnectedness recommends Murakami's practice to a more globalizing perspective.

16. If anything is "unique" about this sensibility it is not the notion of Japan's timeless "authenticity" as such, but the underlying set of historical discourses which essentialize Japan's capacity for cultural appropriation, domestication, and indigenization of foreign influences while maintaining "an image of an organic cultural entity." Koichi Iwabuchi describes this idea as "strategic hybridism," which is "strategically represented as a key figure of national identity," in distinction to notions of cultural hybridity advanced within postcolonial theory. See Koichi Iwabuchi, *Recentering Globalization: Popular Culture and Japanese Transnationalism* (Durham: Duke University Press, 2002), 51–53.

17. In this sense my argument departs from readings of Murakami's work that dismiss issues of the market altogether on the grounds of cultural context. Many writers on Murakami suggest that issues of "high art" and "low culture" are foregone conclusions within Japanese art history, arguing that accusations of kitsch leveled against Murakami's work are Eurocentric as they ignore the complexities by which distinctions between the fine arts and popular culture were historically drawn in Japan in the nineteenth century. See, for example, Murakami's own justification of this idea in his "A Theory of Super Flat Japanese Art," 17–19.

The argument hinges on a relatively recent art historical phenomenon: the establishment, in nineteenth-century Japan, of institutional distinctions between the "fine arts" and the craft tradition, which were previously coextensive. Murakami here refers to the formative role of Okakura Tenshin in the curricular reorganization of what is now the Tokyo University of the Arts. Murakami also discusses the peculiar translation of Western art historical nomenclature into Japanese at roughly the same moment.

18. Stuart Hall cited in Amin, *Post-Fordism: A Reader*, 31.

19. Takashi Murakami, "Life as a Creator," in *Summon Monsters? Open the Door? Heal? or Die?* (Tokyo: Museum of Contemporary Art, 2001), 132.

20. Ibid.

21. Ibid., 132–133; also see "Interview with Takashi Murakami by Helene Kelmachter," in *Takashi Murakami: Kaikai Kiki* (Paris: Fondation Cartier pour l'art contemporain; London: Serpentine Gallery, 2002), 75.

22. Dana Friis-Hansen, "The Meaning of Murakami's Nonsense: About 'Japan' Itself," in *The Meaning of the Nonsense of the Meaning* (Annandale-on-Hudson, NY: Center for Curatorial Studies Museum, Bard College; New York: Harry N. Abrams, 1999), 33.

23. Michael Darling, "Past + Present = Future," in *Summon Monsters*, 66.

24. Ibid.

25. "His work so perfectly mimics consumer obsessions," Amada Cruz notes, "that it embodies all the ambiguities and contradictions inherent in those tropes. Amada Cruz, "DOB in the land of OTAKU," in *The Meaning of the Nonsense of the Meaning*, 14.

26. Murakami, in *Summon Monsters*, 132.

27. Ibid., 133.

28. Thomas LaMarre uses the phrase "devoid of perspective and devoid of harmony" to characterize what he regards as the immanent logic of Superflat and anime. LaMarre, "Otaku Movement," 360.

29. Murakami, "A Theory of Super Flat Japanese Art," 17.

30. Takashi Murakami, "Thought for the Day: Superflat," interviewed on Imomus.Com, http://imomus.com/thought280600 .html (accessed June 9, 2011).

31. For example, the exhibition "Japanese Art after 1945: Scream against the Sky," on postwar Japanese art, is credited with granting greater international visibility to contemporary Japanese art. Organized by Alexandra Munro in 1994, the work traveled from the Guggenheim Museum to the San Francisco Museum of Modern Art to the Yokohama Museum.

The opening of the Tokyo Museum of Contemporary Art (MOT) in 1995 likewise conferred institutional prestige on contemporary art in Japan, but the market was largely driven by Western collectors. The more recent opening of the Mori Art Museum in Roppongi Hills in 2003 seemed similarly directed to both Japanese and Euro-American audiences; its appointment of the curator David Elliott as the first Western director of a Japanese museum would seem to underscore this connection. See Barbara Pollack, "West Goes East: A New Generation of Asian Artists Has Become a Force in the International Art Market," *Art News* 96, no. 3 (March 1997): 86-87. On "Tokyo pop," see Julie Joyce, "Star Blazers: New Pop from Japan," *Art Issues* 54 (September-October 1998): 23-25; Carol Lufty, "Japan '94: Young Crowd, Wide Horizons," *Art News* 94, no. 1 (November 1994): 124-129.

32. Margit Brehm, "The Floating World That Almost Was," in Brehm, *The Japanese Experience*, 8.

33. Consider Murakami's own relationship to the past through Nihonga. The artist received the Japanese equivalent of a Ph.D. in Nihonga at the Tokyo School of Fine Arts, an institution that has conventionally, if erroneously, been claimed to have been the site of its invention. Nihonga, which literally translates as "Japanese "painting," was the name given to a loosely organized "school" developed in the 1880s during the Meiji Era (1868-1912). Typically, its theorization is attributed to the critic Okakura Tenshin and the American philosopher Ernest Fenollosa. Together at the Tokyo School of Fine Arts—the very same institution from which Murakami received his advanced degree—the two upheld the cultivation traditional Japanese painting against the encroachments of Western styled oil painting (Yoga).

While a Japanese critic and an American collector collaborated in theorizing Nihonga, especially in Tokyo, Kyoto, and elsewhere, its history is hardly reducible to the influence of two individuals alone. Ellen Conant provides an infinitely more complex picture of Nihonga's historical emergence, noting that its development preceded the academic meanings proposed by Tenshin and Fenollosa; and that its extrainstitutional history suggests that the apparent split between Nihonga and Yoga was not so starkly drawn at the moment of its original formation. The commingling of Western painting techniques with Eastern aesthetics confirms the nonnative dimension of its aesthetic and historical elaboration. See Conant, *Nihonga*.

34. Murakami, "A Theory of Super Flat Japanese Art," 9.

35. Ibid.

36. Ibid.

37. Ibid.

38. Massey, *For Space*, 4 and 9.

39. Ibid., 69.

40. Ibid., 68–70.

41. For the "official" perspective of this history see Tony Silvia, "CNN: The Origins of the 24-Hour, International News Cycle: An Interview with Tom Johnson," in Tony Silvia, ed., *Global News* (Ames: Iowa State University Press, 2001), 45–51. Massey, for her part, cites research on the myth of instantaneous media events. Massey, *For Space*, 70.

42. Massey, *For Space*, 7.

43. Fredric Jameson, *Postmodernism; or, The Cultural Logic of Late Capitalism* (Durham: Duke University Press, 1991), x.

44. Brehm, *The Japanese Experience*, 12. The following passage captures this down-the-slippery-slope perspective between then and now: "The arrival of the American fleet (1854), the Japan-China War (as of 1937), the attack on Pearl Harbor (1941), the atomic bombs on Hiroshima and Nagasaki (1945) and the American military government (until 1952) constitute what is Japan today."

45. Massey, *For Space*, 76.

46. Nihonga was one of many instances of what some historians call the period's "neotraditionalism"—a peculiar form of Japanese nativism developed in the late nineteenth century as a protracted historical response to its centuries-old relations with the West, continental Asia, and Russia. A cultural product of the Meiji Restoration, it embodied, in part, the impulse to nativism underwriting the *Fukku* movement of the late nineteenth century, in which intellectuals and artists rallied under the banner "Restore Antiquity." See Marius B. Jannsen, *The Making of Modern Japan* (Cambridge, MA: Belknap Press of Harvard University Press, 2002), 478, 457, 215.

47. This is not to say that Murakami's riff on Nihonga is just another instance of cultural hybridity. The notion of hybridism in Japan is complicated (as developed in Iwabuchi, *Recentering Globalization*, 51–53).

48. Murakami, "A Theory of Super Flat Japanese Art," 17.

49. On the extraordinary rise of Japan's postwar economy, see Shigeto Tsuru, *Japan's Capitalism: Creative Defeat and Beyond* (Cambridge, UK: Cambridge University Press, 1996).

50. See Tsuru, *Japan's Capitalism*; and Thomas F. Cargill, Michael M. Hutchinson, and Takatoshi Ito, *The Political Economy of Japanese Monetary Policy* (Cambridge, MA: MIT Press, 1997).

51. Cargill, Hutchinson, and Ito, *The Political Economy of Japanese Monetary Policy*, 91.

52. Murakami, "A Theory of Super Flat Japanese Art," 17.

53. Ibid.

54. Ibid., 9.

55. Ibid.

56. James Meyer, "Nomads: Figures of Travel in Contemporary Art," in Alex Coles, ed., *Site-Specificity: The Ethnographic Turn* (London: Black Dog Publishing, 2000), 10–26.

57. For an "entertaining ethnography" of Murakami's studio, a popular account of his practice as it relates to the contemporary art world, see Sarah Thornton, "The Studio," in *Seven Days in the Art World* (New York: Norton, 2008): 181–219. Thornton recounts her experience at Kaikai Kiki's more recent location in advance of his retrospective at the Museum of Contemporary Art, Los Angeles, and the Brooklyn Museum.

58. The notion that the factory is equivalent with Fordism should be qualified. In the general understanding, Fordism has come to mean little more than assembly line production: the practice of having a car built in continuous and uninterrupted fashion on a conveyer belt. While Fordism is inevitably tied to the logic of the conveyer belt, engineers stress that the assembly line is actually *a by-product* of mass production's more fundamental tenets: the notion of an interchangeable worker, assigned to his one task, and the principles of integration that enable the progressive fabrication of the commodity.

59. The artist's repeated references to the use of Internet circulars at his studio baldly acknowledge this influence. Bill Gates, *Business @ the Speed of Thought: Succeeding in the Digital Economy* (New York: Warner Books, 1999).

60. Ibid., 444. Gates further explains: "The Internet makes it easier for buyers and sellers to find one another, provides buyers more information about products and services, and provides sellers more information about customer preferences and shopping patterns."

61. Ibid., 141.

62. Ibid., 142. Gates mentions Japan's economic successes in passing but is as quick to point to "Ford's strides in production" following the corporation's adoption of such techniques and their global success. Gates's switching between the Japanese context for automobile production and its American iteration is not just nationalistic in motivation, but consistent with the historical record. The roots of the Toyota production system in the postwar era were established not only through close analysis of the Big Three on the part of the Japanese, but through the particular fascination exerted by American supermarkets on Toyota's engineers. Ultimately it was the wastefulness of the Big Three companies—waste in the form of effort, supply chain, and time—that inspired Toyota's chief production engineer, Taiichi Ohno, to develop a system "beyond large-scale production." On this history, see Womack, Jones, and Roos, *The Machine That Changed the World*, 56.

63. Ohno, *Toyota Production System*, 121.

64. Ibid., 27.

65. Womack, Jones, and Roos, *The Machine That Changed the World*, 62.

66. Ohno, *Toyota Production System*, 127.

67. Chiho Aoshima, "Digital Drawings," in *Summon Monsters*, 86.

68. Ibid. Aoshima's longer statement on Bézier curves reads as follows: "The most important point when drawing Bézier-type vector lines is the deftness with which you drive the curves. Elegant-looking curves must be drawn as smoothly as possible. When I first started, I was often admonished with 'These lines look sloppy.' I learned that the placement in Illustrator of the Bézier points is crucial for drawing clean lines. Inserting a large number of points willy nilly creates a rickety-looking line. The trick is to place the fewest number of points at just the right locations."

69. For a technical introduction to the Bézier curve, see David Salomon, *Curves and Surfaces for Computer Graphics* (New York: Springer, 2006).

70. In an essay criticizing the work of the Danish artist Olafur Eliasson, among others, James Meyer has identified an analogous "loss of scale" in the exhibition of contemporary art, wherein so-called global museums and the works of art

specifically made for them all but dwarf the viewer in gargantuan spaces of art world spectacle. James Meyer, "No More Scale: The Experience of Size in Contemporary Sculpture," *Artforum International* 42, no. 10 (Summer 2004): 220–228.

71. Haruki Murakami, *Hard-Boiled Wonderland and the End of the World*, 4.

2 Gursky's Ether

1. Peter Galassi, ed., *Andreas Gursky* (New York: Harry N. Abrams and Museum of Modern Art, 2001), 30.

2. Andreas Gursky cited in Rupert Pflab, *Andreas Gursky: Photographs from 1984 to the Present* (Düsseldorf: Kunsthalle Düsseldorf and Te Neues Publishing, 2001), 9.

3. Michael Fried, "Jean-François Chevrier on the 'Tableau Form': Thomas Ruff, Andreas Gursky, Luc Delahaye," in *Why Photography Matters as Art as Never Before* (New Haven: Yale University Press, 2008), 143–189.

4. Emily Apter, "The Aesthetics of Critical Habitats," *October* 99 (Winter 2002): 21–44.

5. Roland Barthes, "The Reality Effect," in *The Rustle of Language*, trans. Richard Howard (New York: Hill and Wang, 1989), 76.

6. See Edward Leffingwell, "Making Things Clear," *Art in America* 89, no. 6 (June 2001): 77–86.

7. For example, Calvin Tomkins, "The Big Picture: Andreas Gursky: Laying to Rest Photography's Inferiority Complex," *Modern Painters* 14, no. 1 (Spring 2001): 28.

8. I credit the philosopher Gregg Horowitz with this wholly convincing association. In a lecture on Gursky delivered at Vanderbilt University in April 2006, Horowitz appropriated Adam Smith's famous metaphor in *The Wealth of Nations* to speak of the uncannily agentless arenas of production Gursky surveys in his images of the 1990s.

9. Albert Einstein, "Ether and the Theory of Relativity" (1920), http://www.tu-harburg.de/rzt/rzt/it/Ether.html (accessed October 1, 2007).

10. Cited in Harold Aspden, "Discourse No. 4: The Heresy of the Aether," http://www.energyscience.co.uk/ov/ov004 .html (accessed October 28, 2002).

11. Joe Milutis, *Ether: The Nothing That Connects Everything* (Minneapolis: University of Minnesota Press, 2006), xi.

12. Norman Bryson, "The Family Firm: Andreas Gursky and German Photography," *Art/text* 67 (November 1999/January 2000): 80.

13. Otto Steinart, quoted in James R. Hugunin, "*Subjektive Fotografie* and the Existentialist Ethic," *Afterimage* 15, no. 1 (January 1988): 146. Gursky worked primarily with Michael Schmidt, as Steinart died not long after Gursky enrolled.

14. The notion of a "school" forming around the Bechers is highly qualified, in no small part because the "students" themselves would see their practices as quite distinct from one another (as the conclusion to this chapter will suggest). No doubt the Bechers' interest in the typological motif and in large-format prints does bind this group of artists together if in a generic way. Stefan Gronert is most explicit about this, and notes that "the first use of the dubious term 'Becher School' probably came on the occasion of an exhibition called 'Bernhard Becher's School,'" in 1988 in Cologne. Stefan Gronert, "Photographic Emancipation," in *The Düsseldorf School of Photography* (New York: Aperture, 2010), 14.

15. See Benjamin H. D. Buchloh, "Conceptual Art 1962-1969: From the Aesthetic of Administration to the Critique of Institutions," *October* 55 (Winter 1990): 105–143. Hilla Becher recalls that they became interested in the work of

Sol LeWitt, Lawrence Weiner, and Carl Andre through their shared connection in the figure of Konrad Fischer, the important gallerist. See "The Birth of the Photographic View from the Spirit of History: Bernd and Hilla Becher in Conversation with Heinz-Norbert Jocks," in Susanne Lange, *Bernd and Hilla Becher: Life and Work* (Cambridge, MA: MIT Press, 2007), 215.

16. "The Music of the Blast Furnaces: Bernhard and Hilla Becher in conversation with James Lingwood," in Lange, *Bernd and Hilla Becher*, 192.

17. Ibid., 212.

18. See, e.g., Allan Sekula, "The Body and the Archive," in Richard Bolton, ed., *The Contest of Meaning: Critical Histories of Photography* (Cambridge, MA: MIT Press, 1992); Abigail Solomon-Godeau, "The Legs of the Countess," *October* 39 (Winter 1986): 65–108.

19. Becher notes that his teacher in Stuttgart was close to the group of artists associated with the Neue Sachlichkeit in the 1920s; but in the same interview, Hilla Becher notes that August Sander "had to be rediscovered, he was hardly known. Bernd found one of Sander's books in an old bookshop." Lange, *Bernd and Hilla Becher*, 195.

20. See Susanne Lange and Gabriele Conrath-Scholl, "Introduction," in *August Sander: People of the Twentieth Century II* (New York: Harry N. Abrams, 2002), 30–40.

21. Blake Stimson, "The Photographic Comportment of Bernd and Hilla Becher," in *The Pivot of the World: Photography and Its Nation* (Cambridge, MA: MIT Press, 2005), 105–137.

22. Margaret Sundell, "Review: Andreas Gursky, Matthew Marks," *Artforum* 38, no. 7 (March 2000): 131.

23. If the notion of medium specificity is almost always linked with Clement Greenberg, it is worth recalling that his writing on photography appealed to photography's strangely hybrid status. Greenberg argued that the most salient characteristics of the photograph were its capacity for narrative: in short, "the literary possibilities of pictorial art." Clement Greenberg, "Four Photographers: Review . . . ," in *The Collected Essays and Criticism*, vol. 4: *Modernism with a Vengeance, 1957–1969*, ed. John O'Brian (Chicago: University of Chicago Press, 1995), 187.

24. Jorge Ribalta, "Molecular Documents: Photography in the Post-Photographic Era, or How Not to Be Trapped into False Dilemmas," in Robin Kelsey and Blake Stimson, eds., *The Meaning of Photography* (Williamstown, MA: Sterling and Francine Clark Art Institute, 2008), 178–185.

25. William J. Mitchell summarizes an account of the digital revolution in photography in such fatal terms. As early as the late 1950s, the potential for digitally enhancing photographs was considered by scientists. Its application is generally dated to 1964, when NASA experimented with modifying photographs of the lunar surface, a practice that the organization would expand through the era of the space race. Yet not until the 1980s did the controversy around the "post-photographic" era begin to rage as digital imaging technology was progressively introduced into communications media, usually unaccompanied by any explanation as to how an image had been altered. For Mitchell himself, however, the turn to the post-photographic is ultimately characterized in liberating terms. William J. Mitchell, *The Reconfigured Eye: Visual Truth in the Post-Photographic Era* (Cambridge, MA: MIT Press), 16.

26. Ibid.

27. Ibid., 19.

28. On "post-photography," see Fred Richtin, *After Photography* (New York: Norton, 2009); Carol Squiers, ed., *Essays on Contemporary Photography* (Seattle: Bay Press, 1990); Hubertus von Amelunxen, Stefan Iglhaut, and Florian Rötzer

in collaboration with Alexis Cassel and Nikolaus G. Schneider, eds., *Photography after Photography: Memory and Representation in the Digital Age* (Amsterdam: G+B Arts, 1996).

29. Gursky in Tomkins, "The Big Picture," 28.

30. Alexander Alberro, "The Big Picture: The Art of Andreas Gursky," *Artforum* 39, no. 5 (January 2001): 104–113.

31. Bryson, "The Family Firm," 81.

32. The flashpoint in the debate is Rosalind Krauss's influential appropriation of C. S. Peirce in her essay of 1985, "Notes on the Index: Part 2." Krauss takes up the notion that photography falls in a peculiar class of sign motivated by physical connection in order to survey a wide variety of practices in the 1970s, which she treats as postmodern. She cites Peirce directly: "'Photographs,' Peirce notes, 'especially instantaneous photographs are very instructive, because we know they are in certain respects exactly like the objects they represent. But this resemblance is due to the photographs having been produced under such circumstances that they were physically forced to correspond point by point to nature.'" See Rosalind Krauss, "Notes on the Index, Part 1," in *The Originality of the Avant-Garde and Other Modernist Myths* (Cambridge, MA: MIT Press, 1986), 215.

 Amidst the progressively heated debates on photographic indexicality, perhaps no one is more to the critical point than Joel Snyder, who calls discussion of photographic indexicality "pointless" and is especially impatient with Krauss's reading. See Snyder, "Pointless," in James Elkins, ed., *Photography Theory* (New York: Routledge, 2007), 369–400. More sanguine are the essays published in the section "Part 1: Beyond the Index" in Kelsey and Stimson, *The Meaning of Photography*. In particular see Mary-Anne Doane, "Indexicality and the Concept of Medium Specificity," and François Brunet, "'A Better Example Is a Photograph': On the Exemplary Value of Photographs in C. S. Peirce's Reflection on *Signs*," 3–15, 34–50.

33. Fried, *Why Photography Matters*, 166. "What matters to my argument, however, is that the resulting images are intrinsically not, at least not in their entirety, the record of anything that could have been seen in the real world by a human observer or indeed a mechanical recording instrument."

34. Anthony Giddens's notion that ours is an epoch disembedded from traditional time/space relations (which he notably defines in terms of time/space *distantiation*) is a signal feature of what he calls "reflexive modernism." Anthony Giddens, *The Consequences of Modernity* (Cambridge, UK: Polity Press, 1990).

35. Sundell, "Review: Andreas Gursky, Matthew Marks," 141.

36. Karl Marx, *Grundrisse: Foundations of the Critique of Political Economy*, cited in Milutis, *Ether*, 115.

37. See Jacques Derrida, *Specters of Marx: The State of Debt, the Work of Mourning and the New International* (New York: Routledge, 2004). For another reading of a mystical or uncanny vein in the Marxian tradition, as in the work of Walter Benjamin, see Margaret Cohen, *Profane Illumination: Walter Benjamin and the Paris of Surrealist Revolution* (Berkeley: University of California Press, 1995). On Marx's "melodrama," see Thomas M. Kemple, *Reading Marx Writing: Melodrama, the Market, and the "Grundrisse"* (Stanford: Stanford University Press, 1995).

38. Karl Marx and Friedrich Engels, *The Communist Manifesto* (New York: International Publishers, 1983), 18. On Marx's famous passage and globalization, see Douglas Kellner, "Globalization and the Postmodern Turn," http://pages .gseis.ucla.edu/faculty/kellner/essaysglobalizationpostmodernturn.pdf. (accessed January 31, 2012).

39. David Harvey, "Uneven Spatial Development," in *Spaces of Global Capitalism: A Theory of Uneven Geographical Development* (New York: Verso, 2006), 78.

40. Jeremy Rifkin, *The End of Work: The Decline of the Global Labor Force and the Dawn of the Post-Market Economy* (New York: Tarcher, 2004).

41. Ribalta, "Molecular Documents," 178.

42. Daniel Bell, *The Coming of Post-industrial Society: A Venture in Social Forecasting* (New York: Basic Books, 1973), 51–53.

43. Ibid., 125.

44. Ibid., 12. Bell writes: "The central person is the professional, for he is equipped, by this education and training, to provide the kinds of skills which are increasingly demanded in the post-industrial society. If an industrial society is defined by the quantity of goods as marking a standard of living, the post-industrial society is defined by the quality of life as measured by the services and amenities—health, education, entertainment, recreation, and the arts—which are now deemed desirable and possible for everyone."

45. Review essays include: Brian J. L. Berry, "Review: The Coming of Post-industrial Society: A Venture in Social Forecasting," *Geographical Review* 64, no. 3 (July 1974): 447–449; Morris Janowitz, "Review: The Coming of Post-industrial Society: A Venture in Social Forecasting," *American Journal of Sociology* 80, no. 1 (July 1974): 230–241; Jeffrey D. Straussman, "Review: What Did Tomorrow's Future Look Like Yesterday?," *Comparative Politics* 8, no. 1 (October 1975): 166–182.

46. Bell, *The Coming of Post-industrial Society*, 313–314. Bell's extended discussion on "the eclipse of distance" appears in his *The Cultural Contradictions of Capitalism* (New York: Basic Books, 1976).

47. Francis Fukuyama, *The End of History and the Last Man* (New York: Harper Perennial, 1993).

48. See "Post-Industrial Society: He Said It First," *Economist* 353, no. 8145 (November 13, 1999): special section, 4.

49. Zygmunt Bauman, "Foreword: On Being Light and Liquid," in *Liquid Modernity* (Cambridge, UK: Polity Press, 2000), 1–16.

50. Contemporary references to the ether are assimilated within the rhetoric of Ethernet. Ethernet was developed in the early 1970s at Xerox Parc (Palo Alto Research Center), principally by Bob Metcalfe. On this history, see Michael L. Hiltzik, *Dealers of Lightning: Xerox Parc and the Dawn of the Computer Age* (New York: Harper, 2000).

51. Fredric Jameson, "Culture and Finance Capital," *Critical Inquiry* 24, no. 1 (Autumn 1997): 260.

52. Michael Hardt and Antonio Negri, "Capitalist Sovereignty," in *Empire* (Cambridge, MA: Harvard University Press, 2000), 347.

53. See http://en.wikipedia.org/wiki/Salerno (accessed September 25, 2007).

54. For a more specific take on Salerno's recent fortunes relative to development, tourism, and, most important, design and architecture, see Richard Burdett, "A Future for Salerno," *Domus*, 829 (2000): 95–105.

55. See the discussion of critical realism in Sekula in Benjamin H. D. Buchloh, "Allan Sekula: Photography between Discourse and Document," in *Fish Story* (Düsseldorf: Richter Verlag, 2005), 192–194.

56. Edward Said, cited in Pasquale Verdicchio, introduction to Antonio Gramsci, *The Southern Question* (Toronto: Guernica, Pica Series, 2005), 9.

57. Daniel Bell, "The Racket-Ridden Longshoremen: The Web of Economics and Politics," in *The End of Ideology: On the Exhaustion of Political Ideas in the Fifties*, 2d ed. (Cambridge, MA: Harvard University Press, 2002), 175–209.

58. Allan Sekula, "Notes on the Work," in *Fish Story*, 202.

59. Ibid., 134.

60. "Sea-Land" is the name of the company founded by Malcolm Mclean (and sold in 1969), widely credited as the "inventor" of containerized shipping in the mid-1950s.

61. Sekula, *Fish Story*, 62, 76. The caption refers to the disappearance of an American sailboat, *Happy Ending*, described in an anonymous French newspaper clipping which was posted in the officers' and crews' mess room.

62. Ibid., 51.

63. Ibid.

64. A technical discussion with a dedication to Bézier is David Salomon, *Concise Introduction to Data Compression* (London: Springer, 2008).

65. Bennett Simpson, "Ruins: Thomas Ruff's Jpegs," in *Thomas Ruff: Jpegs* (New York: Aperture, 2009).

3 Perpetual Revolution: Thomas Hirschhorn's Sense of the World

1. Okwui Enwezor, "Interview," in James Rondeau, ed., *Thomas Hirschhorn: Jumbo Spoons and Big Cake: The Art Institute of Chicago; World Airport: The Renaissance Society at the University of Chicago* (Chicago: Art Institute of Chicago and University of Chicago, 2000).

2. Gilles Deleuze, *Spinoza: Practical Philosophy*, trans. Robert Hurley (San Francisco: City Lights Books, 1988), 124. Also see Deleuze, *Expressionism in Philosophy: Spinoza*, trans. Martin Joughin (New York: Zone Books, 1990).

3. Leon Trotsky, "On Optimism and Pessimism, on the Twentieth Century, and on Many Other Things," quoted in Isaac Deutscher, *The Prophet Armed: Trotsky, 1879–1921* (London: Verso, 2003), 45.

4. Baruch Spinoza, *Ethics*, part V, proposition 29, in *Spinoza: Complete Works*, ed. Michael L. Morgan, trans. Samuel Shirley (Indianapolis: Hackett Publishing, 2002), 376.

5. Michael Hardt, introduction to Antonio Negri, *Savage Anomaly* (Minneapolis: University of Minneapolis Press, 1991), xiii.

6. Alison Gingeras, "Striving to Be Stupid," *Art Press*, no. 239 (October 1998): 25.

7. Thomas Hirschhorn, "Spinoza Monument," statement for the exhibition "Midnight Walkers & City Sleepers" (Amsterdam, 1999), distributed at Documenta 11 (2001).

8. On Hirschhorn's early work as a collage practice, see Catherine de Smet, "Relier le monde. Thomas Hirschhorn et l'imprime," *Cahiers du Musée national d'art moderne* 72 (Summer 2000): 36–56.

9. For the most sustained consideration of Hirschhorn's work as it is positioned relative to the history of modern sculpture, see Benjamin Buchloh, "Detritus and Decrepitude: The Sculpture of Thomas Hirschhorn," *Oxford Art Journal* 24, no. 2 (2001): 55. Also see Buchloh's survey "Thomas Hirschhorn: Lay Out Sculpture and Display Diagrams," in Benjamin H.D. Buchloh, Alison M. Gingeras, and Carlos Basualdo, *Thomas Hirschhorn* (London: Phaidon Press, 2004).

10. Susan Snodgrass, "The Rubbish Heap of History," *Art in America* 88, no. 5 (May 2000): 156–157, 277.

11. For example, see my "The World as Figure/Ground and Its Disturbance," in *Thomas Hirschhorn: Utopia, Utopia = One World/One War/One Army/One Dress*, exhibition catalog, Institute of Contemporary Art, Boston and Wattis Institute, California College of Arts, fall 2005.

12. Likewise, the relationship between art and design (typically architectural and industrial) has been productively and critically mined by artists from the 1960s to the present. See Alex Coles, ed., *Design and Art* (London: Whitechapel; Cambridge, MA: MIT Press, 2007).

13. Hal Foster, *Design and Crime (and Other Diatribes)* (London: Verso, 2002), 18.

14. Ibid.

15. Véronique Vienne, "Pierre Bernard: Staying True to the Frenchman in Him," *Graphis* 320 (March/April 1999): 60.

16. Thomas Hirschhorn, letter to the author, June 26, 2003.

17. Thomas Hirschhorn in conversation with the author, San Francisco, March 28–29, 2003.

18. Thomas Hirschhorn in conversation with the author, March 28–29, 2003.

19. The artist is to the point about his engagement with philosophy: "I think philosophy is not only not-political it is *'transpolitical.'* This means a way to think the political without being political or getting apolitical." Thomas Hirschhorn, letter to the author, June 26, 2003.

20. Sebastian Egenhofer reminds us that the notion of working politically (and not making political art as such) comes from Godard. Sebastian Egenhofer, *Image and Machine: Introduction to Thomas Hirschhorn's Spinoza Monument* (Minneapolis: University of Minnesota Press, forthcoming).

21. Egenhofer, *Image and Machine*, 1.

22. Ibid., 13. It is worth noting that Hirschhorn's *Spinoza Monument* preceded the publication of *Empire*, perhaps the most influential of many recent books returning to the philosopher's example.

23. El Al flight 1862 crashed in Bijlmer in October 4, 1992, killing 4 onboard (the entire flight crew and a passenger) and 39 on the ground. The mortality rate was considered low given the population density of the apartment blocks, but it has been suggested that the numbers did not account for undocumented Surinamese who may have been in the buildings that were hit. The cause of the crash has been officially cited as metal fatigue leading to overload failure.

24. On the controversy of Spinoza's reception in recent political philosophy (that is, after the publication of Hardt and Negri's *Empire*)—in particular, its relevance to coalition politics of alterity—see E. San Juan, Jr., "Spinoza and the War of Racial Terrorism," *Left Curve* (Oakland, CA), no. 27 (2002): 62–72. San Juan is particularly concerned with Spinoza's adequation of right (*jus*) and power (*potentia*) as discussed in the *Tractatus Theologico-Politicus*.

25. Spinoza's three most important texts—the *Ethics*, the *Tractatus Theologico-Politicus*, and the posthumously published *Tractatus Politicus*—were all written during a moment of unbridled violence and civil unrest in his native Holland, precipitated by conflicts between the nascent republic and the House of Orange. On this history, see Étienne Balibar, *Spinoza and Politics*, trans. Peter Snowdon (London: Verso, 1998).

26. Christopher Norris provides a lucid introduction to this reception. See Christopher Norris, *Spinoza and the Origins of Modern Critical Theory* (Oxford: Basil Blackwell, 1991), 35. For a more recent account of Spinoza's thought, see Warren Montag, *Bodies, Masses, Power: Spinoza and His Contemporaries* (London: Verso, 1999).

27. Norris, *Spinoza and the Origins of Modern Critical Theory*, 34.

28. Ibid., 36. Much of this reading is derived from Althusser and Balibar's formulation of "structural causality" which they oppose to models of linear causality, the latter of which supports vulgar readings of ideology as unilaterally determined through the base/superstructure nexus. As Norris puts it, structural causality, rather, was "an order of relations where economic forces may indeed play a determining role in 'the last instance,' but only as components within a complex ensemble where the other levels maintain their 'relative autonomy' and cannot be reduced to an epiphenomenal or merely derivative status."

29. In "aleatory materialism" as a potential philosophy for Marxism radically opposed to the conventional Hegelian mandate, Althusser draws on Democritus and Epicurus in laying claim to a "negation of all teleology" and instead proposes a kind of atomism that he calls "a materialism of the encounter, of contingency—in sum, of the aleatory." This aleatory materialism "is opposed even to the materialisms that have been recognized as such, including that commonly attributed to Marx, Engels and Lenin, which, like every other materialism of the rationalist tradition, is a materialism of necessity and teleology, that is, a disguised form of idealism." Louis Althusser, *Philosophy of the Encounter: Later Writings, 1978-1987* (London: Verso, 2006), 260-262.

30. Spinoza, *Ethics*, 217.

31. Ibid.

32. Ibid.

33. See Deleuze, *Spinoza: Practical Philosophy*, 54. Also see Gilles Deleuze and Félix Guattari, "The Plane of Immanence," in *What Is Philosophy?*, trans. Hugh Tomlinson (New York: Columbia University Press, 1996).

34. Warren Montag, intro to Balibar, *Spinoza and Politics*, n. ix.

35. Antonio Negri, *Time for Revolution*, trans. Matteo Mandarini (New York: Continuum, 2003), 233.

36. Deleuze, *Spinoza: Practical Philosophy*, 124.

37. For example, Antonio Negri, *Insurgencies: Constituent Power and the Modern State* (Minneapolis: University of Minnesota Press, 1999), 28-29. For both Balibar and Negri, the conflicts that organize the multitude arise from what Negri describes as the "divergence of opinions (arising from individuals' diverse ingenium)": they are the source of the multitude's constituent power.

38. Deleuze, *Spinoza: Practical Philosophy*, 124.

39. See Sylvère Lotringer, "Foreword: We the Multitude," in Paolo Virno, *A Grammar of the Multitude* (New York: Semiotext(e), 2004), 7-19.

40. Michael Hardt and Antonio Negri, *Empire* (Cambridge, MA: Harvard University Press, 2000), 230.

41. Ibid., 232.

42. Letter from Thomas Hirschhorn to the author, June 26, 2003.

43. For example, see my "The Marketplace of Temporality," in *Yokohama International Triennale of Contemporary Art: Time Crevasse* (Yokohama: Yokohama International Triennale, 2008).

44. Buchloh, "Detritus and Decrepitude," 41.

45. Ibid., 55.

46. On the overproduction of capital as it relates to the overproduction of commodities, see Karl Marx, chapter 15, "Development of the Law's Internal Contradictions," in *Capital: A Critique of Political Economy*, vol. 3 (London: Penguin 1991), 359–373.

47. On China's explosive market economy and its relation to earlier histories of capitalism, see the brilliant work of Giovanni Arrighi, *Adam Smith in Beijing: Lineages of the Twenty-First Century* (London: Verso, 2007). My thanks to Bryan Holmes for an insightful conversation about the book.

48. Flavin Judd, "Josephine Meckseper," *Bombsite* (Web-only journal, posted December 2008), 3 (Bombsite.com/issues /999/article/3233).

49. Lotringer, "Foreword: We the Multitude," 13.

50. Ibid., 14.

51. Egenhofer, *Image and Machine*, 1.

52. Hirschhorn's impatience with references to Walter Benjamin should be noted in this light. Thomas Hirschhorn in conversation with the author, Aubervilliers, France, November 8–9, 2003.

53. Francesco Bonami, "Thomas Hirschhorn: Energy Yes, Quality No," *Flash Art* 34, no. 216 (January/February 2001): 90.

54. Thomas Hirschhorn in conversation with the author, Aubervilliers, France, November 8–9, 2003. The artist has sourced a few dozen magazines in mining such imagery—as well as countless Internet sites. On this process or recycling and repurposing, see Hans-Ulrich Obrist, Interviews, ed. Thomas Boutoux, vol. 1 (Milan: Charta, 2003), 393–400; Gingeras, "Striving to Be Stupid," 19–25.

55. Lotringer, "Foreword: We the Multitude," 12.

56. Bonami, "Thomas Hirschhorn: Energy Yes, Quality No," 90.

57. Rondeau, *Thomas Hirschhorn*, 10.

58. Buchloh, "Thomas Hirschhorn: Lay Out Sculpture and Display Diagrams," 42–93.

59. An analog to these conductors is an earlier series of works called the "virus drawings," in which Hirschhorn defaced various advertisements and pictures from magazines with red and blue ink, lines crawling from one image to the next. As if extending off the page, some of these branching structures—like synapses or viruses—find passage into adjacent displays, establishing additional means of continuity and connection.

60. Rondeau, *Thomas Hirschhorn*, 10.

61. See Buchloh, "Thomas Hirschhorn: Lay Out Sculpture and Display Diagrams," 84. As Buchloh points out, acts of participation in Hirschhorn's work tend toward the debased: "planned" vandalism (as we saw in the *Spinoza Monument*); or the theft of small objects from the site works; or the banalized form of commodity exchange, as in his *Souvenirs of the Twentieth Century*, in which one could purchase various souvenirs produced to honor certain artists—a Warhol or an Oiticica. On relational aesthetics, see Nicolas Bourriaud, *Relational Aesthetics*, trans. Simon Pleasance and Fronza Woods (Paris: Les presses du réel, 2000).

62. Hirschhorn is emphatic that his art does not aim principally to communicate, nor is it modeled after site-specific or interactive practices. On the rhetoric of interactivity in contemporary art, he states bluntly that "interactivity is capitalism," as if this type of art making subscribed to the model of a service economy. Thomas Hirschhorn in conversation with the author, April 2003, San Francisco.

4 On Pseudo-Collectivism; or, How to Be a Collective in the Age of the Consumer Sovereign

Sections of this chapter appeared as "My Enemy/My Friend," in *Grey Room* 24 (Summer 2006): 100–109; and an abbreviated version, "How to Be a Collective in the Age of the Consumer Sovereign: The Raqs Media Collective," was published in *Artforum International* 48, no. 2 (October 2009): 184–189. Interviews with the Raqs Media Collective were conducted in San Francisco in April 2006, and at Sarai, the Center for the Study of Developing Societies, Delhi, on December 31, 2007; additional exchanges took place on-line.

1. The Invisible Committee, *The Coming Insurrection* (New York: Semiotext(e), 2009), 19.

2. Giorgio Agamben, *Homo Sacer: Sovereign Power and Bare Life* (Stanford: Stanford University Press, 1998), 12.

3. The Invisible Committee, *The Coming Insurrection*, 15.

4. I refer to the infamous episode in which a subsidiary of the Bechtel Corporation, as licensed by the IMF and World Bank, laid claims to the water rights of Cochabamba, Bolivia, in 2000, effectively resulting in a water rate hike of 100 percent or more. This development was met by ferocious resistance on the part of thousands of Bolivians in the "Cochabamba Water Wars," including a four-day general strike. For a brief account see David McNally, *Another World Is Possible: Globalization and Anti-Capitalism*, expanded edition (Monmouth, Wales: Merlin Press, 2006), 292–295. On South Africa, see David A. McDonald and Greg Ruiters, *The Age of Commodity: Water Privatization in South Africa* (London: Earthscan Publications, 2005).

5. An excellent survey of this phenomenon is Blake Stimson and Gregory Sholette, eds., *Collectivism after Modernism: The Art of Social Imagination after 1945* (Minneapolis: University of Minnesota Press, 2007).

6. On Claire Fontaine, see the numerous texts linked to their website http://www.clairefontaine.ws/. On the Bernadette Corporation, see Bennett Simpson, "Techniques of Today," *Artforum International* 43, no. 10 (September 2004): 220–223.

7. Simpson, "Techniques of Today," 220.

8. Bryan Holmes, *Unleashing the Collective Phantoms: Essays in Reverse Imagineering* (Brooklyn: Autonomedia, 2008).

9. Stimson and Sholette, *Collectivism after Modernism*, xii.

10. See Caroline Jones, "Doubt Fear," *Art Papers*, January/February 2005 (available at http://www.artpapers.org/feature_articles/feature1_2005_0102.htm). Jones's essay is concerned with the use of visual images in fomenting collective fear in advance of the 2003 invasion of Iraq. Looking at the work of the Atlas Group, Mark Lombardi, and Gerhard Richter, she argues that, in the wake of this ideological fear mongering, artists deploy "a hermeneutics of doubt" as a form of critical intervention.

11. An instructive parallel to my concerns here, explicitly engaged in psychoanalysis, is the important argument advanced by Peggy Phelan in *Unmarked: The Politics of Performance* (London: Routledge, 1993), 1. As Phelan writes, "By locating a subject in what cannot be reproduced within the ideology of the visible, I am attempting to revalue a belief in subjectivity and identity which is not visibly representable. This is not the same thing as calling for greater visibility of the hitherto unseen. *Unmarked* examines the implicit assumptions about the connections between representational visibility and political power which have been a dominant force in cultural theory in the last ten years."

12. Jacques Rancière, *The Politics of Aesthetics* (New York: Continuum, 2006). Rancière's influence on recent art criticism has been profound, as suggested by the symposium "Communities of Sense" organized by the Department of Art History at Columbia University in 2003, for which Rancière was the keynote speaker. The papers have now appeared

as an edited volume: see Beth Hinderliter, William Kaizen, Vered Maimon, Jaleh Mansoor, and Seth McCormick, eds., *Communities of Sense: Rethinking Aesthetics and Politics* (Durham: Duke University Press, 2009). For an especially instructive account on the relationship, see Vered Maimon, "The Third Citizen: On Models of Criticality in Contemporary Artistic Practices," *October* 129 (Summer 2009): 85–112. For an excellent reading and a related model, see Carrie Lambert-Beatty, "Make-Believe: Parafiction and Plausibility," *October* 129 (Summer 2009): 51–84. Caroline Jones has written the most detailed account of Ra'ad's intellectual formation and its impact on his early work. See Jones, "Doubt Fear."

13. Rancière, *Politics of Aesthetics*, 12.

14. Ibid., 13.

15. An updating of the politics of the commons is Michael Hardt and Antonio Negri, *Common Wealth* (Cambridge: Belknap Press of Harvard University Press, 2009). A distillation of these issues is presented in their interview with David Harvey, "Commonwealth: An Exchange with Michael Hardt and Antonio Negri," *Artforum International* 48, no. 3 (November 1, 2009): 210–215, 256, 258, 262.

16. Oleg Kharkhordin, *The Collective and the Individual in Russia: A Study of Practices* (Berkeley: University of California Press, 1999), 1.

17. Ibid.

18. Ibid., 78.

19. On this notion as represented within Soviet art, see Leah Dickerman, ed., *Building the Collective: Soviet Graphic Design 1917–37* (New York: Princeton Architectural Press, 1996).

20. V. I. Lenin, quoted in Kharkhordin, *The Collective and the Individual in Russia*, 231.

21. On these many debates, see the indispensable work on constructivism by Maria Gough, *The Artist as Producer: Russian Constructivism in Revolution* (Berkeley: University of California Press, 2005); also see the classic account by Christina Lodder, *Russian Constructivism* (New Haven: Yale University Press, 1985).

22. Gene Ray, "Another World Is Possible," in Stimson and Sholette, *Collectivism after Modernism*, 569.

23. A good account of both the history and the organizational challenges that took place at one of the polycentric forums is Michael Blanding, "The World Social Forum: Protest or Celebration?," *The Nation*, March 6, 2006, 17–20. Blanding reports on the Caracas iteration held in January 2006. For a study on the various social movements continuous with the World Social Forum, see Tom Mertes, ed., *A Movement of Movements: Is Another World Really Possible?* (London: Verso, 2004).

24. The World Social Forum Charter of Principles is widely available on line. One such version is: http://www.forumsocialmundial.org.br/main.php?id_menu=4&cd_language=2.

25. Blanding, "The World Social Forum," 17.

26. Ray, "Another World Is Possible," 567.

27. With the possible exception of Utopia Station, a project which, like the Forum, thematizes its transient status through the language of movement, passage, and process. The brainchild of Molly Nesbit, Rirkrit Tiravanija, and Hans-Ulrich Obrist, Utopia Station's best-known stop was at 2003's Venice Biennale, where it occupied a sizeable portion of the Arsenale and trafficked seamlessly between individual efforts and collaboration, the latter of which was embodied in its outdoor poster project and extensive discussions staged both in Venice and elsewhere. Far less known was Utopia

Station's participation at the 2005 meeting of the World Social Forum in Porto Alegre, Brazil, the first time in the Forum's short history that a decisive stress was placed on the cultural in its wide-ranging deliberations. In leaving behind its usual stomping grounds of the art world and the university, Utopia Station found an especially suitable climate for its experiments. Appropriately ambitious, its Porto Alegre appearance involved a video program broadcast late on local Brazilian television (including the participation, among many others, of Dominique Gonzalez-Foerster, Alexander Kluge, Jonas Mekas, Lygia Pape, Martha Rosler, Anri Sala and Edi Rama, and Allan Sekula); a bilingual radio show, hosted by Arto Lindsay; a poster project; and a bus used to "improvise mobile programming, projections, screenings, performances and presence on the grounds of the Forum and around the city." If the latter activity proved the most difficult to realize, it was not because more conventional art took center stage. As Molly Nesbit observes, "I was always struck by how marginal, actually, traditional art practices were at the WSF. In spite of themselves, they became folkloric or just plain stiff. For the first few meetings . . . there was nothing 'cultural' to speak of. Or better, what was 'cultural' was not isolated." Molly Nesbit, email communication with the author, summer 2006.

28. *What Is Waiting Out There: 6th Berlin Biennale for Contemporary Art*, curated by Kathrin Rhomberg, exhibition catalog (Cologne: DuMont Buchverlag, 2010), 42.

29. The consciousness of the Forum participants concerning media spectacle owed something to the radical street theater of the 1960s and 1970s. The presence in Caracas of the women-initiated CODEPINK, an American grassroots, antiwar group founded by Medea Benjamin, Starhawk, Jodie Evans, Diane Williams, and some 100 other women, recalled second-wave feminist performances in particular. In their collective efforts to facilitate "creative protest against militarism and injustice," CODEPINK cut a notably roseate figure at the Forum, its at times exaggerated femininity (pink parasols, frilly dresses, and the like) in stark contrast to the drab "revolutionary" garb of camouflage, khaki, and Soviet red.

30. The Invisible Committee, *The Coming Insurrection*, 31.

31. Ludwig von Mises, *Human Action: A Treatise on Economics*, rev. ed. (New Haven: Yale University Press, 1963), 43.

32. Giorgio Agamben, "Biopolitics and the Rights of Man," in *Homo Sacer*, 126–137. Foucault's best-known analysis of biopolitical production is *The History of Sexuality*, vol. 1, *An Introduction* (New York: Vintage, 1990). His posthumously published lectures at the Collège de France advance a theory of biopolitics inseparable from a genealogy of neoliberalism—and a cognate investment in "governmentality." "Governmentality," the art of governing, is a rearticulation of state power distinct from sovereignty and the sovereign exception. Whereas sovereign power is preoccupied with territory and the preservation of itself—its juridical and executive power—governmentality is concerned with extralegal forms of power, of relationships between people and things, maximizing productivity within itself to particular collective effect: reproducibility is key here (hence its centrality to the history of sexuality). For Foucault, the emergent interests in population on the one hand and economy on the other are critical to this shift. See Michel Foucault, *The Birth of Biopolitics: Lectures at the Collège de France, 1978*–79 (New York: Palgrave Macmillan, 2008). Also see Michel Foucault, *Power: Essential Works of Foucault, 1954–1984*, vol. 3, ed. James D. Faubion (New York: New Press, 2004).

Perhaps the best discussion on the relationship between Foucault's biopolitics, governmentality, and neoliberalism is Thomas Lemke, "'The Birth of Bio-Politics': Michel Foucault's Lecture at the Collège de France on Neo-liberal Governmentality," *Economy and Society* 30, no. 2 (May 2001): 190–207. Also extremely helpful is Wendy Brown, "Neoliberalism and the End of Liberal Democracy," *Theory and Event* 7, no. 1 (2003). Finally (if not in a Foucauldian vein) see David Harvey's indispensable *A Brief History of Neo-liberalism* (Oxford: Oxford University Press, 2005). Special thanks to Zhivka Valiavicharska for her insights into this work.

33. Michel Foucault, *The History of Sexuality*, 1:142.

34. Agamben, *Homo Sacer*, 4. Also see Agamben's more topical account of sovereign power in his *State of Exception*, trans. Kevin Attell (Chicago: University of Chicago Press, 2005).

35. Agamben, *Homo Sacer*, 15.

36. Carl Schmitt, *The Concept of the Political*, trans. with an introduction by George Schwab (Chicago: University of Chicago Press, 1996), 271.

37. This is hardly to suggest that George W. Bush has ever heard of, let alone read, Carl Schmitt. Yet Schmitt's convoluted reception history does, in fact, take us to the door of the White House. Through the figure of Leo Strauss, the conservative philosopher and Jewish refugee from Nazi Germany, Schmitt's rhetorical legacy is stamped on recent policy. Strauss's analysis of *The Concept of the Political* argued, for all intents and purposes, that Schmitt's critique of liberalism wasn't radical enough; and Strauss's profoundly antimodernist teachings at the University of Chicago found a ready audience with an entire generation of neoliberal thinkers, among them Paul Wolfowitz. On this history, see Anne Norton, *Leo Strauss and the Politics of American Empire* (New Haven: Yale University Press, 2004).

38. Mises, *Human Action*, 270.

39. Richard M. Ebeling, "Ludwig von Mises: Political Economist of Liberty," in *Political Economy, Public Policy and Monetary Economics* (London: Routledge, 2010), 23.

40. Percy L. Greaves, Jr., *Mises Made Easier* (Dobbs Ferry, NY: Free Market Books, 1974), 109.

41. Mises, *Human Action*, 42.

42. Ibid., 257.

43. Isabelle Mandraud and Caroline Monnot, "Investigation: The Tarnac Nine," *Le Monde*, November 21, 2008.

44. Ibid., and Angelique Chrisafis, "Rural Idyll or Terrorist Hub?," *The Guardian*, January 3, 2009, http://www.guardian.co.uk/world/2009/jan/03/france-terrorism-tarnac-anarchists (accessed June 13, 2011).

45. Daniel Miller, "Back to Meinhof," *New Statesman*, October 15, 2009, http://www.newstatesman.com/non-fiction/2009/10/coming-insurrection-france (accessed June 13, 2011). According to Miller, a Sorbonne criminologist named Alain Bauer "first brought the Tarnac group to the French government's attention by circulating copies of *L'Insurrection que vient* among the security forces in 2007."

46. Rachel Kushner describes the resonance between *The Coming Insurrection* and the "anonymous philosophical writings" in the journal on which Coupat served as a member of the editorial committee, and which counted Agamben as a supporter by way of connections to an Italian printing house. Rachel Kushner, "Books: Best of 2009," *Artforum International* 48, no. 4 (December 2009): 76–78, 81–82, 84.

47. The Invisible Committee, *The Coming Insurrection*, 13.

48. Ibid., 15.

49. Ibid., 28.

50. Ibid.

51. Ibid., 31.

52. Ibid., 23.

53. Ibid., 113.

54. Mandraud and Monnot, "Investigation: The Tarnac Nine." One of the Tarnac 9 arrested would insist to the press "there was no group," the implications being that the assumption of organized collectivity was a willful misrecognition on the part of the French authorities.

55. The Invisible Committee, *The Coming Insurrection*, 113.

56. See Walid Ra'ad as interviewed by Alain Gilbert, *Bomb* 81 (Fall 2002), http://bombsite.com/issues/81/articles /2504 (accessed June 13, 2011).

57. Husssein Mehdi, "Already Been in a Lake of Fire: Notebook Volume 38," in the Atlas Group and Walid Ra'ad, *The Truth Will Be Known When the Last Witness Is Dead: Documents from the Fakhouri File in the Atlas Group Archive* (Cologne: Walther König Editions, 2005), 86.

58. Ibid., 87.

59. As in Benjamin Buchloh, "Conceptual Art 1962–1969: From the Aesthetic of Administration to the Critique of Institutions," *October* 55 (Winter 1990): 105–143.

60. The Atlas Group and Walid Ra'ad, *The Truth Will Be Known When the Last Witness Is Dead*.

61. Raqs Media Collective, "Fragments from a Communist Latento," http://www.raqsmediacollective.net/latento.html (accessed June 13, 2011).

62. Lawrence Lessig, *The Future of Ideas: The Fate of the Commons in a Connected World* (New York: Vintage, 2001), 85.

63. Mike Caloud, "Sarai" (interview first appearing on Rhizome.org), http://www.noemalab.org/sections/ideas/ideas _articles/caloud_sarai.html (accessed April 17, 2006).

64. See Lawrence Lessig, *Free Culture: The Nature and Future of Creativity* (New York: Vintage, 2004).

65. Quoted in Lessig, *The Future of Ideas*, 12.

66. Ibid., 74.

67. http://www.opuscommons.net/templates/doc/index.html

Conclusion: Numbers

1. Shannon Jackson, *Social Works: Performing Art, Supporting Publics* (London: Routledge, 2011); and Carrie Lambert-Beatty, "Make-Believe: Parafiction and Plausibility," *October* 129 (Summer 2009): 51–84.

2. Robert Andrews, "Baiters Teach Scammers a Lesson," *Wired*, 08, 04, 2006, http://www.wired.com/techbiz/it/news /2006/08/71387 (accessed May 22, 2011).

3. "Advanced-Fee Fraud," http://en.wikipedia.org/wiki/Advance-fee_fraud (accessed May 22, 2011).

4. Insa Nolte, quoted in ibid.

5. See Ai Weiwei, *Ai Weiwei's Blog: Writings, Interviews, and Digital Rants, 2006–2009*, ed. and trans. Lee Ambrozy (Cambridge, MA: MIT Press, 2011).

6. Ai Weiwei, "Silent holiday, June 1, 2008," in ibid., 152.

7. "Ai Weiwei on Twitter in English (beta)," community-based translations, http://aiwwenglish.tumblr.com/post/4076265694/according-to-analysis-the-large-scale-attacks-to (translation adjusted by Yao Wu; "has imposed stricter censorship" is more literally "has upgraded its means of Internet screening").

8. "Ai Weiwei on Twitter in English (beta)," community-based translations, http://aiwwenglish.tumblr.com/post/4307501905/one-hour-ago-a-bunch-of-police-came-to-ai-weiwei. The online translation into English was further adjusted by Yao Wu, who also makes the following notations:

> Dongjie: Literally "Older Sister Dong"
> Xiaowei: Literally "Little Wei"
> Xiaoxie: Literally "Little Xie"
> Xiaopang Zhizi: Literally "Little Fat Nephew"
> As of June 22, 2011, Ai Weiwei was freed by the Chinese government but has remained silent about his treatment in prison.

Index

The letter f following a page number denotes a figure.